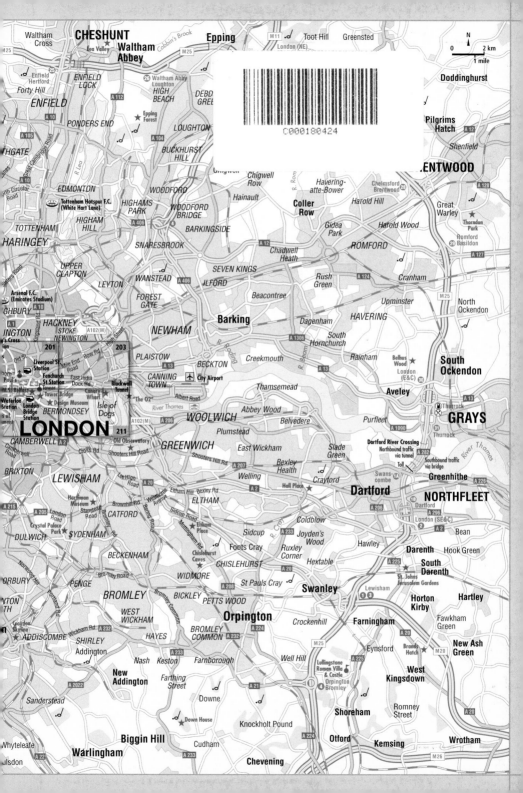

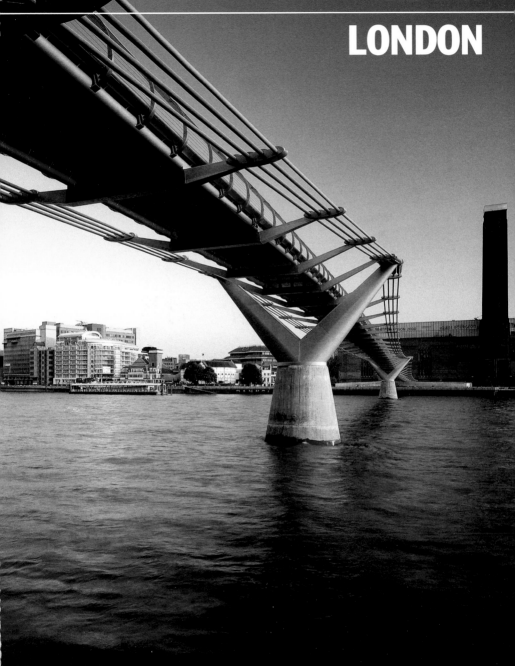

**Photo Guide**

# LONDON

The River Thames is London's lifeblood. Along its banks, old meets new as historic landmarks come face to face with the city's newest architecture. Here, the Palace of Westminster, Big Ben, and the London Eye are the focus of attention.

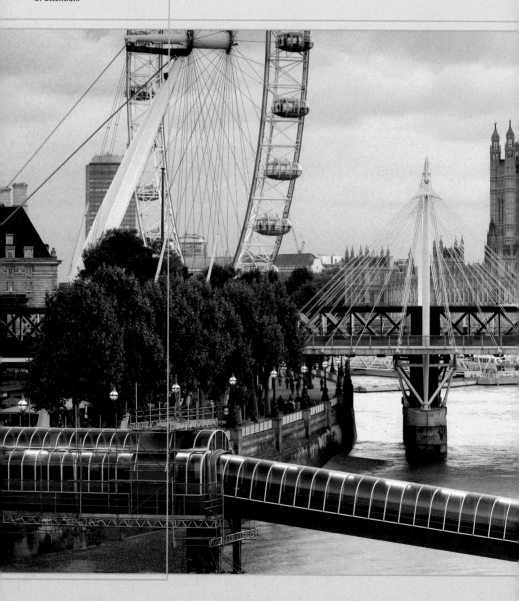

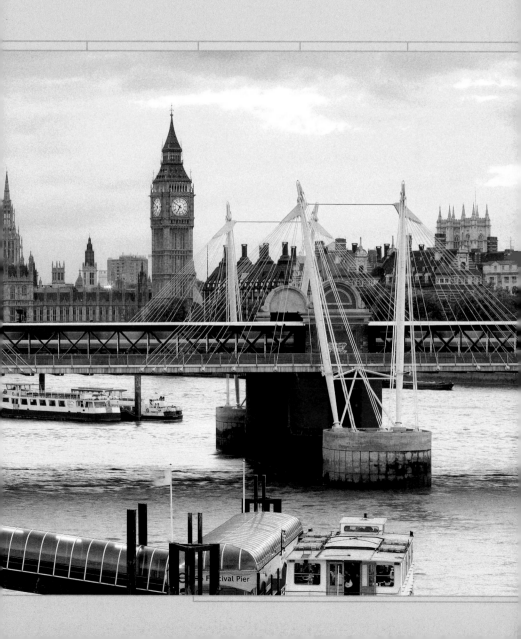

**Photo Guide**

# LONDON

In the heart of the West End, the magnificent façade of the National Gallery proudly overlooks Trafalgar Square. A popular meeting point for tourists, the square is also the scene of numerous events and festivals.

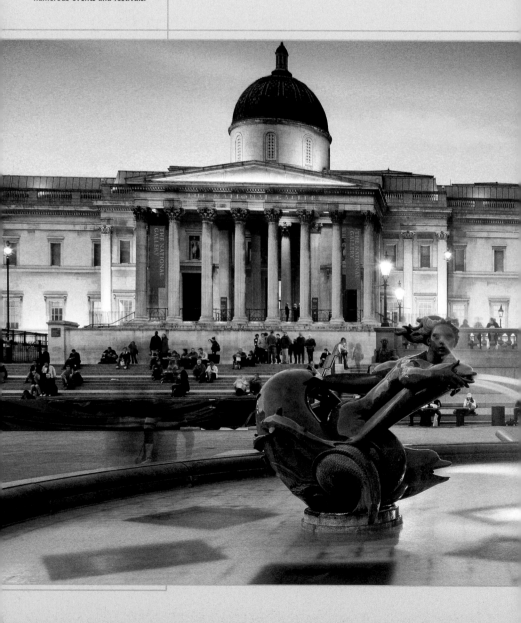

# ABOUT THIS BOOK

"By seeing London, I have seen as much of life as the world can show."

Samuel Johnson

The whole world in one city – the phrase is not just a catchy advertising slogan, but a good description of contemporary London. A metropolis in the true sense of the word, London is a city shaped by people from all over the globe. Generations of new arrivals have contributed to create the distinct cultural mix that gives the city its unique flair. London's diversity stems from the interplay of different cultural influences, which has resulted at the very least – and contrary to popular prejudice – in Europe's widest choice of dining options and its most interesting restaurants.

Fitting in all that London has to offer is no light undertaking. The sheer size of the city and the vast number of things to see and do is overwhelming – from the palaces of royal London to the futuristic architecture of the financial districts and, of course, the countless lively markets, department stores, and shops. London's cathedrals and the old City are reminders of the medieval capital, while the magic of maritime London awaits in Greenwich. London's many parks are welcoming green oases, and the city is also an artistic and cultural hub – its numerous museums and galleries home to some of the world's most awe-inspiring collections, and its hundreds of theatrical venues provide a stage for many great productions. The temptations of London's nightlife complete the package of a city that never sleeps.

This book is part of a new and unique series. *Photo Guides* combine the stunning photography of a coffee table picture book with the practical information of a traditional guidebook, making a handy and portable companion for the visitor to each city featured. Each book contains over 400 high-quality photographs and maps, with everything you need to know about the sights, festivals, and character of each district. You'll also find special features on culture, history, and food and drink, as well as an interesting city history, guided walks, insider tips on shopping and dining out, an introduction to the best museums, and – of course – a complete listing of useful addresses. At the back of each book, a detailed City Atlas ensures you won't get lost.

*Note:* The international telephone code to call the United Kingdom is 00 44 and 00 353 for the Republic of Ireland, followed by the local area code. Local codes begin with 0 (020 for London), which should be omitted when calling from abroad (e.g. 00 44 20 1234 5678) but retained when calling within the United Kingdom (e.g. 020 1234 5678).

London is a giant marketplace and if what you are looking for is to be found anywhere, it will be here. But the traditional, ornate Victorian home of Leadenhall Market is surely the city's most beautiful market hall.

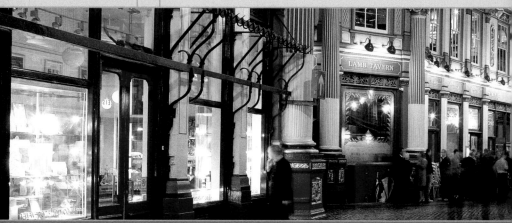

## TIMELINE

## THE HIGHLIGHTS

# CONTENTS

According to Peter Ackroyd in his extensive city history *London: The Biography* (2000), London is such a big and sprawling city that all of life is to be found here. It's certainly true that the diversity of the British capital is unmatched by any other city – and diversity is something of an understatement. The city on the banks of the River Thames has been a magnet for people from other countries since its very foundation. Each brought with them a piece of their own culture, and it is from this mix of constituent parts that today's fascinating city has developed.

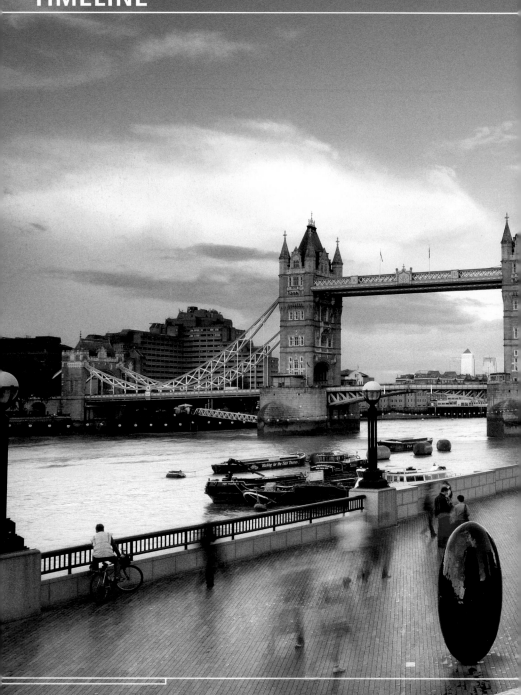

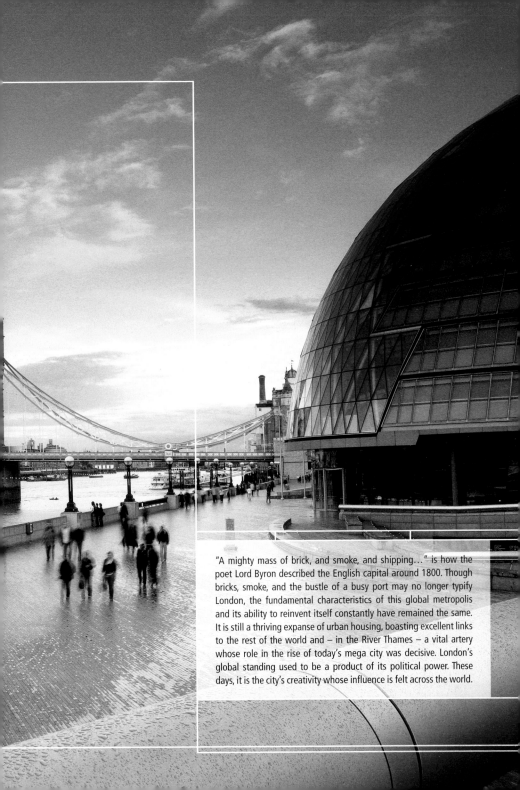

"A mighty mass of brick, and smoke, and shipping…" is how the poet Lord Byron described the English capital around 1800. Though bricks, smoke, and the bustle of a busy port may no longer typify London, the fundamental characteristics of this global metropolis and its ability to reinvent itself constantly have remained the same. It is still a thriving expanse of urban housing, boasting excellent links to the rest of the world and – in the River Thames – a vital artery whose role in the rise of today's mega city was decisive. London's global standing used to be a product of its political power. These days, it is the city's creativity whose influence is felt across the world.

# TIMELINE: THE AGES OF LONDON

In the year AD 43, the Romans founded Londinium in the hostile Celtic territories. You can still see remains of the Roman settlement, right in the heart of the modern city. The dark centuries of the early Middle Ages – characterized by Saxon and Viking invasions – were followed in the 11th century by the ascension to the throne of Edward the Confessor (right). His reign (1042–1066) marked an important phase of London's development.

**43**
The Roman Emperor Claudius founds Roman Londinium and builds the first bridge across the Thames.

**60**
The Celtic-British warrior queen Boudicca attacks the Roman settlement. The city is destroyed.

**60–90**
The Romans rebuild the devastated city.

**200**
The Romans erect London's first city wall to defend the city.

**410**
Roman troops withdraw from Britain and London.

**604**
King Ethelbert builds the first St Paul's Cathedral.

**834**
The Vikings attack London for the first time.

**886**
The Saxon king Alfred recaptures London from the Vikings.

**1014**
Scandinavian invaders take London and destroy the bridge. Canute, a Dane, is crowned king of England.

**1042**
Anglo-Saxon Edward the Confessor becomes king.

**1065**
Consecration of Westminster Abbey under Edward the Confessor.

Living history: a street performer dressed as a Roman centurion.

## Early history

Seen from the air, the twists and turns of the Thames are obvious. It flows into the city from the west, turning northwest at Hampton Court and then east out toward the sea – making a series of elegant curves through central London along the way, then widening into an estuary around Greenwich before finally flowing into the North Sea. It is believed that when the Romans founded Londinium in the year AD 43, they did so where the North Sea tides met the river. Like all major cities, early London was positioned strategically – accessible by ocean-going ships coming in from the sea, London also offered good access to the rest of the country by river, making it a perfect location for trade.

## The Romans

Expert logisticians, the Romans built a wooden bridge across the Thames to connect modern-day Southwark with a newly erected

**Modest beginnings: Roman Londinium.**

encampment on the north bank. The camp initially consisted of just two roads running parallel to the river, but the wooden bridge proved so important that the original military base quickly developed into a supplies hub,

complete with its own small port. In the year 60, the Roman settlement at Londinium was burnt to the ground in an attack led by the British Celtic warrior queen

Ruins of a Roman temple.

Statue of Queen Boudicca.

Remains of the Temple of Mithras on London's Queen Victoria Street.

Edward the Confessor's funeral (Bayeux Tapestry, late 11th century).

Boudicca, a member of the Iceni tribe whose daughters had been raped by the Romans and whose kingdom they had annexed. But the city was quickly rebuilt, this time in more splendid style than it had ever seen before. Its population would soon number some 30,000–50,000 residents.

## Angles, Saxons, and Vikings

As the power of the Roman Empire waned, its northern capital Londinium also entered a period of gradual decline, culminating in the final withdrawal of foreign power from Britain at the beginning of the 5th century. By that time, the Angle and Saxon tribes had been established in southern England

for some 200 years. These Germanic tribes had not previously shown much interest in London, but as the city became an increasingly important trading port and

the Celtic Britons finally accepted the superiority of the ever-stronger Saxons, the Saxons declared it their capital. Named Lundenwic (London port), the Saxons' new settlement was located just outside the old city walls – somewhere around modern-day Covent Garden.

An Anglo-Saxon with Norman roots: Edward the Confessor, king of England.

The Anglo-Saxon king Alfred the Great – depicted here by Hamo Thornycroft (19th century) – drove the Vikings out.

In 851, Vikings sailed up the Thames in 350 ships to attack London. The Vikings razed the city to the ground, using what was left as their headquarters until Alfred, king of Wessex, broke their grip on power and seized back control of London in 886. The Vikings did not give up completely however, and provided two more kings before

the throne was returned to Saxon hands with the accession of Edward the Confessor. Known for his piety, the new king established a cloister on an island some 3 km (2 miles) upriver and ordered the construction of a palace that would later become Westminster. By moving his court here, Edward created a division that has endured to the present day: the City of London is the capital's trade and business base, while Westminster is its political hub.

In the Middle Ages, England's kings were constantly dealing with war and political intrigue. From left: The legendary Richard the Lionheart (1157–1199) took charge of his army at just 16 years of age; Edward IV (1442–1483) was heavily involved in the dynastic battles between the Houses of Lancaster and York known as the Wars of the Roses, which were brought to an end by the accession of Henry VII, the first Tudor king.

**1066**
William the Conqueror is crowned king of England in Westminster Abbey.

**1154**
Henry II, a member of the House of Plantagenet, becomes king.

**1176**
The first stone bridge across the Thames is built on the site of the former Roman wooden bridge.

**1190/1191**
Henry Fitz-Ailwin becomes the first mayor of London.

**1215**
Signed by King John, the Magna Carta grants London greater privileges.

**1240**
The first Parliament meets in Westminster.

**1269**
The new Westminster Abbey is consecrated.

**1348**
Tens of thousands of Londoners fall victim to the plague. Only a third of the city's population survives.

**1394**
Westminster Hall is rebuilt under Richard II.

**1397**
The merchant Dick Whittington becomes the first elected mayor of London.

**1509**
St James's Palace is built on the orders of King Henry VII.

## William the Conqueror

The influence of England's Norman king on the course of English history was massive, and it was William who laid the foundations of the future global empire's economic and political success. Born in Falaise, Normandy, in 1027 or 1028, William was the illegitimate son of Duke Robert the Magnificent. He crossed the Channel and arrived in England after the death of the English king Edward the Confessor in 1066. Edward had died childless, and William had come to claim the crown that had been promised to him.

He defeated his rival for the crown at the Battle of Hastings that year. Having crowned himself king of England, he quickly set about distributing the Anglo-Saxon landowners' property among his Norman allies. William died in 1087.

1066: For London as for the rest of England, the reign of William I marked the beginning of Norman rule.

## The Normans

With England under Viking rule, Edward the Confessor spent his childhood and youth with his Norman relatives in Rouen before returning to England to claim his throne. When Edward died in 1066, two men made a bid to succeed him: Harold Godwinson, son of the Earl of Wessex and Edward's brother-in-law, and Edward's cousin William, Duke of Normandy, named by Edward himself as his successor. Harold was quick to have himself crowned king upon

1381: Richard II looks on as the rebel leader Wat Tyler is executed by Mayor Walworth.

Edward's death, but William was not about to allow the crown of such a prosperous country to slip from his grasp. William and his army landed on the English coast in the same year, and quickly overpowered William's ill-prepared adversary Harold at the Battle of Hastings. William marched into London and, on Christmas Day 1066, was crowned in Westminster Abbey, which had only been completed a year earlier. Afterwards, he adopted the epithet "the Conqueror". William made the city-state of London the capital of a kingdom that spanned not only Britain, but also Normandy

The Battle of Hastings changed the course of history.

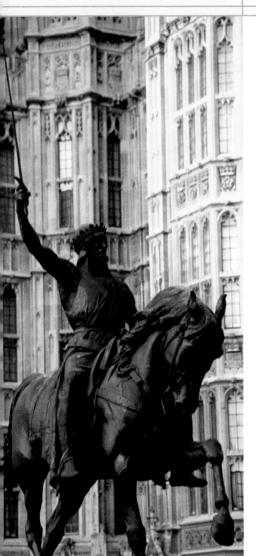

Leading from the front: Richard the Lionheart towers over passers-by outside Parliament. The Victorian statue is a monument to centuries of British striving for power.

and other territories in France. Although William acknowledged London's independent status, this did not stop the new king from building the White Tower – the oldest part of the Tower of London – in the heart of the city. In its role as a fortress, the White Tower was designed to protect the Normans from the people of London, as much as to protect London from invaders.

## Trade and prosperity

London's independence was officially confirmed by Richard the Lionheart in 1191, and would be recognized by all subsequent monarchs.

Richard's concession was not, however, entirely selfless, since he needed the money and support of London's wealthy merchants. The first Lord Mayor of London was appointed a year later, along with a city council composed of merchants from the powerful guilds. In 1240, the first English Parliament was convened in Westminster. Yet despite growing prosperity, thriving trade, and the expansion of the city, living conditions for the majority of its population were still pretty abysmal. The less well off lived on narrow streets in houses built from straw and clay. Their drinking water came directly from the Thames – the same river into which the city's sewage flowed. In 1348, the population was decimated by plague and reduced to a third of its original 100,000 residents. Political unrest also took its toll. When King Richard II attempted to introduce a poll

tax in 1381, thousands of already disgruntled peasants, led by Wat Tyler, marched on London to protest. They dragged the Archbishop of Canterbury from the Tower, beheaded him, and destroyed large parts of the city. In the end, however, the rebellion was defeated and its leaders executed.

The crown's greatness expressed in architecture (from top): the Tower of London; Westminster Hall; and the Henry VII Chapel, Westminster Abbey.

History makers (from left): Elizabeth I (1533–1603), daughter of Henry VIII, was the politically astute "Virgin Queen" whose influence permeated an entire era; Charles I (1600–1649) fought both Parliament and the Puritans, but was eventually executed by order of the powerful parliamentarian Oliver Cromwell; William of Orange (1650–1702) took on France to strengthen England's claim to great power status.

**1534**
Henry VIII breaks with Roman Catholicism and founds the Anglican Church instead.

**1558**
Elizabeth I becomes queen. The first map of London is drawn.

**1565**
The Royal Exchange is founded as a base for commerce in the city.

**1584**
Walter Raleigh founds the first English colony in America.

**1605**
The Catholic rebel Guy Fawkes attempts to murder King James I by blowing up Parliament.

**1642**
The bloody English Civil War between crown and Parliament begins.

**1649**
The Stuart king Charles I is executed. Oliver Cromwell assumes power.

**1660**
After Cromwell's death, the monarchy is restored under Charles II.

**1666**
The city is almost completely destroyed by the Great Fire of London.

**1688**
The Catholic king James II is deposed by his Protestant son-in-law William of Orange.

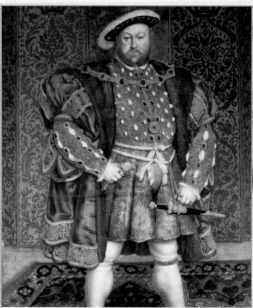

Henry VIII (1491–1547) – the ultimate Renaissance monarch – as depicted by his court artist, Hans Holbein the Younger.

## Henry VIII

"Divorced, beheaded, died/ Divorced, beheaded, survived." This popular English rhyme records the fate that met the six wives of Henry VIII. The king's turbulent succession of marriages not only secured his place in history, but also set the course of English religion. When the pope refused to annul Henry's first marriage to Catherine of Aragon, his brother's widow, Henry renounced the papacy and founded the Anglican Church. Merciless toward his opponents, he is said to have murdered over 70,000 people who got in his way.

The king surrounded by his family (top) and with the royal insignia of his office (bottom).

## The Tudors

In 1485, a dynasty came to power whose rule would see the start not only of England's rise to global superpower, but also of London's elevation to one of the world's foremost cities. Henry VII, the first Tudor king, brought stability to his kingdom and filled the royal coffers. His son Henry VIII loved pomp, palaces, and women, but his most notable contribution to English history was the split from the Roman Catholic Church. In 1536, he unified England and Wales, declaring himself king of Ireland – already under English rule for 400 years – in 1542.

## Elizabeth I

The 45-year-long reign of Queen Elizabeth I is one of the most important periods of English history. Under Elizabethan rule, the country successfully established itself as both an economic and naval power. North America became an important focus for the ambitions of an expansive England, and

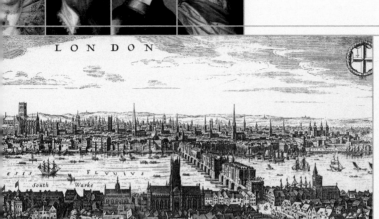

The capital under Elizabeth I: residential property, shops, and a chapel were all to be found on London Bridge (depicted here in a contemporary engraving).

## William Shakespeare

"The Bard" – as Shakespeare is affectionately known – was born in Stratford-upon-Avon in 1564. He married Anne Hathaway and fathered three children before moving to London some time in his mid- to late-twenties. Shakespeare spent the next 20 years of his life in the capital. Although his plays, poems, and sonnets were already popular in his own lifetime, it wasn't until the 18th century that Shakespeare's work received worldwide recognition. When the first English

imports from the new colonies brought not only great prosperity but also new fashion styles to the city. Smoking tobacco and drinking coffee became de rigeur for the well-to-do. In the year 1571, the Royal Exchange was awarded its Royal title by Queen Elizabeth I; it helped make London the most important trading city in the world.

## The Stuarts

Elizabeth's successor, her cousin James I, son of Mary, Queen of Scots, was Catholic, as was his successor Charles I. Embroiled in a power struggle with an increasingly strong Parliament, Charles plunged the country into civil war. The wealthy merchants of London and the Puritans took the side of the parliamentarian rebels under Oliver Cromwell. His armies defeated, Charles was executed in 1649. Cromwell ruled England for 11 years. It was Europe's first true parliamentary government, but the

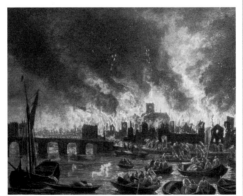

The catastrophic Great Fire of 1666 started in a bakery and turned London into a raging inferno.

monarchy was restored after Cromwell's death in 1658.

## Catastrophes

Large areas of London were densely developed, dirty, and overpopulated. Plague was a regular feature of the city's history, but in 1665 an epidemic broke out whose ferocity surpassed anything London had yet encountered.

The plague claimed some 100,000 victims, and no sooner had it passed than fate struck once more. On 2 September 1666, a fire started in a bakery located on Pudding Lane. The flames quickly spread through the narrow city streets, and for four days London was a blazing inferno. Almost 80 percent of the capital was completely destroyed.

A portrait of William Shakespeare, held by many to be the most important dramatist of all time.

dictionary was compiled, Shakespeare's use of English in his works was used to help standardize a language whose spelling and grammar had not previously been formalized. Shakespeare died in 1616. Little is known about his life, but his work has exerted a lasting influence on world literature.

The House of Hanover inherited the British throne in 1714. Hanoverian rule saw a new sense of elegance in London, and splendid buildings such as Cumberland Terrace in Regent's Park (right) were erected. Great riches came from the West Indies (below bottom); new buildings – like Somerset House, shown with St Paul's in the background (below middle) – sprung up along the Thames; and, last but not least, Westminster Bridge (below top) was built.

**1714**
The prince-electors of Hanover, Germany, become the legitimate heirs of the British throne, which George I duly assumes.

**1717**
The West End is one of the new London districts established at the beginning of the 18th century.

**1768**
Foundation of the Royal Academy of Art.

**1776**
After the American War of Independence, Britain signs the Declaration of Independence and loses its American colonies.

**1802**
The new Stock Exchange strengthens London's position as an economic and financial hub.

**1806**
Having been killed on board the *Victory* at the Battle of Trafalgar on 21 October 1805, Admiral Horatio Nelson is laid to rest in St Paul's Cathedral.

**1811**
Suffering from mental illness, George III is declared unfit to rule. His son, the future king George IV, becomes prince regent.

**1830**
When George IV dies, his brother William becomes king.

**1836**
London's first railway terminus is constructed.

## The Bank of England

When William of Orange acceded to the English, Scottish, and Irish throne in the 17th century, the state finances were in dire straits. It was a Scottish merchant, William Paterson, who suggested a credit scheme that would lend the state £1.2 million. The subscribers established themselves as the Bank of England, which evolved from its role as manager of the state's debts to become the nation's leading financial institution – invested, among other things, with the right to issue bank notes. The bank moved to its current Threadneedle Street address in 1734, gradually expanding its premises over the centuries. Today, it is one of the oldest banks in the world, and the reassuring saying "as safe as the Bank of England" is firmly established in popular usage.

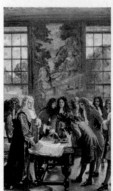

The founding meeting of the Bank of England (the "Old Lady of Threadneedle Street") at Mercer's Hall, Cheapside.

## The new kings

In 1688, the English, Scottish, and Irish crowns were thrust into a new crisis when the Protestant William of Orange toppled his father-in-law James II from the throne and declared himself king. William died without leaving an heir, as did his successor and sister-in-law Queen Anne, the last Stuart monarch to occupy the throne.

Under the provisions of the 1701 Act of Settlement, British monarchs had to be Protestant, and when Anne died the search for a suitable successor spanned the royal houses of Europe before settling on the prince-electors of Hanover. The four Guelphic Georges – George I, George II, George III, and George IV – constituted a dynasty whose total reign lasted 120 years, but they were not always popular among the British. King George I barely spoke a word of English in all his life, and spent much of his time in Germany. It was only in the third King George – who was born in England – that the country found a monarch who regarded the local language as his native tongue.

## London expands

Foreign immigrants arrived in the up-and-coming city in their droves. Most found accommodation in poorer east and south London, while the better off settled in the west and north of the city – a division that, broadly speaking, still stands today.

Around 1700, London's population numbered some 600,000 residents, making it Europe's largest city.

New districts were established at the beginning of the 18th century, most of them in the more exclusive West End between Soho and Hyde Park. The royal palaces of Whitehall gave way to government buildings, Grosvenor Square was created in aristocratic Mayfair, and, in 1759, the British Museum was opened. To top it all off, the growing city also needed a new bridge across the Thames, the city's traffic having long surpassed the capacity of old London Bridge. Westminster Bridge was completed in 1750, and a

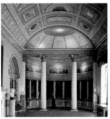

**Kenwood House in Hampstead was restructured in contemporary style in 1765.**

third bridge, at Blackfriars, followed ten years later.

## Art and culture

In the 18th century, London was a popular destination for many artists. This was where George Frideric Handel composed his *Messiah* and *Water Music*, where Thomas Gainsborough painted his most beautiful paintings, and where William Hogarth created his caricatures of London society. Parks such as Ranelagh and Vauxhall became popular venues for concerts, firework displays, and other entertainment. The

city's growing number of coffee houses also provided entertainment, and were frequented by those meeting up to discuss politics and business. New theaters and opera houses opened, their popular productions providing a stark contrast to court ritual.

## The Regency

When, in the last years of his life, King George III was declared unfit to rule, it fell to his son, the fourth George, to rule as prince regent. The beginning of the Regency

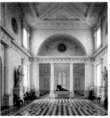

**An equally splendid manor house, Syon House lies in the south-west of the city.**

brought with it the birth of the Regency style, a completely new aesthetic that made itself felt in many different areas of cultural life. One of its most notable representatives was the architect John Nash who designed the elegant houses around Regent's Park and Regent Street, as well as Trafalgar Square and the Haymarket Theatre. He also oversaw the restructuring of Buckingham House to create Buckingham Palace. Equally influential was Beau Brummell, the original dandy and creator of the men's suit that is still fashionable today.

## John Nash

It is hard to think of an architect who has had such a lasting influence on London's streetscape as John Nash. He penned beautiful designs for buildings, squares, and parks, and saw many of them become reality. His design influence permeated the years between Georgian and Victorian England. The Regency, as that relatively short period is known, spawned building projects including Trafalgar Square, Marble Arch, and the restructuring of Buckingham

**Architect of the Regency era: John Nash (1752–1835).**

Palace. But Nash's most famous buildings are his classical terraces – elegant townhouses like Cumberland and Carlton House, which are still the ultimate in high-class London living.

From left: The National Gallery; Big Ben and Parliament at Westminster; Tower Bridge, and the Maritime Museum at Greenwich. The Victorian age was one of technical innovation, museum building, and the celebration of that global British empire "on which the sun never sets". Britain believed itself to be at the peak of its power – and London was the capital of the world.

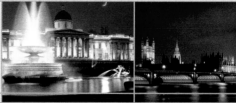

**1837**
Victoria becomes queen of Great Britain and Ireland. Charles Dickens' novel *Oliver Twist*, depicting life in London's poorest areas, appears as a serial in a magazine.

**1843**
Nelson's Column is erected on Trafalgar Square in central London.

**1851**
The Great Exhibition – the first of its kind in the world – takes place in London's Crystal Palace.

**1863**
The world's first working underground railway goes into service in London.

**1884**
Greenwich Mean Time is established as a basis for calculating times throughout the world. The zero meridian passes through Greenwich, making London the arbiter of all things temporal.

**1889**
The London County Council, an independent municipal authority, is founded.

**1890**
The first electric Underground train travels across London.

**1894**
Tower Bridge is completed.

**1901**
Queen Victoria dies at the age of 81. A living legend, her influence was felt throughout the age in which she ruled.

## The Underground

The London Underground is the world's oldest underground railway – although the term is not strictly accurate, since more than half of the track is in fact above ground. The first section was opened in 1863, connecting the districts of Paddington and Farringdon, and the modern-day Circle Line was completed some 20 years later. Today, the Underground network comprises around 400 km (250 miles) of track covering 11 different lines. It has a total of 268 stations and carries over three million passengers every day. These statistics make the London Underground the longest and busiest in the world.

The cutting of tunnels was at the forefront of engineering.

The opening of the Underground in 1863.

Right: Cross section of a street showing an Underground tunnel along with gas and water pipes.

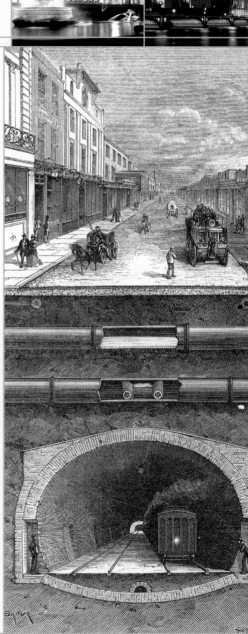

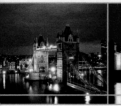

## Industrialization

In the 19th century, London witnessed the emergence of Great Britain as a world power, a rapid growth of industrialization, and a population explosion. But the period was also characterized by a huge gap between rich and poor.

The biggest leaps forward were made in the first half of the century, as London transformed itself into the country's hub of trade and industry. Meanwhile, the industrial areas of the Midlands were connected to the Thames by an extensive canal network, providing a boost to shipping in the capital itself. Vessels from all over the world jostled for space on the river, and new quays and wharfs were built in places such as Blackwell, Deptford, and Greenwich. Before long, the city had more wharfs than anywhere else in the world, and in 1836 the first railway line from London Bridge to Greenwich was laid. The expansion of the rail network brought new stations at Fenchurch Street, Euston, Paddington, Waterloo, and King's Cross, and the first Underground train went into service in 1863.

But the biggest success of all was the Great Exhibition of 1851. The first exhibition of its kind, the event was a showcase for the British empire and a symbol of British superiority. The exhibition hall at Crystal Palace was a revolutionary glass and steel design, whose displays of the latest technologies and products from across the globe attracted over 200,000 visitors. After the exhibition, the building was moved from Hyde Park to a new home in Sydenham, south London, but was destroyed by fire in 1936.

## Rich and poor

For all the riches flowing into the city, Victorian London was also a place of harsh social contrasts. The infrastructure could not keep up with the growing population rate. In 1800, London had just one million inhabitants, but by the end of the century the figure had risen to some six million. In the west and north of the city, highly desirable new districts like Chelsea, Kensington, Paddington, and Hampstead were established, and London's high society frequented the city's exclusive clubs. On the narrow streets of east London, meanwhile, the city's poorer and most impoverished residents crammed into overcrowded housing or headed for the gin palaces to drown their sorrows. Their living conditions are hard to imagine. Children were sent begging, crime and prostitution were endemic, poverty and suffering lay at every corner. It was in the East End that the phrase "slum" was coined, yet the only initial attempt to take charge of the situation was to build new prisons. In 1829, the Metropolitan Police – the first regular police service – was set up, charged with maintaining law and order.

## London air

Victorian London stank to high heaven. Buildings were heated using coal fires, and the permanent cloud of smoke that hung over the city was the inevitable result. Worse still, however, was the fact that London lacked any proper sewage system. Instead, the waste produced by millions of Londoners drained straight into the Thames, leading not only to an unholy stench, but also to epidemics of illness that devastated the poorest districts. An outbreak of cholera claimed the lives of some 10,000 Londoners around the middle of the century, but it was only after the "Great Stink" in the summer of 1858 – during which anyone passing by the Thames was overcome by the smell – that the

**The Great Exhibition was opened in 1851.**

**London's Crystal Palace was a venue worthy of the spectacular event.**

engineer Joseph Bazalgette was instructed to build a new sewerage network. The completion of the extensive building works lead to a dramatic decline of cholera, although the aquatic life of the Thames – which was then a biologically dead river – has only recently begun its recovery.

## Queen Victoria

Victoria, queen of the United Kingdom of Great Britain and Ireland, and later the first empress of India, is among the most popular figures of British history. She is a symbol of Britain at the peak of its global power, and gave her name to an entire era. Victoria was only 18 years old when she was crowned queen in 1837. She married her cousin Prince Albert of Saxe-Coburg-Gotha three years later, bearing him nine children. Victoria loved her husband devoutly, and con-

**Mother of the nation: Victoria (1819–1901) at 78.**

tinued to do so after his death. She was inconsolable when Albert succumbed to typhoid in 1861, and dressed in her famous black mourning clothes for the rest of her life. Unlike her ancestors before her, Victoria set great store by family and moral values. It was a conviction that permeated the period, and prudish attitudes are frequently described as "Victorian" to this day.

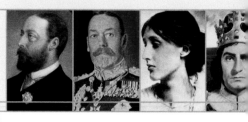

Power, spirit, and artistic talent (from left): Edward VII (1841–1910) was the first British king from the house of Saxe-Coburg-Gotha; George V (1865–1936) gave up his German titles during World War I and changed the royal family's name to Windsor; Virginia Woolf (1882–1941) was a ground-breaking writer; the great Shakespeare actor Sir Laurence Olivier (1907–1989) was director of the Old Vic Theatre for many years.

**1908**
London plays host to the Olympic Games for the first time.

**1915**
German zeppelins drop bombs on London during World War I.

**1922**
The BBC (British Broadcasting Corporation) transmits its first radio broadcast.

**1936**
King Edward VIII opts to abdicate in order to marry an American divorcee, Wallis Simpson. He is succeeded by his brother, George VI.

**1940**
Winston Churchill becomes prime minister. In the years that follow, German bombers cause massive damage and countless civilian casualties.

**1948**
London hosts the Olympic Games for the second time.

**1952**
Agatha Christie's murder mystery *The Mousetrap* has its West End premiere. The show is still in production today.

**1953**
After the death of George VI, Queen Elizabeth II ascends to the throne.

**1958**
The Notting Hill race riots are an unsettling sign of racial tension.

## Winston Churchill

Winston Churchill gave some 60 years of his life to politics, occupying a variety of different posts. Most fondly remembered by some for his "no sports" strategy for long life, Churchill was already a legendary figure during his time as secretary of state for

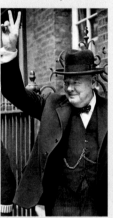

Ever confident of victory: wartime prime minister Winston Churchill in 1943.

war. He served his country as prime minister from 1940–45, and again from 1951–55, but it was his calm, level-headed leadership through the war years that really cemented his reputation. Famously partial to his daily whisky, Churchill was – both as statesman and Nobel prize-winning author – a truly unique personality. In 2002, one million people chose Churchill in a BBC poll to find the Greatest Briton of all time. Engineer Brunel came second and Diana, Princess of Wales third.

## The World Wars

For the rich at least, the advent of the 20th century heralded a more glamorous, modern London. The first motorized buses trundled along the city streets, and beneath them the first electric Underground trains were going into service. Luxury

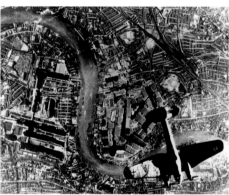

"The Blitz", 9 July 1940: German bombers over London.

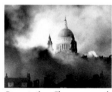

Devastation: Flames around St Paul's Cathedral…

… and Tower Bridge.

hotels such as the Ritz were constructed; Harrods – still Europe's biggest department store to this day – unveiled its new home in Knightsbridge; and magnificent new entertainment venues such as the Palladium were springing up like mushrooms. London was a metropolis, and one from which over a quarter of the

world's population and landmass were ruled.
World War I, however, was a sobering wake-up call. Although London itself was spared heavy damage in the attacks upon it, the conflict that had begun as an apparently minor altercation had turned out to be a human and economic catastrophe. Great

Britain had eventually won the war, but the casualties had exceeded everyone's worst fears. The military losses, the enormous financial burden, and – crucially – the realization that this great colonial power could not, in fact, rule the world were the factors that led to the gradual decline of the empire.

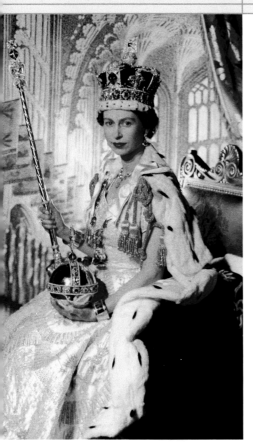

The start of a long reign which would rival that of Queen Victoria: Elizabeth II's official coronation photograph, 1953.

In the interwar years, London's population grew to some 7.5 million. New housing estates stretched ever further into the surrounding countryside. At the same time, unemployment was rising and working conditions were deteriorating. Unrest followed, and 1926 saw a general strike. World War II took a far heavier toll on London than its predecessor. The "Blitz" – the Nazi air attack on London – destroyed a third of the city, including its wharfs and quays. Class differences were temporarily set aside as Londoners came together to resist the German bombing campaign. Even the royal family insisted on sitting out the war in their vulnerable London palaces. London's tube stations were used as shelters from the air raids – at the peak of the Blitz, over 175,000 people were regularly spending the night in underground stations.

## The postwar years

As in World War I, Britain emerged victorious from the war against Hitler. But the economy was in tatters and the following years would see the final collapse of the empire. In the colonies, a new sense of nationalism found convincing proponents in figures such as India's Mahatma Gandhi. The demand for independence was equally loud in Britain's Caribbean, African, and Asian colonies, and in the end the London government – powerless to retain its colonial possessions – would grant their wish.

Their homelands newly independent, countless former subjects of British colonial rule now flocked to the UK, settling in the main industrial cities, including London. Notting Hill, for example, became a focus for migrants from the Caribbean – a fact reflected in the famous Notting Hill Carnival that still takes place there today. Many Chinese migrants – most of them from Hong Kong – settled in Soho, while Sikhs from the Indian Punjab arrived in Southall and Greek Cypriots in Finsbury. The first racial unrest led to a heightening of social tension in the city, and bleak high-rise apartments were erected across parts of the city in an attempt to satisfy the demand for housing created by the migrant influx.

## Elizabeth II

The queen is not only the British monarch and head of the Anglican Church, but also the queen regnant of 16 independent states, including Canada, Australia, and New Zealand. She is also the queen regnant of these states' overseas territories, to

The coronation of Elizabeth II in Westminster Abbey.

say nothing of her many other titles. The queen is not, of course, allowed to express her own political opinions, and getting involved in domestic politics is completely out of the question. Nonetheless, she is at the heart of British society – even if she and her family are more likely to be the subject of tabloid gossip than broadsheet debate. The sometimes eventful lives of the royal family are a constant source of interest to many in Britain and across the world. The queen is now in her 80s, her mother, Elizabeth, the Queen Mother, widow of George VI, was 101 when she died in her sleep in 2002. Queen Elizabeth II is now the longest serving reigning British monarch after Queen Victoria.

# TIMELINE: THE AGES OF LONDON

There are no better representatives of 1960s London as the global capital of pop than the Beatles – from left: John Lennon (1940–1980); Mary Quant (born 1934) invented the miniskirt and hot pants; prime minister Margaret Thatcher (born 1925) shook Britain to its core; the Nobel prize-winning playwright Harold Pinter (born 1930) has won worldwide acclaim for his plays; Sir Norman Foster (born 1935), ground-breaking architect.

**1963**
Founding of the National Theatre (Royal National Theatre) at the Old Vic.

**1967**
The legendary Beatles' *Sergeant Pepper* album is released, touching a nerve with an emerging new generation.

**1981**
The most violent race riot in London's history breaks out in Brixton.

**1986**
Prime Minister Thatcher dissolves the Greater London Assembly.

**1990**
The controversial poll tax sparks violent clashes in Trafalgar Square.

**1992**
Canary Wharf, the first major project in the regeneration of the Docklands, is completed.

**1997**
Tony Blair leads the Labour Party to a landslide victory at the general election.

**2000**
Ken Livingstone is elected mayor of London following Labour's resurrection of city government.

**2005**
Islamist terrorists target London with multiple bomb attacks.

**2012**
London looks forward to hosting the Olympic Games for the third time.

## Swinging London

In the 1960s, London once more became the focus of the world's attention. This time, however, it wasn't the city's political status that assured its place on the global stage, but the fact that "swinging London" was synonymous with the cultural revolution that was sweeping aside the stale society of the 1950s. The world looked to London for the latest trends in music and

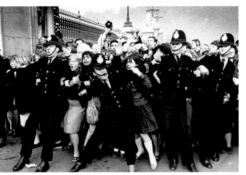

Beatlemania: in 1965, police hold excited fans back from Buckingham Palace, where the Beatles have just received their MBEs from the queen.

fashion. The music and provocative lifestyles of the Beatles and Rolling Stones – alongside artists such as Manfred Mann, the Kinks, and The Who – inspired a generation tired of social barriers and rigid morality. The fashion designer Mary Quant created a style that epitomized the era, and models like Twiggy and Jean Shrimpton set new standards of beauty. The cultural revolution became a quiet social revolution, and neither the city nor the country would ever be the same again.

## Modernism takes on the slums

It took London a long time to emerge from the desolation of the postwar years. City planners went far beyond simple reconstruction, and – spurred on by the vision of a new, modern London – construction companies set about demolishing many of the buildings that the Blitz had failed to destroy. The demolition was indiscriminate – old streets, historic buildings, and, sadly, even some of the city's established infrastructure were all torn down. London's biographer Peter Ackroyd wrote that this was always an ugly city, and it was never more so than in the decades following World War II.

Things started to change in the 1970s, when yuppies – young professionals armed with plenty of creativity and no shortage of cash – began to move into the capital's more run-down areas. The result was gentrification – a

term now recognized in cities across Europe to describe the smartening up of neglected districts.

But the 1970s also saw recession. The Docklands – the traditional home of London's shipbuilding industry – was left in terminal decline, and the docks were largely idle by the time that Margaret Thatcher's strict economic policy created renewed prosperity. Yet not everyone would benefit. Big

In the 1960s, Twiggy was the first super-skinny model.

business was booming, but unemployment was on the rise and the gaping chasm between rich and poor growing wider still. An undercurrent of social tension ran throughout Thatcher's premiership, bubbling to the surface in the Brixton race riot of 1981 and again in Tottenham in 1985. Bomb attacks by the IRA – the underground Irish Republican Army – continued to be an unsettling feature of London life right up to the mid-1990s, and caused extensive destruction. Nonetheless, London continued to

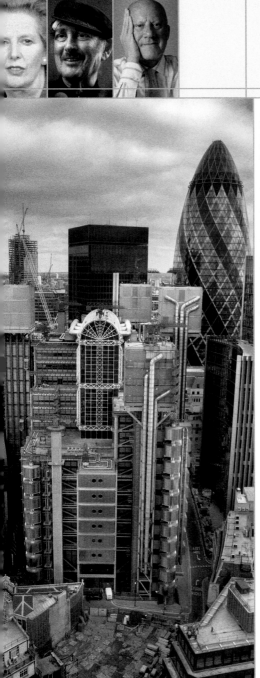

reinvent itself just as it always had done. Canary Wharf, the new financial complex in the east of the city, is an obvious example, and the city's skyline is set to continue changing. Indeed, it is already dominated by a succession of post-modern buildings such as Canary Wharf Tower, the Lloyd's Building, and the "Gherkin" – a glass-fronted, gherkin-shaped skyscraper.

## The world-class city

London is among the world's leading metropolises, and – alongside New York and Tokyo – one of the three linchpins of the global economy. With its five international airports, London is also the world's biggest aviation hub – Heathrow being the city's busiest airport. There are some 7.7 million people living in London itself, but the population of the wider area bound by the M25 London orbital motorway is nearer 14 million. London has always been proud of its multicultural society, even if this diversity can create significant problems. In total, around 300 different languages are spoken. Thanks to the Eurostar and the Channel Tunnel, London now enjoys direct rail connections to the Continent, though that's no reflection on any sense of European identity. London has always seen itself as a world all of its own – a global city, making its own rules.

**Left: Buildings around Sir Norman Foster's "Gherkin." Right, from top, illuminated London: The Lloyd's Building; Tate Modern; the London Eye; the Millennium Dome; and Docklands.**

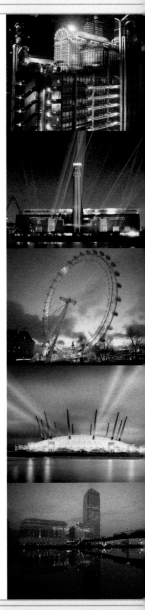

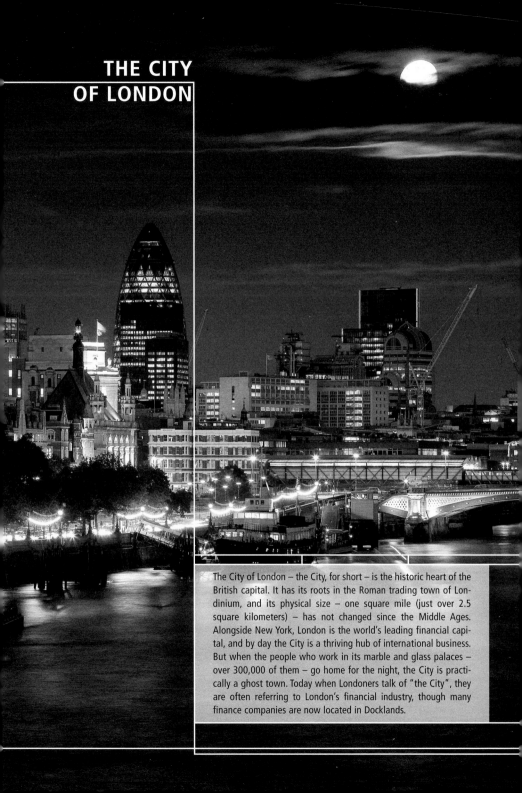

# THE CITY OF LONDON

The City of London – the City, for short – is the historic heart of the British capital. It has its roots in the Roman trading town of Londinium, and its physical size – one square mile (just over 2.5 square kilometers) – has not changed since the Middle Ages. Alongside New York, London is the world's leading financial capital, and by day the City is a thriving hub of international business. But when the people who work in its marble and glass palaces – over 300,000 of them – go home for the night, the City is practically a ghost town. Today when Londoners talk of "the City", they are often referring to London's financial industry, though many finance companies are now located in Docklands.

1. Tower Bridge
2. The Tower of London
3. Lloyd's of London
4. The Royal Exchange, The Bank of England
5. Guildhall
6. The Barbican Centre
7. St Paul's Cathedral
8. The Old Bailey
9. St Bride's, Fleet Street

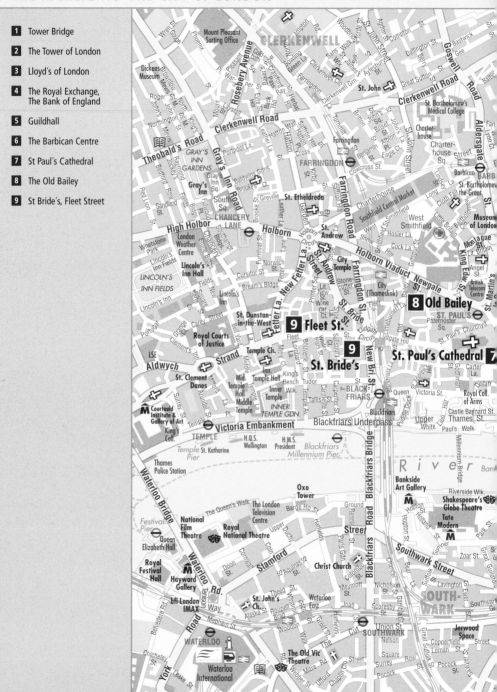

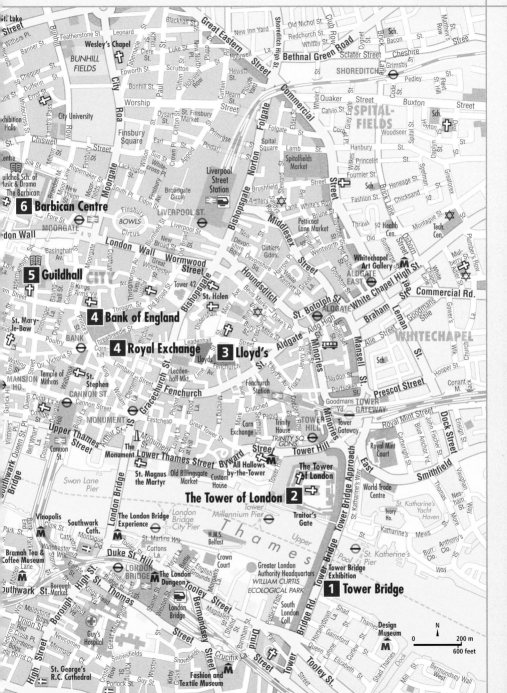

St. Luke
Street

Withers Pl.

BUNHILL
FIELDS

Wesley's Chapel

Featherstone St.

Leonard

Banner St.

City

Road

Blackhall St.

Luke St.

Great Eastern

STREET

Shoreditch High St.

Old Nichol St.

Redchurch St.

Whitby St.

Club Row

New Inn Yard

Bethnal Green Road

Sclater Street

SHOREDITCH

Cheshire

Brick

Grimsby

Sch.

Bacon

Stree

Matthew's
Row

City University

Worship

Finsbury
Square

SPITAL-
FIELDS

Commercial

Spitalfields
Market

Liverpool
Street
Station

Broadgate
Circle

**6** Barbican Centre

MOORGATE

LIVERPOOL ST.

Finsbury
Circus

BOWLS

Liverpool St.

Bishopsgate

Middlesex

Petticoat
Lane Market

Whitechapel
Art Gallery

WHITECHAPEL

London Wall

Wormwood
Street

Tower 42

Houndsditch

ALDGATE
EAST

White Chapel High St.

Commercial Rd.

**5** Guildhall

CITY

St. Helen

Bishopsgate

ALDGATE

Braham

Leman

Goodmans
Stile

**4** Bank of England

St. Mary-
side-Bow

BANK

**4** Royal Exchange

Aldgate

Minories

Sch.

Prescot Street

MANSION
HO.

St.
Stephen

Temple of
Mithras

Fenchurch

Fenchurch
Station

**3** Lloyd's

Lloyds

Leaden-
hall Mkt.

Portsoken

TOWER
GATEWAY

Dock Street

CANNON ST.

MONUMENT

Cannon Street

Eastcheap

Corn
Exchange

Trinity
House

TRINITY SQ.
GDNS.

TOWER
HILL

Tower
Gateway

Royal Mint Street

Smithfield

Upper Thames
Street

The
Monument

Lower Thames Street

Byward

Street

All Hallows
by-the-Tower

Tower Hill

Royal Mint
Court

Swan Lane
Pier

London Bridge

St. Magnus
the Martyr

Old Billingsgate
Market

Custom
House

The Tower
of London

World Trade
Centre

St. Katharine's
Yacht
Haven

Vinopolis

Southwark
Cath.

The London Bridge
Experience

London
Bridge
City Pier

**The Tower of London** **2**

Tower
Millennium
Pier

Traitor's
Gate

St. Katharine's
Pier

Bramah Tea &
Coffee Museum

Duke St. Hill

H.M.S.
Belfast

Thames

Upper

Pool

Tower Bridge

Tower Bridge Approach

LONDON
BRIDGE

The London
Dungeon

Tooley Street

Crown
Court

Greater London
Authority Headquarters
WILLIAM CURTIS
ECOLOGICAL PARK

Tower Bridge
Exhibition

**1** Tower Bridge

Southwark
St.

Borough

High St.

ST. THOMAS

Borough
Market

London
Bridge

Bermondsey
Street

South
London
Coll.

Shad

Thames St.

Design
Museum

N

0        200 m

600 feet

Guy's
Hospital

Crucifix
Street

St. George's
R.C. Cathedral

Fashion and
Textile Museum

Tooley St.

Bermondsey Wall
West

# THE HIGHLIGHTS: THE CITY OF LONDON

Tower Bridge is a London landmark that is instantly recognizable across the world. Its two towers are 65 m (213 feet) high, the main carriageway being some 9 m (30 feet) and the upper walkway 43 m (141 feet) above the river level. The bridge is raised to let tall ships pass on a daily basis – up to ten times a day during the summer months.

## TIP The Anchor Tap

Dark woodwork, an open fire, darts, local beer, and fish and chips – this historic 18th-century pub has all the ingredients you need for a real taste of good old-fashioned England.

*28 Horsleydown Lane, Southwark; Tel (020) 7403 4637; Mon–Sat 12.00–23.00; Sun 12–22.30; Underground: London Bridge.*

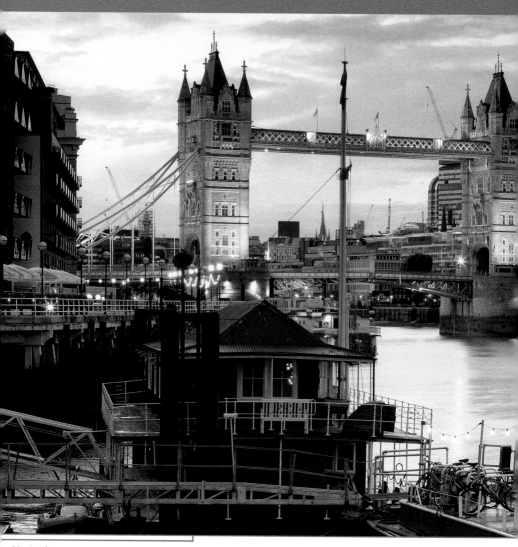

Opened in 1894, Tower Bridge is not only one of London's leading landmarks, but also a great testimony to the ingenious Victorian engineers who built it. By the middle of the 19th century, London's East End had become so densely populated that a new river crossing was essential. The new bridge would, however, be the first to be constructed east of London Bridge, an area previously declared off-limits for fear of impeding the ships using the docks in the east of the city. The answer was to combine a bascule bridge with a suspension bridge. Steam engines were used to power a hydraulic system capable of opening the bridge within a matter of minutes. Today, the bridge is powered by electricity, and the two towers house an exhibition that describes its history. The upper walkway has now been glazed in, and offers a commanding view over the city and its river.

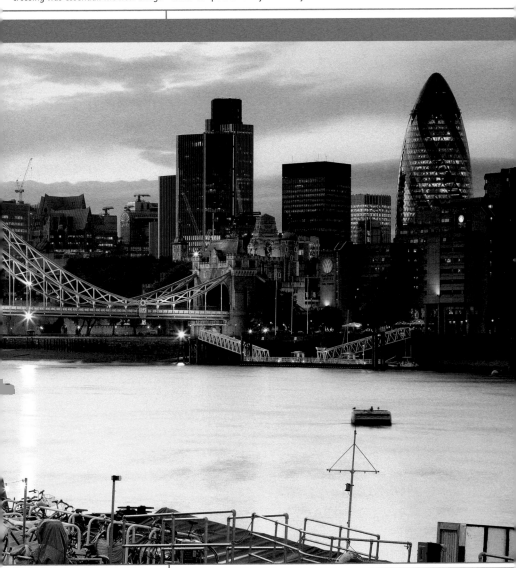

# THE HIGHLIGHTS:
# THE CITY OF LONDON

## TIP Ivory House

The Tower of London was built by William the Conqueror (below far right, pictured in the *Book of Arms, circa* 1445). Many famous heads rolled here, and the place resonates with gruesome tales. But the British crown jewels – among them Queen Victoria's diamond coronet, below left – are the main attraction, fascinating thousands of vistors.

Beneath the trendy bar and restaurant you'll find wine flowing freely at this boisterous medieval banquet – complete with live entertainment.

*St Katherine's Dock, Tower Hamlets; Tel (020) 7480 6116; Mon–Sat 12.00–0.00; Sun 12.00–23.30; banquet April–Oct, Tues–Sun; Underground: Tower Hill.*

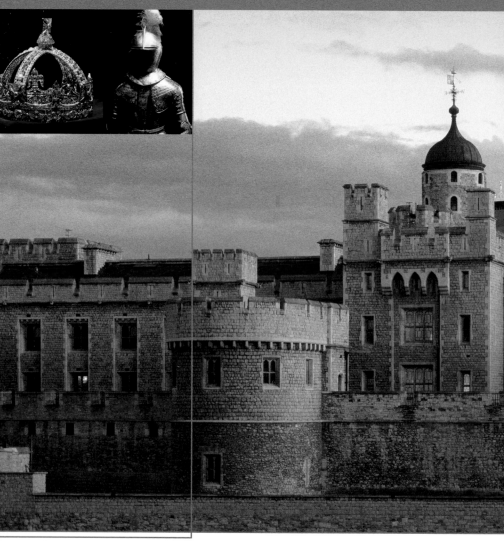

The massive riverside fortress watching over the capital from its position on the eastern edge of the City bears the formidable title Her Majesty's Royal Palace and Fortress The Tower of London – better known simply as the Tower. At its heart stands the White Tower, a mighty fortification built by William the Con-queror in 1078, after he was crowned king of England. It was intended to pro-tect London from attack, while at the same time providing the Norman rulers with a perfect viewpoint from which to keep an ever-vigilant eye on the self-assured inhabitants of the independent city. The Tower's two walls and its moat were added in the 12th and 13th centuries. The complex continued to serve as a royal residence until the 17th century, and was still being used as a prison in the 20th century. Today it houses the famous Jewel House, where the British crown jewels have been on public display for over 300 years.

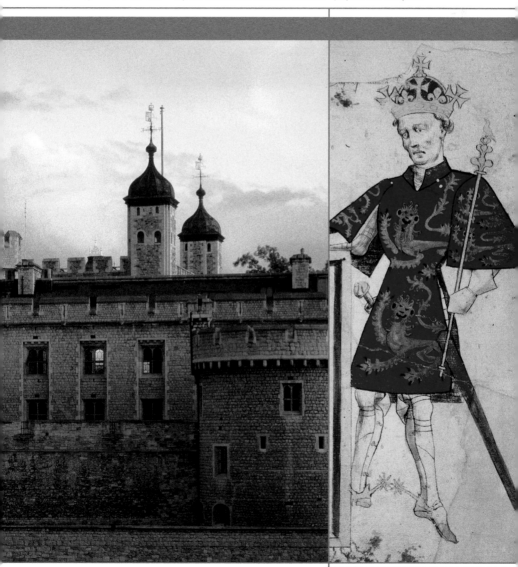

# THE HIGHLIGHTS:
# THE CITY OF LONDON

The post-modernist architecture of the Lloyd's Building provides a striking contrast to the Victorian Leadenhall Market next door (main picture). The former, with its elegant spiral stairwells in gleaming steel (below), was designed by top architect Richard Rogers and constructed between 1978 and 1986.

**TIP** Konditor & Cook

Stylish City café serving a wonderful selection of delicious cakes and gateaux. They look as good as they taste and there's also a tempting choice of hearty snacks.

*The Gherkin, 30 St Mary Axe, City; Tel (0845) 262 3030; Mon–Sat 9.30–23.00; Sun 10.30–22.30; Underground: Liverpool Street.*

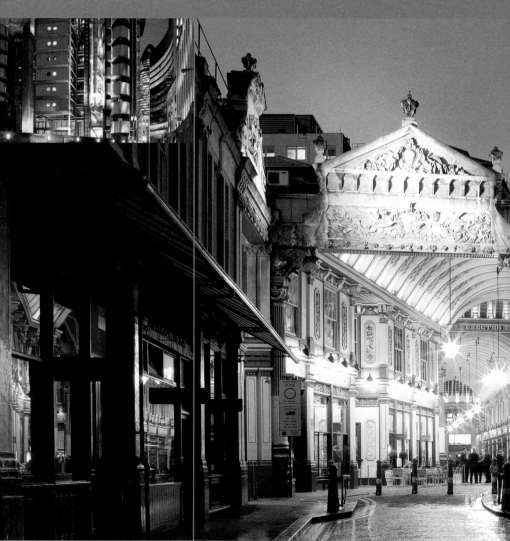

LLOYD'S OF LONDON 3

# LLOYD'S OF LONDON 3

At night, the gleaming steel and glass façade of the dramatically floodlit Lloyd's Building is imbued with an almost otherworldly glow. By day, the external glass elevators, stairwells, and service pipes make the building seem as if it has been turned inside out – which is exactly the impression that its architect, Richard Rogers, set out to create. When the building was opened in 1986, Roger's innovative, award-winning design was hailed as an architectural sensation, paving the way for the far more ambitious building projects that London has witnessed since. For Lloyd's of London, Roger's steel palace was a long way from the insurance market's first home inside Edward Lloyd's coffee house in 1688. As the centuries rolled on, Lloyd's grew to become a giant of the insurance industry, catering for the most complicated of risks – even arranging to insure the legs of the world's most beautiful supermodels.

# THE HIGHLIGHTS:
# THE CITY OF LONDON

A symbol of wealth: the Royal Exchange (main picture) is located opposite the Bank of England. Once occupied by the former bourse, this splendid building is now home to a range of luxury boutiques – from Gucci to Tiffany. They exert an irresistible pull on the rich and famous, with only the oyster bar providing respite from shoppers' spending sprees.

## TIP Grand Café & Bar

This truly excellent café in the inner court of the Royal Exchange serves fine delicacies such as oysters and crayfish alongside heartier dishes such as steaks and hotpot.

*The Courtyard, Royal Exchange, City; Tel (020) 7618 2480; Mon–Fri 8.00–23.00; Underground: Bank.*

The Royal Exchange was founded in 1565. The present neoclassical building, which opened in 1844, is its third premises. The future Bank of England was founded in 1694, when the Scottish financier William Paterson offered the cash-strapped government of King James II a loan of £1.2 million. The Bank of England was established and was soon doing a roaring trade. Its first home on Walbrook stood on the site of the Roman Temple of Mithras, although the latter's foundations were only discovered in 1954. In 1734, the bank moved to Threadneedle Street. Designed by Sir John Soane in the neoclassical style, much of the interior was demolished in the 1920s to make way for Sir Herbert Baker's redesign, which, branded an act of vandalism by some critics, was not universally welcomed. You'll find the extensive Bank of England Museum on the eastern side of the building.

It's been last orders for smokers since 2007, when pubs – like all enclosed public spaces – were officially declared no smoking. But the good old-fashioned pint of ale (just over half a litre) – or perhaps a nice gin and tonic – is still a daily ritual for drinkers at London's magical Victorian pubs, enjoyed after work or shopping

# PUBS – BEER AND LIVELY COMPANY

The traditional pub lies at the very heart of the British psyche, an institution that has been the focus of social life for as long as anyone can remember. Its origins can be traced back to Roman Britain when places of refreshment grew up at strategic intervals along the network of roads built by the colonizing Romans. As well as a welcome stop for those on the road, these inns soon became places where people could meet up to gossip or discuss local matters. The earliest version of the pub sign was a small evergreen bush hung outside an inn, while the pub sign as it is known today, began to develop in the Middle Ages. Ale remained the tipple of choice for the masses until gin became popular in the early 18th century and gin palaces became widespread. In the 19th century, the Wine and Beerhouse Act restricted the hours during which alcohol could be sold and "last orders" were set at 11 pm in 1914, a time that remained in force until 2005. There are several contenders for the position of London's oldest pub, among which are: the Prospect of Whitby in Wapping, popular with smugglers and reputedly a haunt of Dickens, Pepys, and Whistler; the George Inn, Borough High Street – the only galleried coaching inn left in London; the Lamb & Flag, Covent Garden; the Cittie of York, Holborn, on the site of a 1420 tavern, though the present building dates from later.

# THE HIGHLIGHTS: THE CITY OF LONDON

The Guildhall is the City's venerable town hall. Today, its primary purpose is as a venue for ceremonial state receptions, although it also houses an art gallery (pictures, below). Magog (below, far right) is one of the City's two legendary guardians. They have acquired something of a cult status, and are paraded as part of the annual Lord Mayor's Show.

## TIP Le Coq d'Argent

The fine French cuisine is perhaps a bit on the pricey side, but the spectacular views over the City from the extensive roof terrace are worth every penny.
*1 Poultry, City; Tel (020) 7395 5000; Mon–Fri 11.30–15.00; Sat 18.00–22.00; Sun 12.00–15.00; Underground: Bank.*

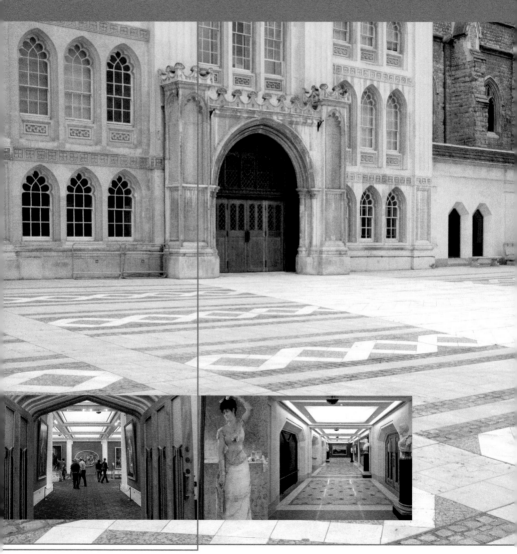

# GUILDHALL 5

The Guildhall has been the seat of government in the City of London since the Middle Ages, and the medieval building remains the representative home of the City authorities today. The building's walls, at least, date from the early 15th century, making the Guildhall one of the oldest buildings in London. The splendid Great Hall is used for civic functions, held beneath the coats of arms of the 12 guilds whose representatives once ran the City with unimpeded power. The glorious medieval crypts with their vaulted ceilings are located beneath the Great Hall. The clock museum is just one of the many attractions in the western part of the Guildhall, and the art gallery is housed in another section of the building. Pictures dating from various periods of the city's history are on display here, and a visit to the gallery is also an opportunity to see the remains of a Roman arena.

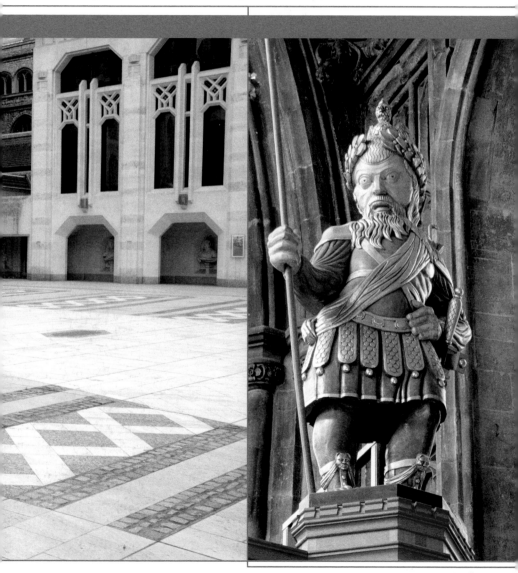

# THE HIGHLIGHTS:
# THE CITY OF LONDON

A listed building, the Barbican provides a stage for cultural events like this video installation (main picture). At its heart lies the Barbican Centre arts complex, a venue for concerts, shows (shown below left: performance artist Laurie Anderson), dance (below right), and more.

## TIP Barbican the Curve

The Curve hosts changing exhibitions of dramatic installations, exciting photography, innovative design, and extreme fashion.

*Ground Level, Concourse Gallery, Barbican Centre, City; Tel (020) 7638 8891; Thurs–Mon 11.00–20.00; Tues and Wed 11.00–18.00; Underground: Barbican.*

This massive complex rose up from a derelict patch of land on the edge of the City in the 1960s and 1970s. Designed by modernist architectural firm Chamberlin, Powell and Bon, its brutalist style was born of a desire to build on a gargantuan scale. The first buildings erected were high-rise appartments. These concrete giants were typical of their time, and could have easily become the hotspots of social breakdown with which similar buildings became synonymous. The Barbican, however, had a narrow escape, thanks in large part to its arts complex. The biggest venue of its kind in Europe, it won over Londoners with its impressive calendar of events. Both the London Symphony Orchestra and the BBC Symphony Orchestra made the Barbican their home, and seasoned culture fans flocked to the Barbican to enjoy drama, cinema, and ballet. The Barbican Gallery, meanwhile, puts on excellent photographic exhibitions.

The magnificent cathedral's dome is a landmark that has become a symbol of the city itself. Its decoration – from the dome interior to the exquisite sculptures (here of Queen Anne) and the ornamental walls and ceilings in the splendid nave – is nothing short of singularly beautiful (main pictures, from left).

## TIP Paternoster Chop House

Reminiscent of an Italian piazza, the location alone makes the Chop House a veritable City oasis. Its superb traditional English cuisine is the icing on the cake.

*Warwick Court, Paternoster Square, City; Tel (020) 7029 9400; Mon–Fri 10.30–22.30; Sun 12.00–16.00; Underground: St Paul's.*

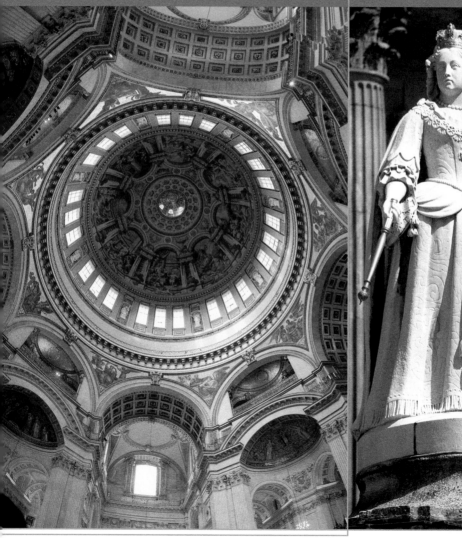

Standing proudly over the palatial offices of the City's financial institutions, the splendid façade and dome of St Paul's Cathedral are hard to ignore. There has been a Christian church located here on Ludgate Hill for some 1,400 years. Built in the English baroque style, the current cathedral is St Paul's fifth and without question most impressive incarnation. Its medieval predecessor was a casualty of the Great Fire of 1666, which destroyed almost the entire city. Sir Christopher Wren was the architect charged with rebuilding both St Paul's and some 50 other devastated London churches. His designs were repeatedly rejected before the first stone of the new building was finally laid in 1677. The first service in the new St Paul's Cathedral took place 20 years after that, and Christopher Wren would later become the first of many great Britons to be buried there.

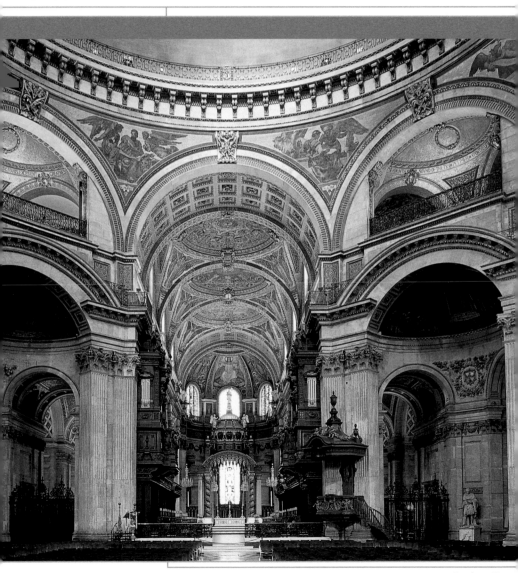

Westminster Bridge (depicted right in an 18th-century painting) is London's second oldest, although the current bridge is relatively modern. Blackfriars Bridge (below top) was the third crossing over the Thames, while the Millennium Footbridge (below bottom) is the most recent.

# LONDON'S BRIDGES

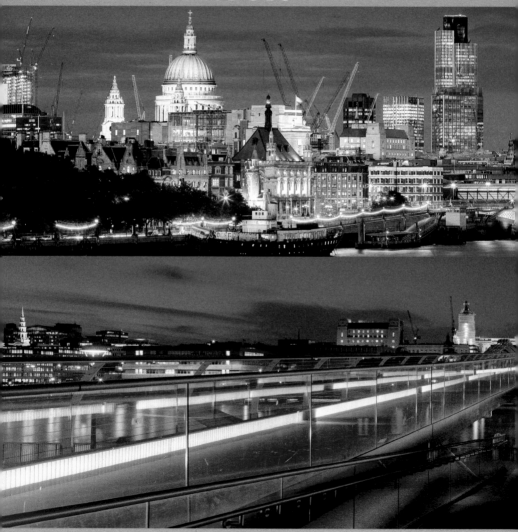

The Thames has always been London's lifeline. It was the Thames that supplied the city with water and food, connected it to the rest of Britain and the world, allowed trade to blossom, and thus ultimately laid the foundations for the growing power and wealth of a metropolis. Yet until the completion of Westminster Bridge in 1751, there was only one bridge across the river. That bridge was London Bridge, and its history goes right back to the 1st century, when the Romans built the first wooden bridge across the river at that same point. There have been several London Bridges over the centuries, and at times the shops on either side of the crossing left only a relatively narrow gap for traffic to pass in between. By 1733, crowding and congestion on London Bridge had become so bad that a decree was issued to all traffic to keep on the left-hand side of the road – possibly the reason that all British traffic now drives on the left. Today's London Bridge is a fairly unassuming structure that does at least accommodate several lanes of traffic. For centuries, however, it was left to ferries and small boats to connect the two sides of the river. As traffic increased, these were no longer sufficient, and the 19th century saw the construction of entirely new bridges. Further bridges were built more recently still – the Millennium Footbridge being the newest – and there are now 34 bridges across the River Thames.

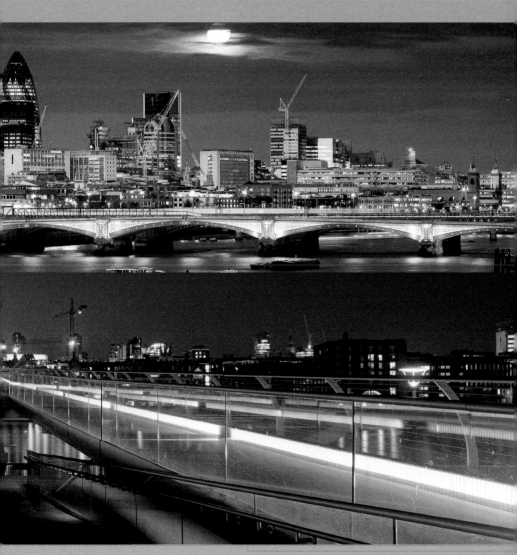

# THE HIGHLIGHTS:
## THE CITY OF LONDON

Justice has been served in the world's most famous court for centuries, always under intense public scrutiny (below). In harsher times than our own, murderers were condemned to execution, after which their bodies were brought back to the Old Bailey to be dissected in the Surgeons' Hall (right).

**TIP** The Tipperary

There are Irish pubs everywhere, but this one (founded in 1700) was the first outside Ireland. As well as beer from the Emerald Isle, it boasts an attractive, original Victorian interior. *66 Fleet Street, City; Tel (020) 7583 6470; Mon–Fri 12.00–23.00; Sat and Sun 12.00–18.00; Underground: Blackfriars.*

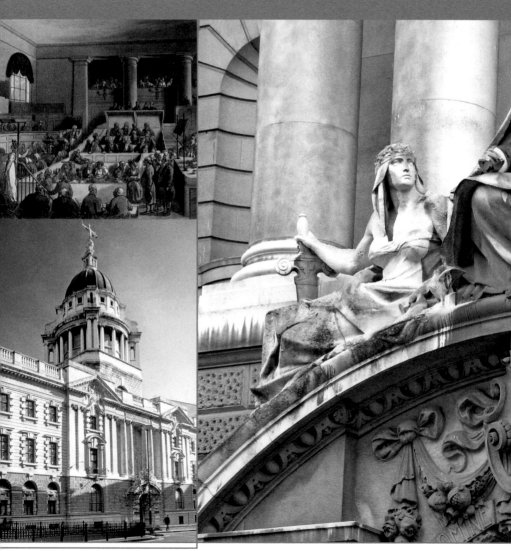

A good TV murder mystery can be enough to keep you awake at night, and the best courtroom dramas can really keep you on the edge of your seat, but neither is a patch on a real trial at London's Central Criminal Court. This architecturally uninspiring building continues to be the venue for some of the world's most spectacular court cases, making headlines in Britain and beyond. In a previous building, the controversial writer Oscar Wilde stood trial at the Old Bailey, and it was here, in 1990, that the Guildford Four had their convictions as IRA terrorists quashed – finally proving their innocence after 15 years in prison. The Yorkshire Ripper, by contrast, was sentenced to life imprisonment at the Old Bailey in 1981. The site of the building itself has a grim, and well-known, past – until 1902, this was the location of Newgate Prison, where convicts sentenced to death were sometimes publicly executed.

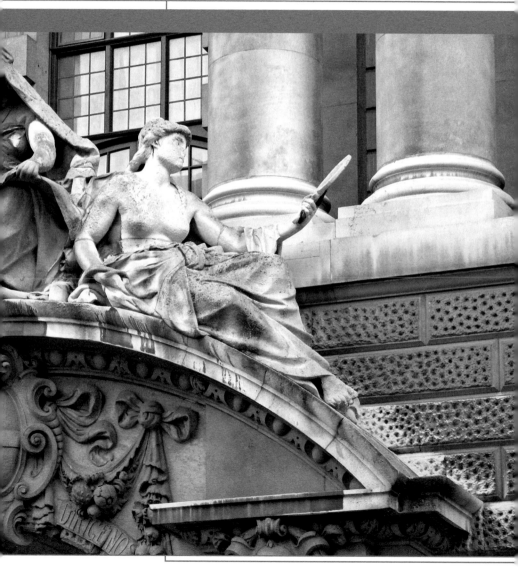

# THE HIGHLIGHTS:
# THE CITY OF LONDON

The major newspapers have all left Fleet Street, but their old offices are still here. Among the most impressive is the art deco Daily Express building (below). It is not open to the public, but you can visit the "journalists' church" of St Bride's, (main picture, from left). Nearby is the Old Bank of England pub.

## TIP Ye Olde Cheshire Cheese

This hidden-away 17th-century tavern is a maze of small rooms. On the menu you'll find old-fashioned pub grub – honest, English food without the fuss.

*145 Fleet Street, City; Tel (020) 7353 6170; Mon–Fri 11.00–23.00; Sat 12.00–23.00; Sun 12.00–17.00; Underground: Blackfriars.*

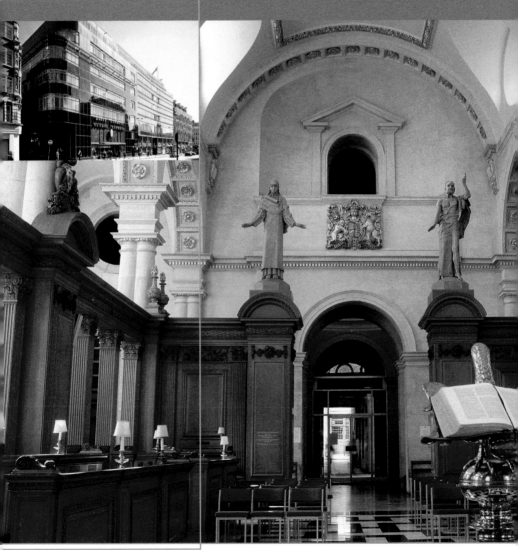

# ST BRIDE'S, FLEET STREET 9

The elegant steeple of St Bride's Church is a familiar feature of the London skyline. Built in the baroque style, it is, after St Paul's, the tallest of the churches designed by Sir Christopher Wren. Originally consecrated to the Irish saint Bridgit of Kildare, St Bride's may also be London's oldest church. It is located on Fleet Street – the traditional home of London's newspaper and printing industries – and became the church of choice of London's publishers and journalists. There is an exhibition about London's printing industry located in the crypt, and although the British press has largely moved to the Docklands area, members of the press still come to find refuge at St Bride's. Inside the church, a selection of posters, cards, candles, and photographs pay tribute to the fearless journalists of all religions and backgrounds who have given their lives in the service of their profession.

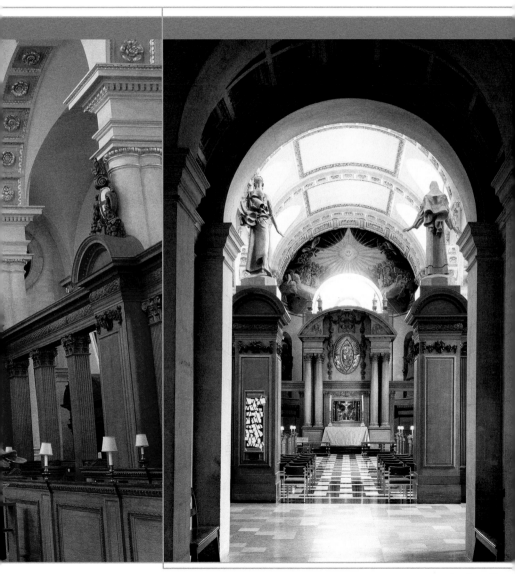

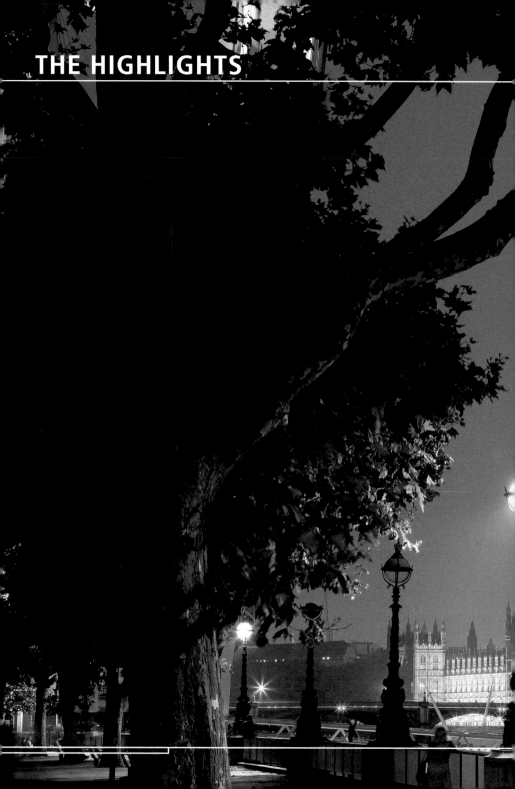

# THE WEST END

Since the 17th century, London's richest and most powerful residents have preferred the western side of the city. There, they found cleaner air, plenty of space on which to build their palatial residences, and no shortage of opportunities to buy the best products and generally pursue the finer things in life. It's no coincidence that many of London's attractions and cultural complexes, as well as its best shopping areas, are all in the West End. The area has become synonymous with culture and nightlife, and with London's commercial theater scene, with many visitors taking in at least one West End show during their stay in the capital. Closer to the Thames, Westminster is the powerhouse of British politics.

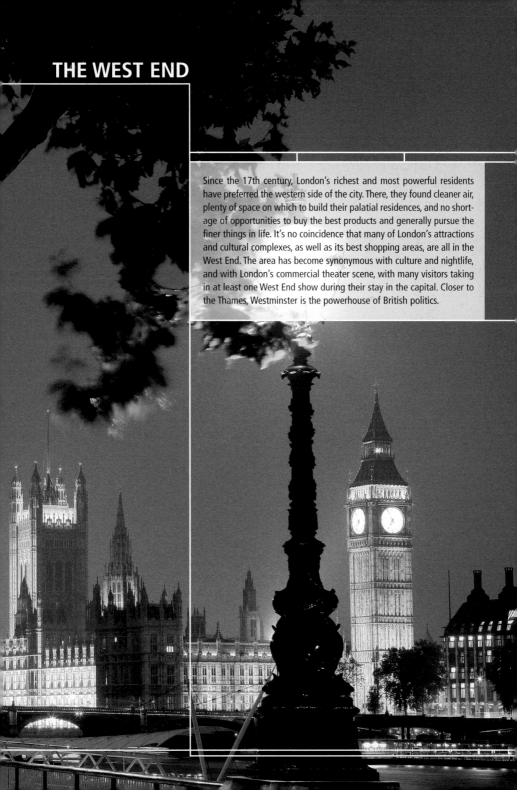

**10** Somerset House

**11** Covent Garden

**12** Trafalgar Square

**13** The National Gallery, The National Portrait Gallery

**14** Piccadilly Circus

**15** Soho

**16** The Palace of Westminster

**17** Westminster Abbey

**18** Tate Britain

**19** Buckingham Palace

**20** Hyde Park, The Albert Memorial

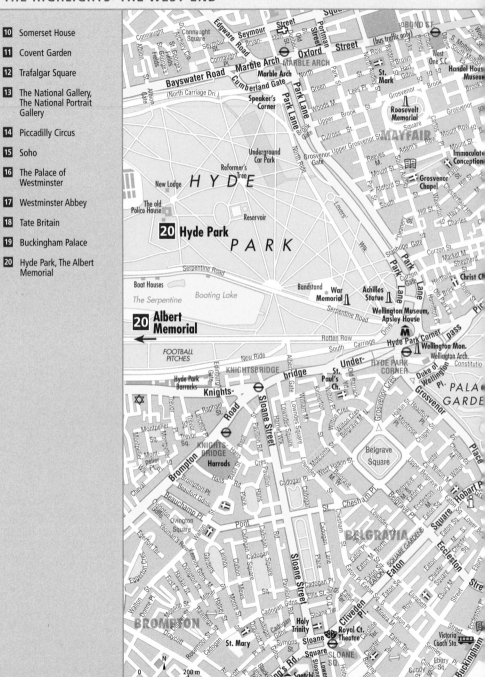

## THE HIGHLIGHTS: THE WEST END

## INFO Embankment Galleries

On the site of the 16th-century house of Edward Seymour, 1st Duke of Somerset and Lord Protector during the reign of the young Edward VI, son of Henry VIII, Somerset House is a venue for both fine art (right: the Courtauld Gallery collections) and entertainment – including the open-air cinema in summer (below left) and the ice rink in winter (below right).

Opened in 2008, this new space shows innovative themed exhibitions of art, design, fashion, architecture, and photography.

*Somerset House, Strand, Westminster; Tel (020) 7845 4600; Fri–Wed 10.00–18.00; Thurs 10.00–21.00; Underground: Temple.*

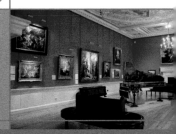

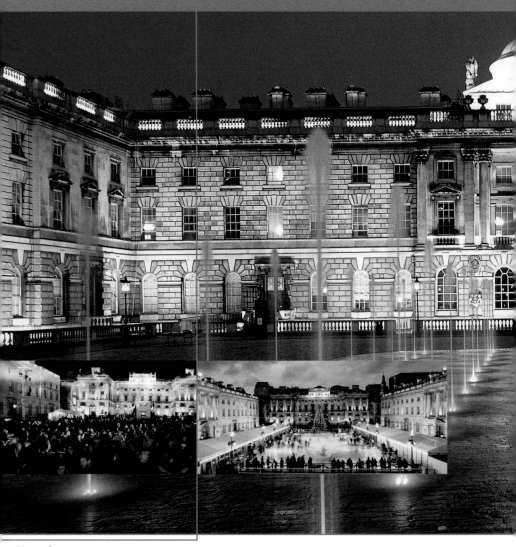

Somerset House once provided offices for the tax authorities, and its transformation into a hub of art, culture, and entertainment was a sheer stroke of genius. The neoclassical structure was erected at the end of the 18th century to house a number of academic and royal societies, and in this sense it was the first public service building. But it was the arrival of numerous cultural institutions that immediately secured the building's place in Londoners' affections. Today it is home to the Courtauld Institute of Art with its collection of old masters and Impressionist paintings, as well as the new Embankment Galleries (see opposite); it is also the London base of the magnificent State Hermitage Museum in St Petersburg. Somerset House's inner courtyard is the ultimate jewel in its crown. In summer, 55 gushing fountains fill the space, making way for London's most beautiful and romantic ice rink in winter.

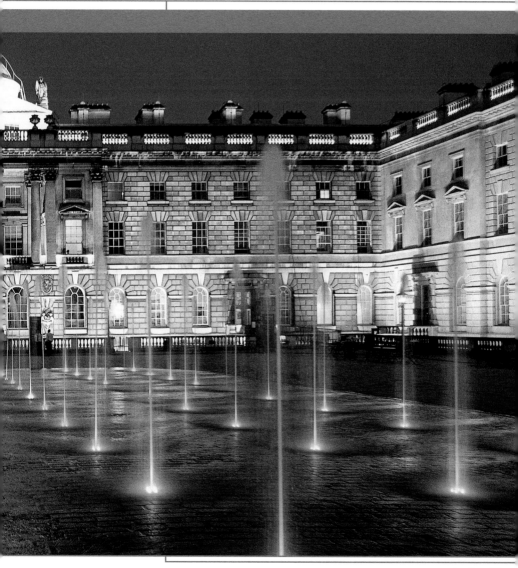

## THE HIGHLIGHTS: THE WEST END

**TIP** The Cove

Where shopping meets art – the old Covent Garden Market is now known as Covent Garden Piazza. The renowned Royal Opera House is a stage not only for the world's most famous operas (right: a scene from Alban Berg's *Wozzeck*), but also for top-quality ballet and drama (below).

This long-established pub above the Cornish pasty shop is a chance to recharge your batteries with pasties and real ale. It also offers a great view over the Piazza.

*1 Covent Garden Piazza, Westminster; Tel (020) 7836 8336; Mon–Sat 11.00–23.00; Sun 11.00–22.30; Underground: Covent Garden.*

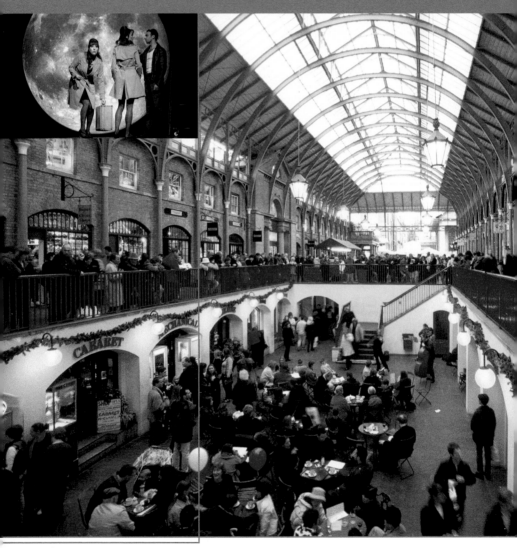

# COVENT GARDEN 🔟

Covent Garden has been a focus of popular entertainment since the 17th century. It all started with the market, formerly a fruit and vegetable market, that still attracts countless sightseers and shoppers today, and it wasn't long before all sorts of street entertainers and itinerant artists were also drawn to Covent Garden. In the 18th century, John Gay's *Beggar's Opera*, which distinguished itself from court opera by targeting a popular audience, proved so successful that it soon required a stage of its own. Thus was born the Theatre Royal, a venue that became synonymous with great, popular art. The Theatre Royal's building later became the Royal Opera, one of the world's foremost opera houses. The area around Covent Garden, meanwhile, continues to be a hub of entertainment. True to its history, there is something for everyone – with popular culture at the top of the agenda.

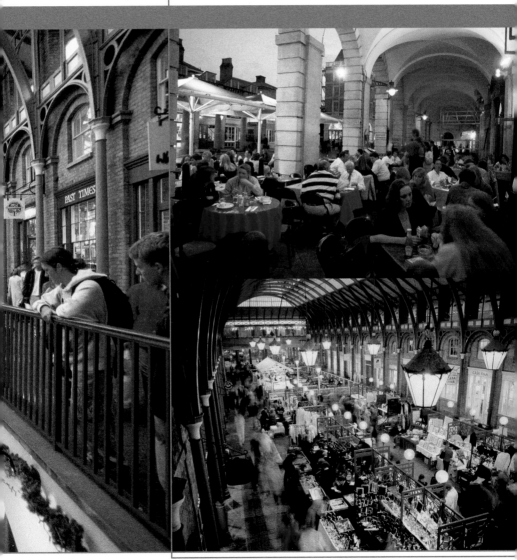

The pictures below left, from top, show the very traditional Theatre Royal, Haymarket; the Aldwych Theatre is the former London home of the Royal Shakespeare Company. The Coliseum (main picture and, below right, a scene from the ballet *Giselle*) is home to the English National Opera and English National Ballet. Right: Theatre Royal, Drury Lane.

# "THE PLAY'S THE THING!"

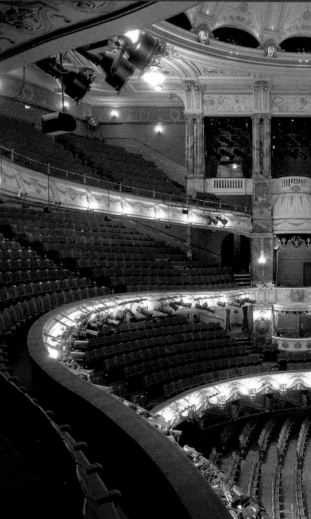

At the heart of London's glittering West End lie its 50 or so major theaters, many of them historic buildings dating back to Victorian or Edwardian times. Hand-in-hand with with the opulent, grand interiors typical of the period, are the sometimes cramped conditions of the seating and the refreshment facilities, but the buildings' protected status makes modernization difficult. In order to survive financially, the majority of the commercial theaters, which are privately owned, are forced to concentrate on those productions likely to produce the fullest audiences – which currently means musicals. The noncommercial theatres such as the National Theatre, Royal Court, and Shakespeare's Globe are assisted financially by subsidies from the state. They can accordingly be more adventurous, trying out new playwrights and contraversial works. Ballet and opera are performed at the Coliseum, home of the English National Opera and the English National Ballet, and the Royal Opera House. The latter dates from the mid 19th century, but was substantially redesigned in the 1990s. Many plays are put on beyond the West End, sometimes in less orthodox venues such as small rooms above pubs. London's oldest theatrical venue is the Theatre Royal Drury Lane (Shakespeare's Globe is a 20th-century re-creation), on the site of a playhouse dating back to around 1662, though the present building dates from 1811.

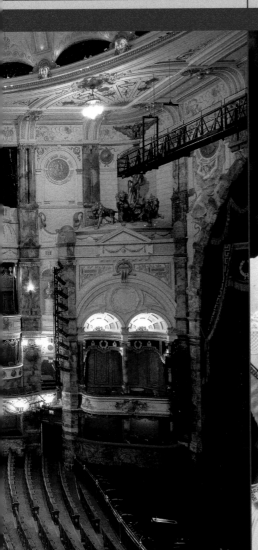

# THE HIGHLIGHTS: THE WEST END

The neoclassical façade of the National Gallery dominates the square (main picture), from where there is a good view down to Big Ben (right). At the heart of the square is Nelson's Column, below bottom, rising to a height of 52 m (171 feet). The church of St Martin-in-the-Fields, built in the early 18th century, is a venue for classical concerts (below top).

Every August, Trafalgar Square is given over to a free, open-air festival of drama, dance, music, and cabaret performed by street artists from Britain and beyond.

*Trafalgar Square; first three weeks in August; evening Thurs and Fri; afternoon Sat and Sun; Underground: Charing Cross.*

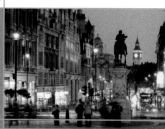

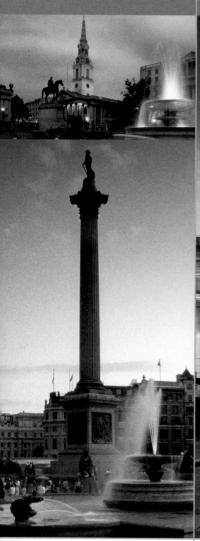

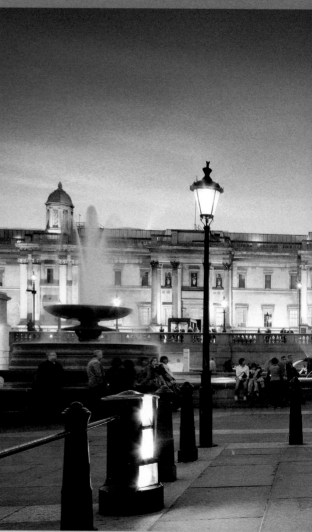

You can almost read the entire history of the British empire from Trafalgar Square, and it is also a place that reflects the many faces of contemporary Britain. Situated right at the heart of the West End, Trafalgar Square is named after one of the most significant battles fought by the British against Napoleon. It was at Trafalgar, off south-west Spain, that the British navy defeated an armada of Spanish and French warships. Legendary naval hero Lord Nelson fell during the battle, and the column erected to commemorate him famously dominates Trafalgar Square. The bronze lions at the base of the monument are said to have been cast from canons captured from the French. Yet despite this backdrop of past glory and heroic achievement – or perhaps precisely because of it – Trafalgar Square has also been the scene of the biggest demonstrations and parties ever witnessed in the British capital. The traditional New Year's celebrations – when thousands of Londoners gather in Trafalgar Square to ring in the new year – are just one example.

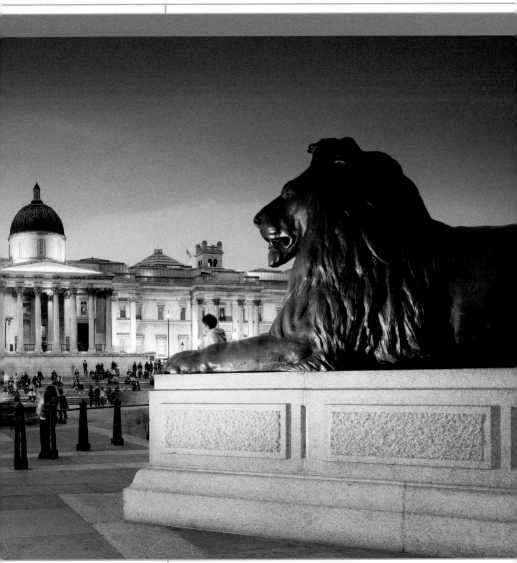

# THE HIGHLIGHTS: THE WEST END

**TIP** National Dining Room

Between them, the National Gallery (right and below right) and the National Portrait Gallery (main picture) house a fantastic art collection. At the National Portrait Gallery, official images of the kings and queens of Britain, as well as portraits of British celebrities past and present, are particularly popular.

This is no ordinary museum café, but an excellent restaurant serving a creative menu of fresh, British dishes – from breakfast to afternoon tea.

*Sainsbury Wing, National Gallery, Trafalgar Square, Westminster; Tel (020) 7747 2525; Thurs–Tues 10.00–17.00; Wed 10.00–20.30; Underground: Charing Cross.*

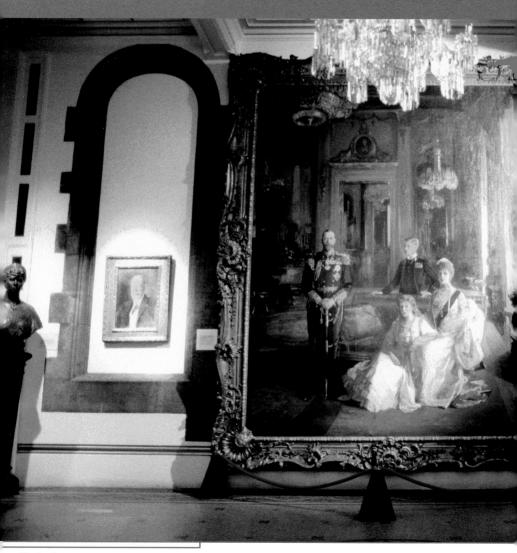

In 1824, the British government purchased 38 pictures from the collection of the deceased banker, John Julius Angerstein. The pictures were initially displayed in Angerstein's Pall Mall townhouse, moving to a new home on Trafalgar Square when the present National Gallery building was completed in 1838. Envisaged as a venue open to all social classes, today, some 2,300 paintings from all the European schools and all historical periods are on permanent display in its galleries, among them some of the most important works by the likes of van Gogh, Monet, Leonardo da Vinci, Cézanne, and Titian. The National Portrait Gallery is situated just around the corner on St Martin's Place. Its focus is not on the artists, but on their subjects, and the gallery is a visual *Who's Who* of the great and good of British history and culture, as depicted in paintings, sculptures, and photographs (see p. 170).

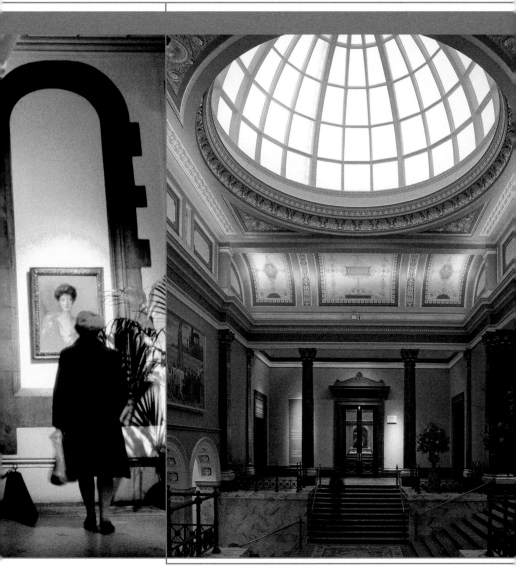

## THE HIGHLIGHTS: THE WEST END

## TIP Chowki

The fountain in the middle of Piccadilly Circus was erected in 1892 in memory of the philanthropist Lord Shaftesbury. Its crowning glory is a slightly scandalous naked statue (main picture), which the Victorians discreetly interpreted as an angel of Christian charity. Londoners, however, have always dubbed it the less ambiguous Eros.

Both food and atmosphere make Chowki far more than your average curry house. Enjoy a wide range of affordable dishes from different regions of India and Pakistan.

*2 Denman Street, Westminster; Tel (020) 7439 1330; Mon–Sat 12.00–23.30; Sun 12.00–22.30; Underground: Piccadilly Circus.*

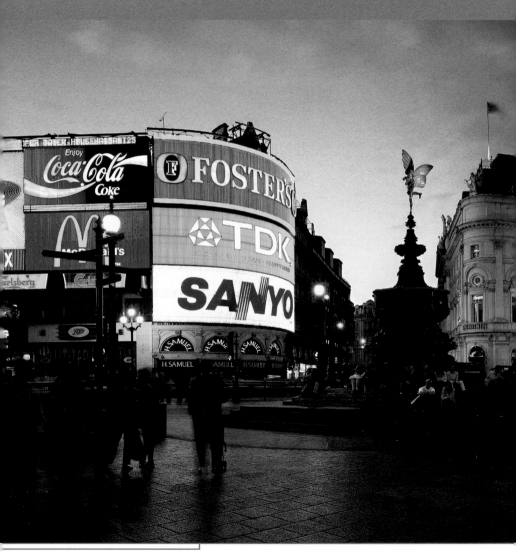

Five busy thoroughfares meet at Piccadilly Circus. The junction is considered to be the gateway to the amusements of the West End and Soho, making it an ever-popular tourist haunt. It's not exactly pretty, but it is always loud and noisy, and its reputation among tourists as the glittering focus of London's fantastic nightlife refuses to go away. The name Piccadilly Circus probably stems from the lace collars – or "piccadills" – sold here in the 17th century. From 1923, huge illuminated billboards were plastered across all sides of Piccadilly Circus, and when night fell their flashing bulbs spelt out the boundless promise of the consumerist society for all to see. The high price of advertising space, however, means that the giant signs are now limited to just one side of Piccadilly Circus. The Trocadero, once a music hall, has also moved with the times – it's now a massive shopping and entertainment complex.

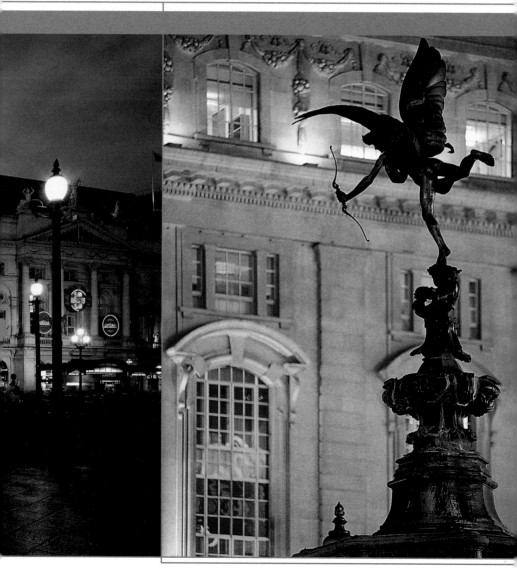

# THE HIGHLIGHTS: THE WEST END

## TIP Algerian Coffee Store

Below, from left: English Romantic painter Constable once drank at the historic Dog and Duck pub; classic Soho – the narrow streets of Chinatown; tattoo parlours, and sex workers' calling cards in the telephone booths. Right: Chinese restaurants and cafés tempt passers-by at every turn.

There are over 140 rare and splendid coffee blends to try here, as well as more than 200 teas and luxury sweets from around the world.

*52 Old Compton Street, Westminster; Tel (020) 7437 2480; Mon–Wed 9.00–19.00; Thurs–Fri 9.00–21.00; Sat 9.00–20.00; Underground: Leicester Square.*

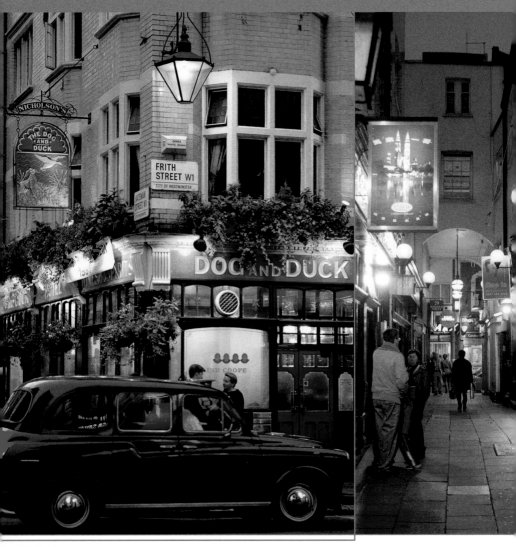

# SOHO 15

Soho has welcomed newcomers almost since its beginnings, from the Huguenots who settled here in the late 16th century to the Chinese who turned the area around Gerrard Street into their own little piece of China after World War II. More than anything, however, Soho was a place where bohemian culture flourished. Artists, writers, and musicians all found refuge here, and if it wasn't for the area's plentiful supply of seedy bars and pubs, their talents might well have created a more enduring legacy. That role was reserved for visiting celebrities, notably Mozart, welcomed here as a child during a tour of Europe, and Karl Max, who once lodged in Dean Street, above the present-day Quo Vadis restaurant. For a long time, Soho's prosperity came from its thriving sex trade. Today, the notorious red-light district of old has smartened up its act somewhat, and the area is now a lively mix of restaurants, shops, and pubs.

# THE HIGHLIGHTS: THE WEST END

## INFO Visiting Parliament

New and old: The London Eye, a towering big wheel, and the Palace of Westminster (main picture), home of the House of Lords and its Peers Lobby. At the State Opening of Parliament (right), the Queen dons her official robes in the Queen's Robing Room before proceeding down the Royal Gallery (inset below, from left).

The House of Commons public gallery is open to visitors whenever Parliament is in session, but be prepared for long queues. The wait for the House of Lords gallery is shorter.

*Parliament Square, Westminster; Tel (0870) 906 3773; guided tours end July–end Sept; Underground: Westminster.*

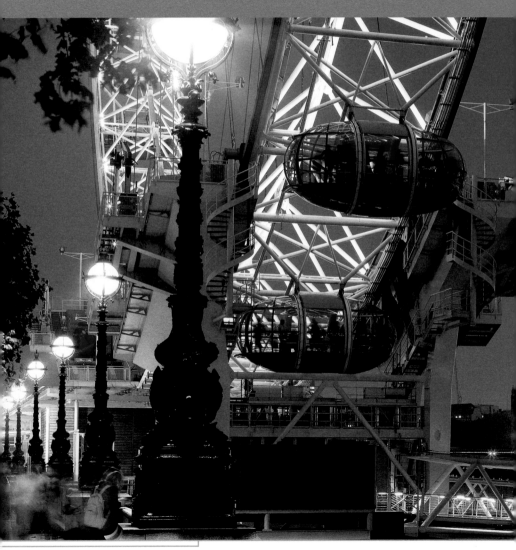

Staring at its reflection in the Thames, you could be forgiven for thinking that the neo-Gothic façade of Westminster Palace – with Big Ben and its other characteristic towers – had stood here since the Middle Ages. There has indeed been a royal palace on this site since the 11th century, but the present building was constructed in the mid-19th century, after its predecessor was destroyed by fire. The only surviving parts of the medieval structure are the Jewel Tower – once King Edward III's treasure chamber and now home to a parliamentary museum – and Westminster Hall, which is now only used for ceremonial occasions. Like Westminster Abbey, the Palace of Westminster is a UNESCO World Heritage Site. It is the world's largest parliamentary building, with over 1,100 rooms, 100 staircases, and 3 km (2 miles) of corridors. Both the upper and lower houses of Parliament sit within its walls.

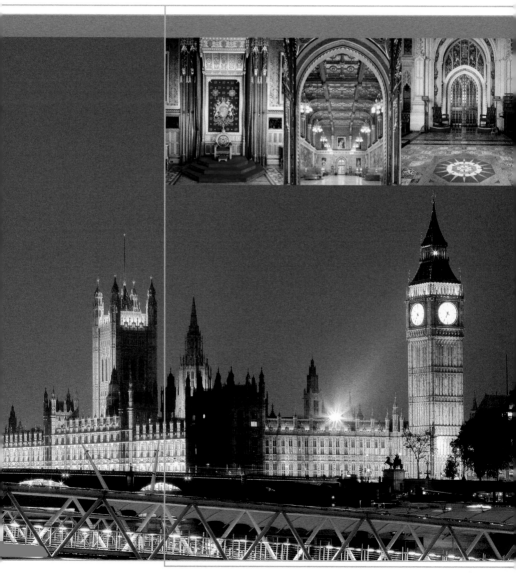

# THE HIGHLIGHTS:
# THE WEST END

Westminster Abbey boasts the highest nave of any English church (below right). Inside and out, the building is a testament to the skill of its medieval builders. Granted special protection by King Henry VIII, the abbey was spared the destruction that befell many other churches during that turbulent period in the history of British religion.

## INFO The Da Vinci tour

Much of Dan Brown's *The Da Vinci Code* is set in the United Kingdom. This guided tour takes you to the places featured in the book and explains the history behind the best-selling thriller.

*Booking Tel 07778 548 631; 13.30 Tues; Underground: Temple.*

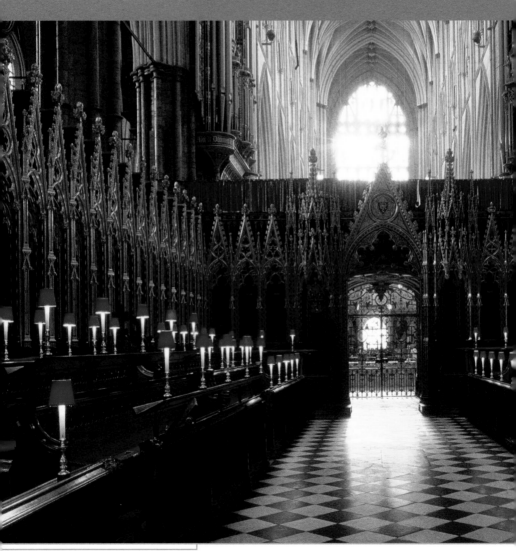

It's not just its magnificent architecture that makes Westminster Abbey – or, to give it its official name, The Collegiate Church of St Peter, Westminster – such a unique place of worship. What really impresses is the wealth of symbolic references contained within the fabric of the building. Almost every British monarch since William the Conqueror has been crowned at Westminster Abbey, in a ceremony traditionally performed by the Archbishop of Canterbury. Many were also laid to rest here, and their remains lie alongside numerous great historical figures, from writers and artists to scientists and politicians. Permission to be buried at the abbey is granted to only the greatest Britons. The building itself demonstrates a mix of architectural styles, the result of various alterations made over the centuries. Taken as a whole, however, the church is still the finest example of English Gothic and the true jewel in London's crown.

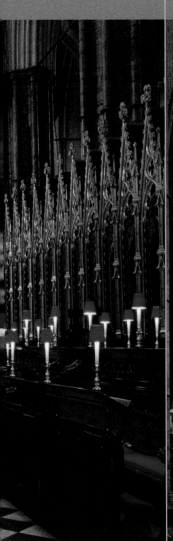
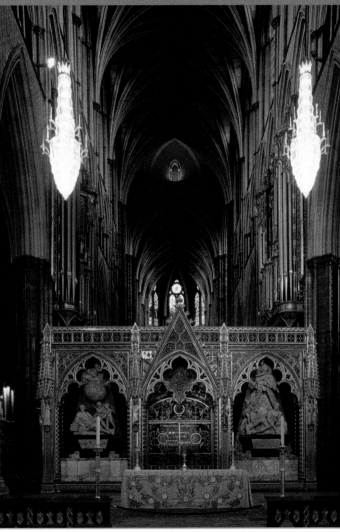

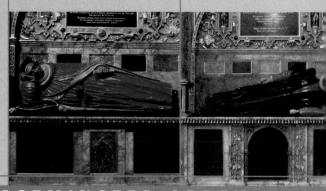

Laid to rest (from left): The judge and Member of Parliament Thomas Owen rests on his right elbow, while the jurist Sir Thomas Hesketh prefers his left. Inset right, from left: Eleanor of Castille; Henry III; and Henry VII with his wife Elizabeth of York.

# TOMBS AT WESTMINSTER ABBEY

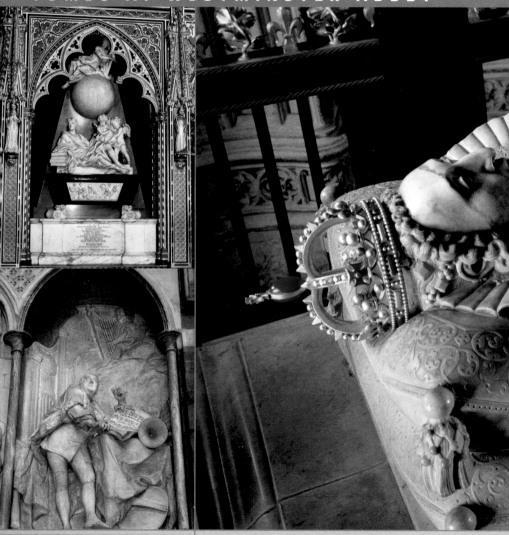

The list of kings, queens, important nobles, top politicians, scientists, writers, musicians, artists, and dignitaries buried at Westminster Abbey is almost endless. Some – like England's great Queen Elizabeth I (main picture) – were given elaborate tombs, while others are commemorated with tasteful monuments, and some with simple memorial stones.

Edward the Confessor, the first king to be buried in Westminster Abbey, was also responsible for its construction. Every British monarch from Henry III (d. 1272) to George II (d. 1760) is also buried in Westminster Abbey, while numerous aristocrats, monks, and other figures with connections to the abbey are buried not in the church itself, but in the

churchyard outside. The poet Geoffrey Chaucer (who died around 1400) was the first literary figure to be buried at Westminster Abbey. Many other great playwrights, poets, and authors are buried here, including Charles Dickens, Thomas Hardy, and Ben Johnson, who was buried upright due to reduced circumstances at the time of

his death. There are also memorials to other writers whose remains lie elsewhere, such as Oscar Wilde and William Shakespeare.

In total, some 3,300 people are buried in the Abbey and its grounds. Among the 600 memorials and monuments are the tombs of Sir Isaac Newton (below left, top), Charles Darwin, and composer Handel (below left).

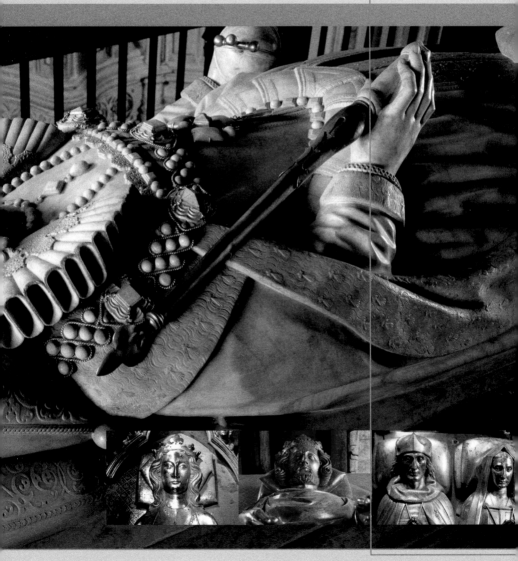

# THE HIGHLIGHTS: THE WEST END

Tate Britain not only houses great works of art, but has also practically become one itself. Its Millbank home, with its characteristic dome, is a truly great museum building. Changing temporary exhibitions and – of course – the paintings of William Turner lie at the heart of the gallery's attractions (main pictures, from left).

Alongside its permanent collection, Tate Britain's highly regarded, regular temporary shows are among the world's best exhibitions of great art.

*Tate Britain, Millbank, Westminster; Tel (020) 7887 8888; 10.00–17.40, daily; Underground: Pimlico.*

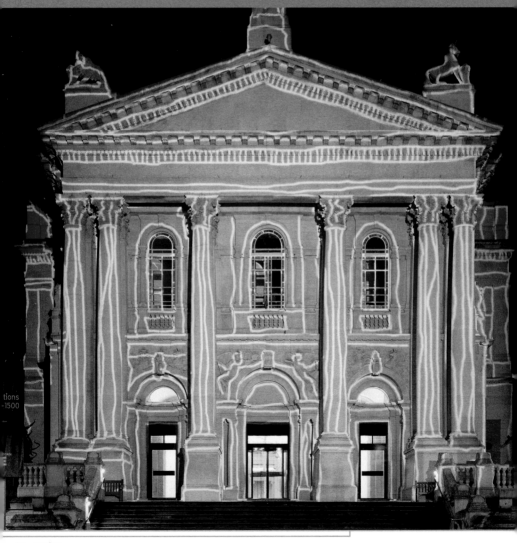

Tate Britain is a unique collection of British art from 1500 to the present day. Next to the neoclassical main entrance, the new Clore Gallery is home to the Tate's collection of paintings by the Romantic master painter William Turner. His memory lives on in the prestigious Turner Prize, awarded to a young British artist every year. The Tate's temporary exhibitions are also the cause of much sensation, often focusing not just on a single artist, but instead exploring all sorts of wider themes. Tate Britain was born as the National Gallery of British Art in 1897. It was popularly known as the Tate Gallery after its 19th-century millionaire benefactor Sir Henry Tate, who bequeathed not only his collection of contemporary art to the state, but also enough money to build a museum worthy of the collection's display (see p. 172). Tate Britain is now one of the four galleries across Britain collectively known as the Tate.

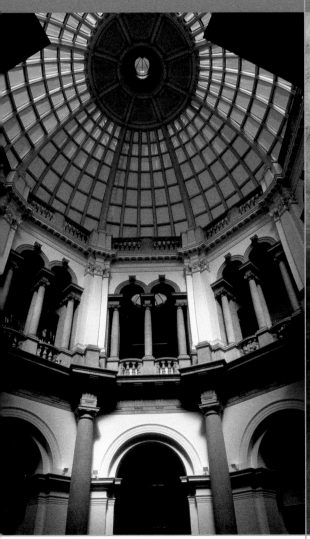

# THE HIGHLIGHTS:
## THE WEST END

### INFO Royal mews

Outside Buckingham Palace, the stony-faced guards in their bearskin helmets are an ever-popular photo opportunity for tourists from all over the world. But the best example of ceremonial pomp and circumstance is the Changing of the Guard (below), which during the summer months takes place daily.

**Both the queen's motor vehicles and her state coaches – used for official occasions – are kept in what is effectively the royal garage.**

*Buckingham Palace, Westminster; Tel (020) 7766 7302; 15 March–30 Oct Sat–Thurs 10.00–16.00; 29 July–29 Sept 10.00–17.00, daily; Underground: St James's Park.*

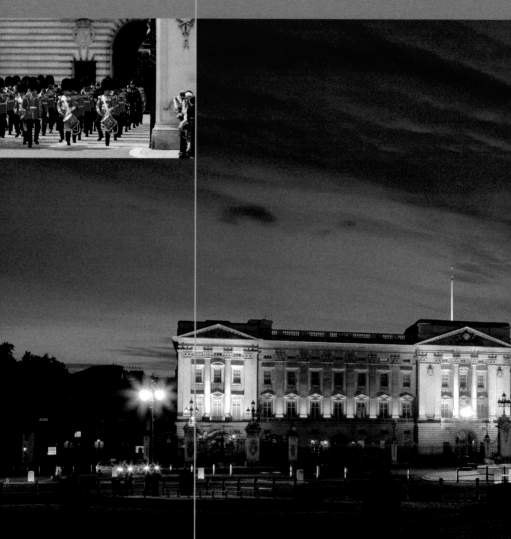

Buckingham Palace is the official weekday residence of the royal family. The royals only abandon it in the summer, so it is only during August and September that the palace doors are thrown open and 19 of its rooms put on public display. The central core of this splendid palace dates back to 1705, when the building belonged to the Duke of Buckingham. In 1837, Queen Victoria decided that St James's Palace no longer measured up to the standards required of a royal residence, and moved into Buckingham Palace instead. By that time, the building had been restructured into a palace truly worthy of the name. Further modernization and improvement works continued until the beginning of the 20th century, culminating in the refacing of the building's eastern façade in 1913. At important state occasions, the royals appear on the balcony on this side of the building, graciously waving to the public waiting below.

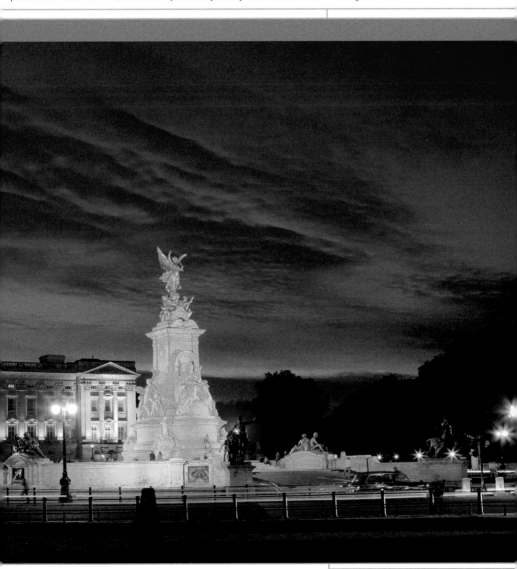

Afternoon tea is firmly established at all of London's finest hotels. From left: At the Savoy, a pianist provides gentle background music in the hotel's Thames Foyer tearoom; while guests at the Ritz can look forward to its occasional tea dances. In true British fashion, it is naturally a very civilized affair. Main picture: The Palm Court at the Ritz.

# TEA AT THE RITZ AND THE SAVOY

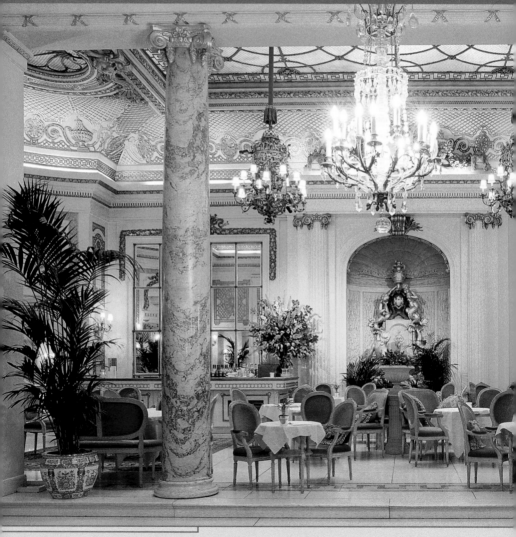

Tea at the Ritz is a London institution, and mere passers-by cannot simply breeze in for a quick cup of tea and a cake. Long considered the ultimate in style, the Ritz gave rise to the word "ritzy" to describe high-class living. It was opened in 1906 by Swiss hotelier César Ritz, who hired chef Auguste Escoffier to please wealthy palates. It should come as no surprise that tea guests are expected to adhere to a formal dress code. At the Ritz's splendid tearoom, the Palm Court, the hotel's refined guests are treated to an array of classic afternoon tea delicacies. The finest tea – often one of the hotel's unique blends – is served in silver teapots and sipped from the best porcelain with milk and sugar to taste. It's generally accompanied by an array of tasty morsels, in particular little sandwiches, cut into bite-size pieces, the crusts removed, and filled with egg and cress, fish paste, smoked salmon, ham, or wafer-thin slices of cucumber. Temptingly indulgent little cakes are also part of the afternoon tea experience, from a slice of pink and yellow Battenberg cake, to fruit cakes, lemon cakes, and – of course – scones with jam and clotted cream (a thick cream made from scalded milk). Though different establishments put their own twist on English afternoon tea, they would be doing it a disservice were they to omit any of the key components listed above. And that – as any true lady or gentleman will tell you – just would not do at all.

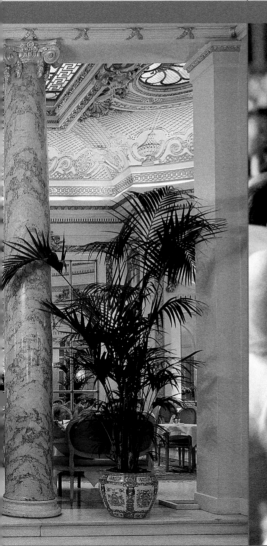
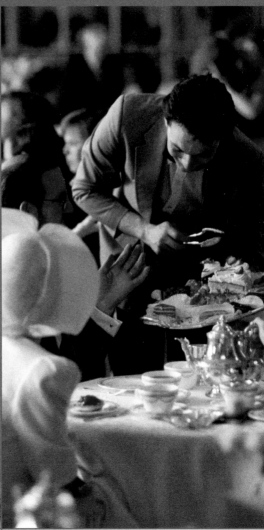

## THE HIGHLIGHTS:
## THE WEST END

Queen Victoria dedicated the Albert Memorial (right) to the memory of her husband, whose passing Victoria mourned for decades after his death. Hyde Park is an open-air paradise with enough room for everyone to relax and enjoy themselves, while Speakers' Corner (inset below) provides an outlet for those with something to say.

**INFO** Concerts in the park

Hyde Park has played host to some of the biggest names in pop. The concerts – whether solo performances or bigger festivals – now attract tens of thousands.

*Hyde Park; Tel (0870) 154 4040 for tickets; Underground: Marble Arch or Hyde Park Corner.*

Pink Floyd and the Rolling Stones are just two of the big rock bands to have played Hyde Park. There was a time when gentlemen came here to duel at dawn, and robbers to stalk their victims, but life in this tranquil London park now moves at a rather gentler pace. Covering an area of some 142 ha (351 acres), Hyde Park is truly a park for the people. At its north-east corner is the only public place where anyone can openly speak their mind to the crowds without the need for any official warrant. Speakers' Corner is an institution, a place where the right of anyone to speak has been enshrined in law since 1872. At the southern edge of the park, the Albert Memorial commemorates Queen Victoria's beloved German husband, Prince Albert of Saxe-Coburg-Gotha. Covered with statues, the memorial was completed in 1876. Victoria and Albert's love for each other has a special place in the Windsor family history.

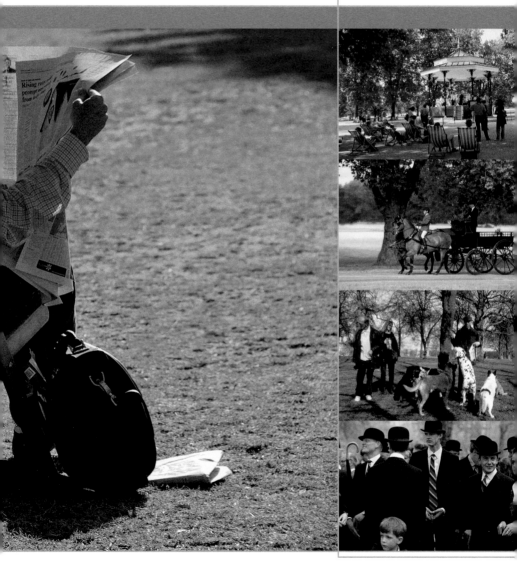

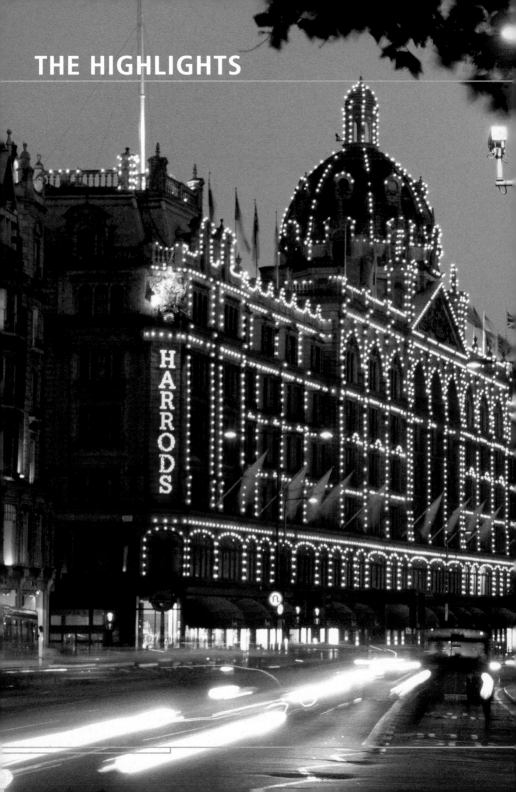

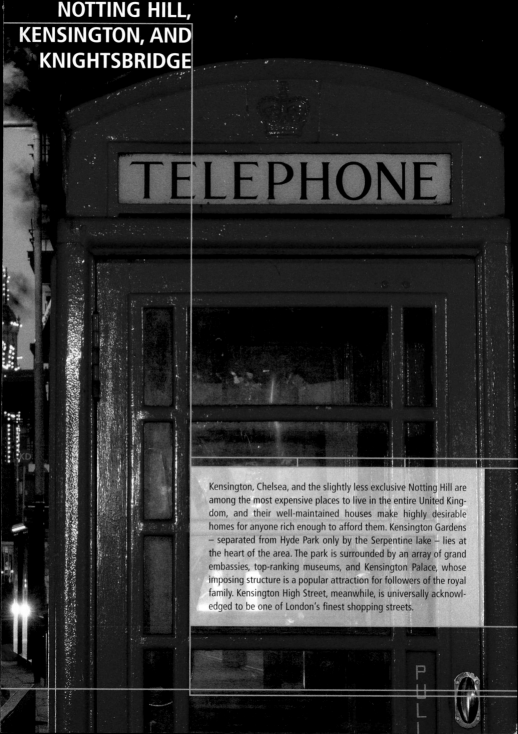

TELEPHONE

Kensington, Chelsea, and the slightly less exclusive Notting Hill are among the most expensive places to live in the entire United Kingdom, and their well-maintained houses make highly desirable homes for anyone rich enough to afford them. Kensington Gardens – separated from Hyde Park only by the Serpentine lake – lies at the heart of the area. The park is surrounded by an array of grand embassies, top-ranking museums, and Kensington Palace, whose imposing structure is a popular attraction for followers of the royal family. Kensington High Street, meanwhile, is universally acknowledged to be one of London's finest shopping streets.

21 Harrods

22 The Victoria and
Albert Museum

23 The Natural History
Museum

24 The Royal Albert Hall

25 Kensington Palace and
Kensington Gardens

26 Notting Hill

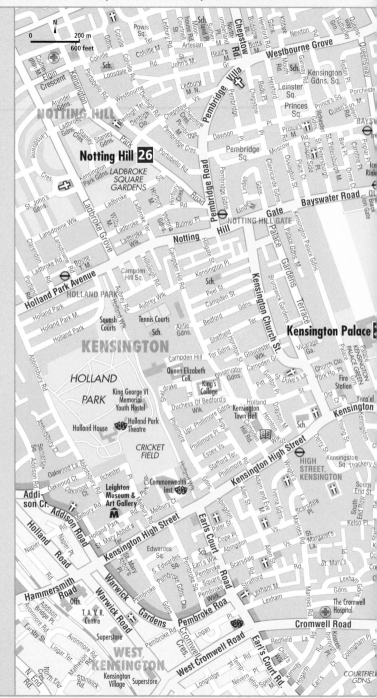

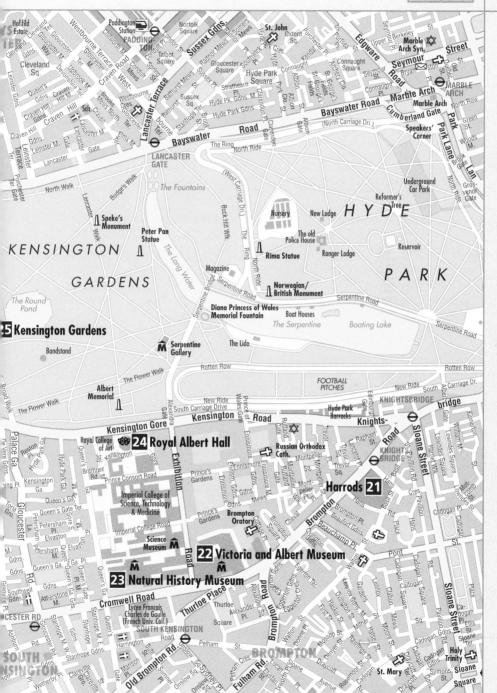

# THE HIGHLIGHTS: NOTTING HILL, KENSINGTON, AND KNIGHTSBRIDGE

Harrods occupies an entire block, and though surrounded by other luxury shops, these are but a pale reflection of the vast array of goods for sale in this shopping temple. From luxury cosmetics to toys, designer fashion, fine furniture, and the many temptations of its heavenly food hall, Harrods truly does offer something for everyone.

## TIP Harrods Hair and Beauty

Time for a complete makeover? Europe's biggest hair and beauty salon boasts 32 rooms dedicated to the beautification of your entire body – from hair to nails.

*Harrods, 87–135 Brompton Road, Kensington; Tel (020) 7893 8333; Underground: Knightsbridge.*

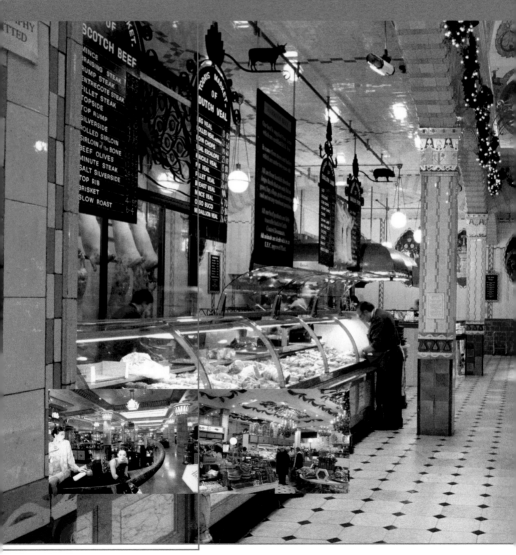

Never make the mistake of confusing Harrods with just any old department store. This temple of consumerism is a British institution. The store stands on a 1.8-ha (4.5-acre) plot and the sales floors cover some 93,000 sq m (111,200 sq yards). A total of 330 departments and 28 restaurants provide work for 5,000 employees, and up to 300,000 customers pass through its doors every day. All this makes Harrods the biggest department store in Europe, and one of the biggest in the world. The store's motto is *Omnia Omnibus Ubique* ("all things for all people, everywhere"), and it certainly lives up to its promise. Now part of a larger business empire, Harrods was originally founded by Charles Henry Harrod in 1834 and started life as a grocery and tea merchants based in London's East End, moving to the more exclusive Knightsbridge 15 years later. The current building dates from 1905 after its predecessor was destroyed by fire.

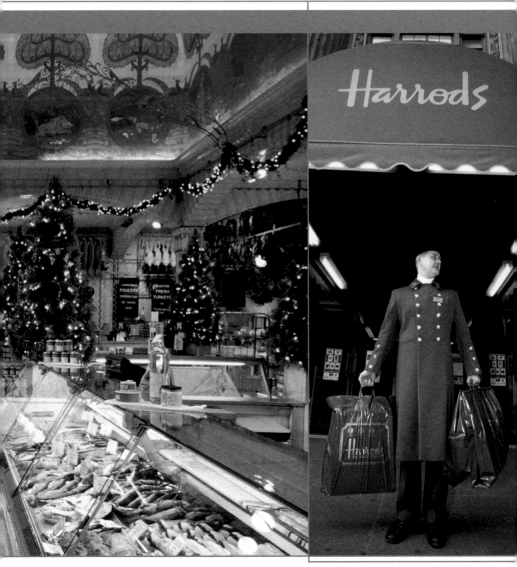

Inside and out, the museum is a feast for the eyes. Below, from left: In the entrance rotunda, there is a chandelier made from hand-blown glass, and in the Cast Court you'll find incredible copies of some of Europe's most famous monuments – such as Trajan's Column in Rome – alongside important original sculptures.

**TIP** The Anglesea Arms

Located in London's most exclusive area, this gastropub serves English and Mediterranean dishes. Relax in style with a pint of real ale on the summer terrace.

*15 Selwood Terrace, Kensington; Tel (020) 7373 7960; Mon–Sat 11.00–23.00; Sun 12.00–22.30; Underground: South Kensington.*

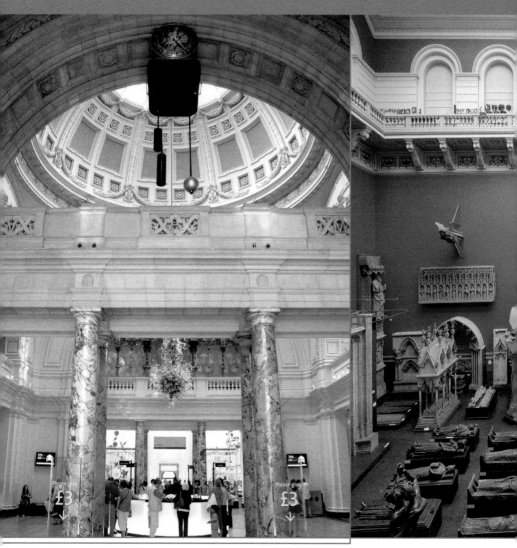

Named after Queen Victoria and her husband Prince Albert, the V&A (for short) and its vast building are a showcase for around 4.5 million valuable examples of craft and design from Europe, North America, Asia, and North Africa, spanning a period from some 5,000 years ago right up to the present day. As if the geographic and historic breadth of the museum's exhibits were not impressive enough, the collection also encompasses the entire gamut of creative design, from sculpture, painting, drawing, and photography to glasswork, porcelain and ceramic, furniture, toys, clothing, and jewelry. This is the biggest collection of its kind in the world. It all started after the Great Exhibition of 1851, from which some of the more unusual exhibits were acquired. The collection quickly grew, and in 1899 Queen Victoria laid the foundation stone of the V&A's current building (see p. 174).

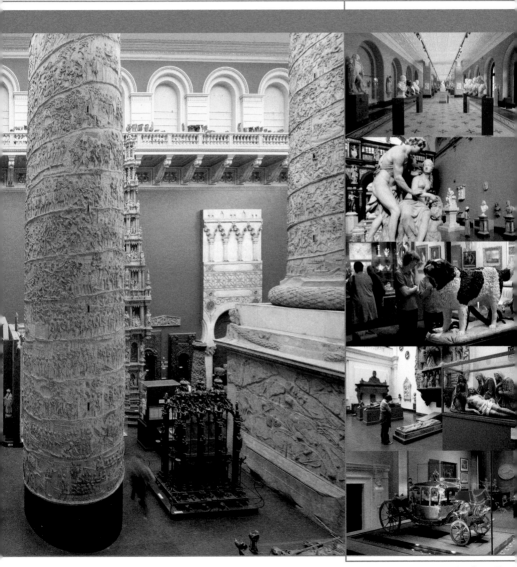

# THE HIGHLIGHTS: NOTTING HILL, KENSINGTON, AND KNIGHTSBRIDGE

## TIP Oddono's

Though its façade is very much in keeping with Victorian tastes, the building's iron framework was highly innovative (below left). For all the museum's latest attractions, old treasures like the giant dinosaur skeleton (below middle) are as popular now as they always have been, and no visitor can fail to be impressed by the Earth Galleries (below far right).

Don't let the weather stop you from treating yourself to an ice cream. Oddono's ice creams and sorbets are handmade, often with intriguing ingredients such as basil or vodka.

*14 Bute Street, Kensington; Tel (020) 7052 0732; Sun–Thurs 11.00–23.00; Fri–Sat 11.00–24.00; Underground: South Kensington.*

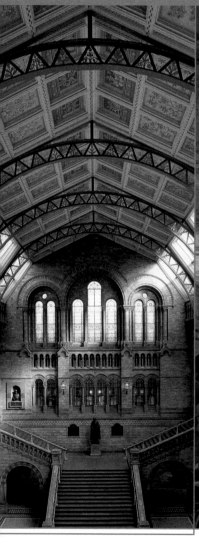

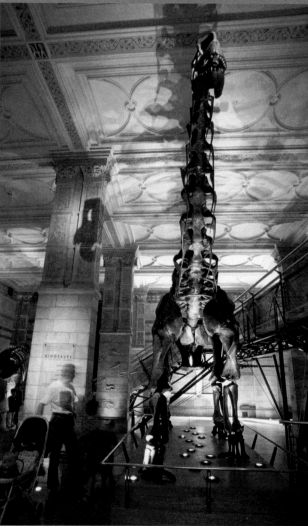

Over and above its size and the scope of its collection, you could be forgiven for thinking that there is little to distinguish the Natural History Museum from its counterparts elsewhere. Like them, it was born of the 19th-century fascination with all creatures great and small – be they stuffed, preserved, a skeleton, or a model. It is a preoccupation from which the museum continues to thrive, but delve a little deeper and it soon becomes apparent that this truly is a museum without comparison, a treasure trove of over 70 million specimens that together document the complete history of the natural world. The collections of preserved specimens are in the main part of the museum, along with the newly enlarged Darwin Centre, which tells the story of evolution. The amazing Earth Galleries, meanwhile, provide a fascinating insight into the geological history of our planet (see p. 176). A new phase of the Darwin Centre opens soon.

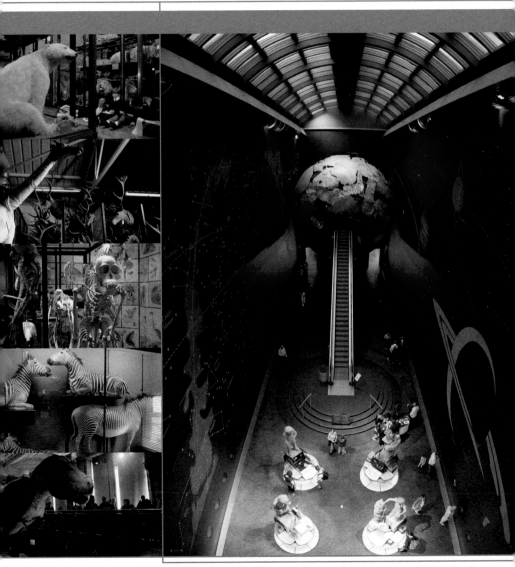

## THE HIGHLIGHTS: NOTTING HILL, KENSINGTON, AND KNIGHTSBRIDGE

The much-loved Royal Albert Hall has played host to a wide range of musicians – from symphony orchestras to rock bands. Once a year, at the spectacular "Last Night of the Proms", the concert hall is also transformed into a sea of British patriotic passion – an event at which even the most reserved of Britons cannot help but to wave the flag.

### TIP Launceston Place

At Launceston Place, traditional English recipes are given a sophisticated twist – aided by some creative taste combinations.

*1a Launceston Place, Kensington; Tel (020) 7937 6912; Tues–Sat 12.00–14.30; Sun 12.00–15.00; Mon–Sun 18.30–22.30; Underground: High Street Kensington.*

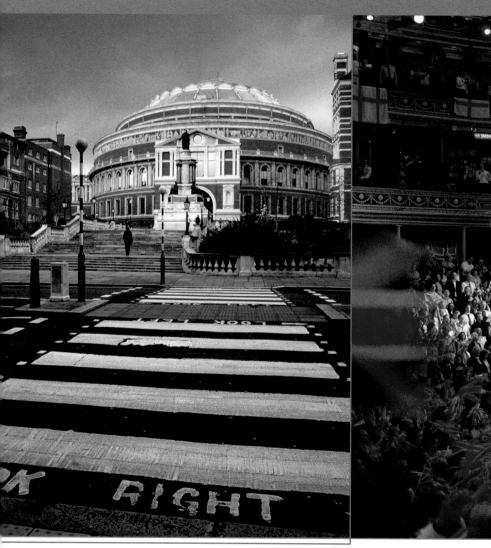

The Royal Albert Hall's huge, domed roof marks the heart of an area often termed the Albertopolis – named after Queen Victoria's husband, Prince Albert, in whose memory the widowed queen dedicated numerous cultural institutions in this part of town. Opened in 1871, the circular design of the Albert Hall borrowed from ancient Roman arenas. The organ, which dominates the stage area, has nearly 10,000 pipes and is one of the largest organs in the country. Some of the world's most famous classical concerts – as well as many of the greatest ever pop and rock performances – have taken place on the stage below. In 1963, the Beatles and the Rolling Stones performed their only joint concert here. From Pink Floyd to Abba, many acts have played this venerable hall, which has – at other times – hosted tennis tournaments, conferences, award ceremonies, and all manner of charity galas.

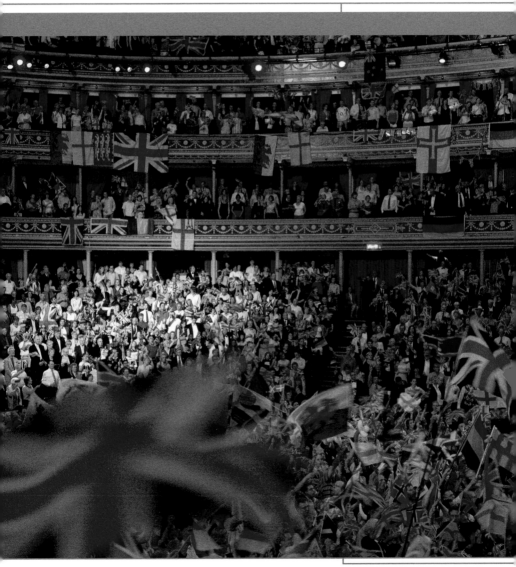

London may be pricey, but it is always on the cutting edge of fashion. There is a wide variety of boutiques in Notting Hill, from Mary Moore (far right) to Sera of London (right). On the international stage, renowned designers like Vivienne Westwood (main picture), John Galliano, whose first collection shocked the fashion world (below middle), and Alexander McQueen (below right) set the latest trends.

# LONDON, THE FASHION CAPITAL

Central Saint Martins, at the heart of London's West End, is one of the world's most famous design schools. This is where the fashion designers who make London a style capital cut their teeth. Photos of its most successful alumni line the corridors – John Galliano, Alexander McQueen, Stella McCartney, and Paul Smith. It is a place where eccentricity is celebrated as a breath of fresh air, so it comes as no surprise to find that London's designers – especially the younger generation – have ruffled a few feathers with their experimental and at times shocking designs. The English capital first shook the fashion world in 1962, when the miniskirt, designed by Mary Quant, was unveiled. Designers like Zandra Rhodes and Ossi Clark were next to make a name for themselves, followed by Vivienne Westwood, whose punk and pirate looks are still much copied today. In 2004, the Victoria and Albert Museum recognized Westwood's influence with a retrospective of her work (main picture). The original young guns of British fashion are now hot property at the world's leading couture houses, with Stella McCartney at Gucci and Galliano employed as chief designer by Dior. Alexander McQueen, made it from college student to Gucci haute couture in a little less than five years, all the while remaining true to his guiding principle – shock, at any price, even to the point of using amputees to model his clothes on the catwalk.

# THE HIGHLIGHTS: NOTTING HILL, KENSINGTON, AND KNIGHTSBRIDGE

## TIP The Orangery

When news spread of the death of Princess Diana in 1997, the gates of Kensington Palace were soon covered with flowers. Admirers of the late princess still visit the palace today, and it is also possible to hire some of its rooms for private functions. On the right, the palace's beautiful Sunken Garden.

The former orangery is the perfect spot for a regal breakfast, light lunch, or afternoon tea.

*Kensington Gardens, Kensington; (020) 7938 1406; March–Oct 10.00–18.00, daily; Nov–Feb 10.00–17.00, daily; afternoon tea from 15.00; Underground: High Street Kensington.*

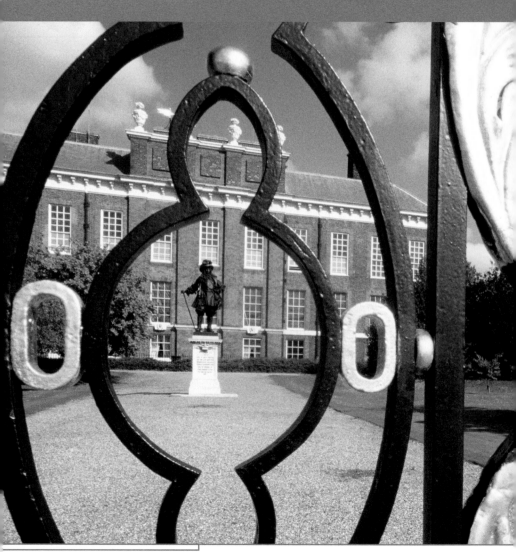

# KENSINGTON PALACE AND
# KENSINGTON GARDENS 25

Set in 111 ha (274 acres), Kensington Gardens was once the garden of Kensington Palace, and its landscaping is more formal than that of nearby Hyde Park. It is especially popular with children, who'll find plenty to keep them occupied within the confines of the well-tended park. In the east, not far from the Serpentine lake, stands the enchanting Peter Pan statue – a tribute to the famous fictional hero. The Diana Memorial Playground lies to the west – home to an adventure playground, a pirate ship and Indian tepees. For adults, the Serpentine Gallery is – along with the park itself – the biggest single attraction. This 1930s tea pavilion is the venue for changing exhibitions of contemporary art, and the gallery's temporary summer pavilion – created anew each year by a different leading architect – is a work of art in itself. Nearby, the Diana Memorial Fountain is a reminder of the late princess's connection to Kensington.

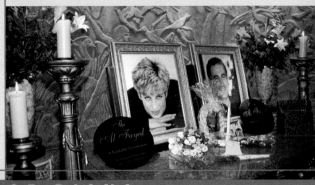

The shrine (right) on the lower ground floor of the Harrods department store is a memorial to Diana, Princess of Wales, and Dodi Al-Fayed, who died in the same accident. It was commissioned by Dodi's father, Mohammed Al-Fayed, the owner of Harrods. Among other items, the shrine incorporates the wine glass Diana drank from at her final meal, and the ring bought by Dodi for his very own queen of hearts. Main pictures: Memorials in Kensington Palace.

# IN MEMORY OF DIANA

Beautiful, elegant, glamorous, yet tragic – Diana, Princess of Wales, is as much a media icon in death as she was in life. Diana was one of the 20th century's most notable examples of the cult of celebrity. She became the most photographed woman on the planet, and pictures of her continue to fill the pages of the world's celebrity magazines even after her death. In 1997, when Diana – the ex-wife of the heir to the throne, Prince Charles, and mother of the next in line, Prince William – was killed in a car crash in Paris, her death was greeted in Britain by unprecedented mass mourning. The then prime minister, Tony Blair, captured the mood of the nation when he described her as the "people's princess", the queen of hearts.

In dying tragically young, Lady Di was instantly immortalized. Numerous memorials have since been erected in her memory. Diana's grave at her family home in Althorp has been turned into a shrine, and there is also a memorial fountain in Hyde Park and the Diana Memorial Playground in Kensington Gardens. But by far the most interesting memorial is the one at Kensington Palace, the Princess of Wales' last home. Here, alongside extensive audiovisual displays and a good collection of memorabilia, some of Diana's incredibly elegant dresses have been put on public display. Diana was a fashion-conscious princess, and Britain's top designers created most of the garments shown here specifically for her.

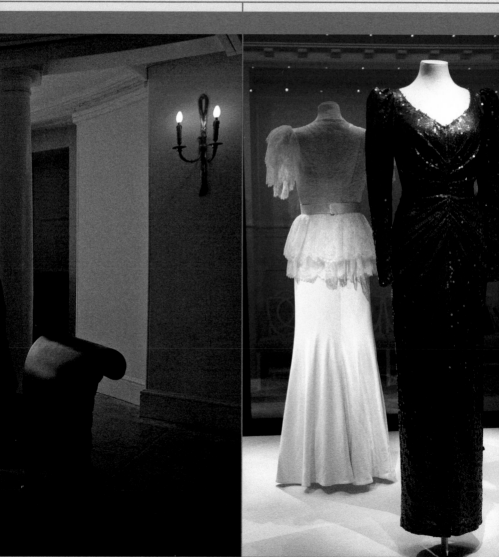

# THE HIGHLIGHTS: NOTTING HILL, KENSINGTON, AND KNIGHTSBRIDGE

Portobello Road is the throbbing heart of Notting Hill. It's hard to think of something you can't buy here, and the area's charming mix of distinctive shops and character properties ensures that its attraction extends well beyond the famous Saturday market. Quieter Westbourne Grove is home to many a fine pub.

## TIP Portobello Gold

A real Notting Hill institution, this lively combination of bar, Internet café, and restaurant serves good, honest food in the relaxed ambience of the Gold's tropical conservatory.

*95 Portobello Road, Kensington; Tel (020) 7460 4918; Mon–Sat 12.00–23.00; Sun 12.00–22.30; Underground: Notting Hill Gate.*

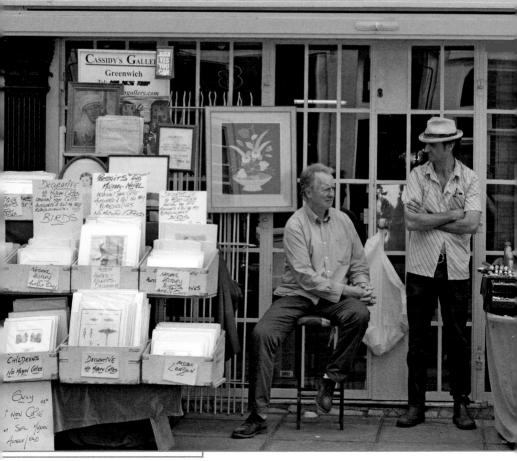

Up until a few decades ago, Notting Hill was seen as a faded blot on the upper-class Kensington cityscape. It was a hotbed of social tension, and the scene, in 1958, of Britain's first race riots. At the time, most of the area's residents were of Afro-Caribbean origin, and it was these residents who, in the years after the racial clashes, started the Notting Hill Carnival – now one of London's brightest and best-known events. Notting Hill is still not exactly beautiful, but it is always exciting. The process of "gentrification" – meaning not just the redevelopment and general tidying up of an area, but above all the influx of affluent young residents – has really had a dramatic impact on the face of Notting Hill. It has also seen prices soar. Portobello Road, for example – the heart of Notting Hill – boasts one of London's best markets, but it is now rarely the place to snap up a good bargain.

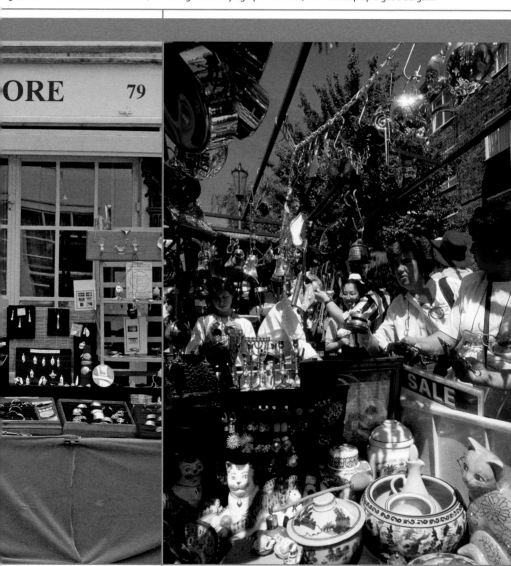

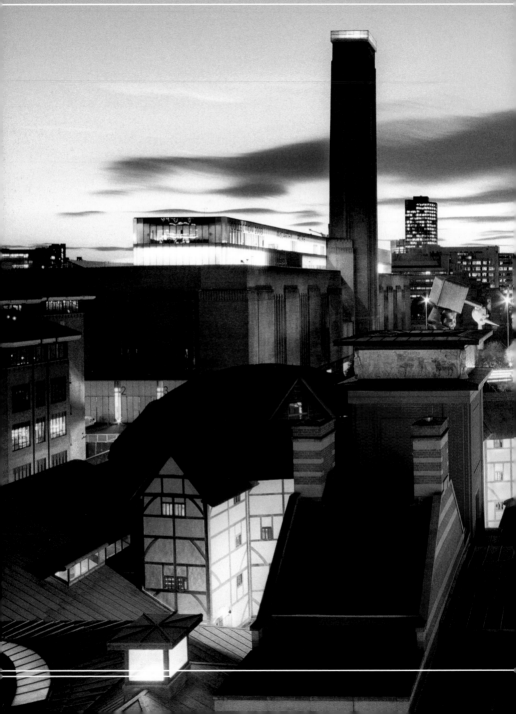

# THE HIGHLIGHTS

# THE SOUTH BANK

The south bank of the Thames may only be a stone's throw from the City and London's other most desirable areas, but it has always tended to be rather disparaged by the capital's residents. Historically, this was the location of the city's main popular entertainment attractions and also its red-light district. Later, prisons and industrial facilities were built here, the latter running into crisis in the 20th century. More recently, the area has been helped by wide-ranging regeneration, shedding its old reputation to become instead a thriving hub of art and cultural life.

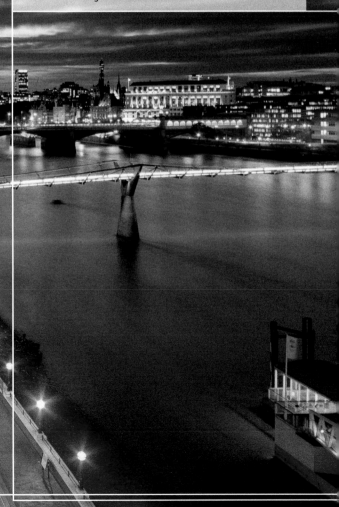

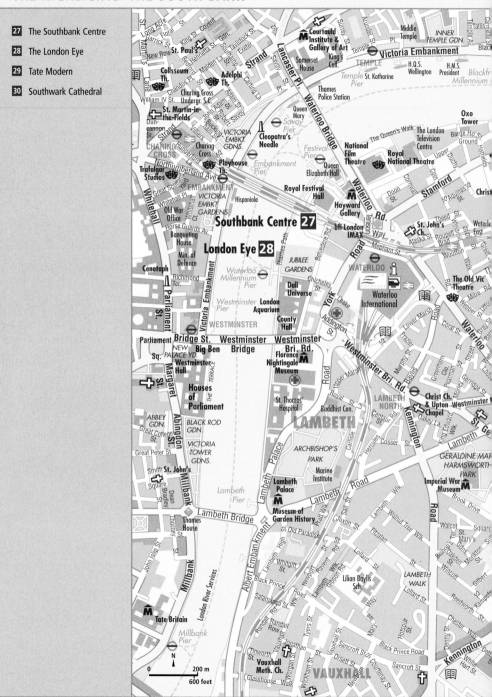

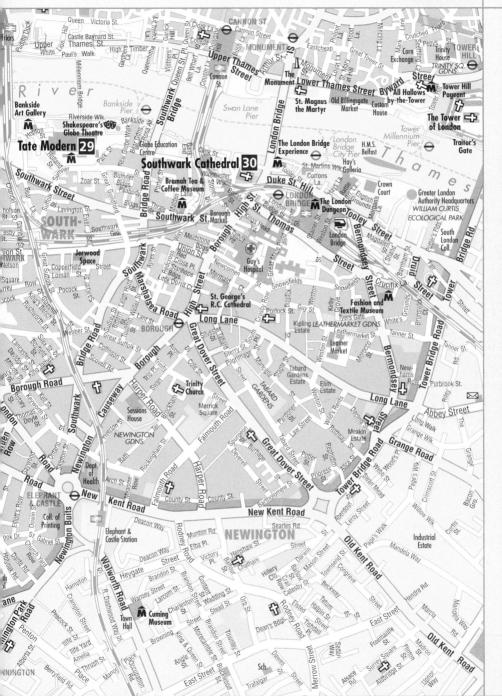

# THE HIGHLIGHTS: THE SOUTH BANK

The Hayward Gallery Queen Elizabeth Hall, National Theatre, and the Royal Festival Hall (below left, from top) are the heavyweight cultural institutions of the South Bank. You'll find exciting contemporary art, ballet, drama, and music at almost every turn. The main picture and pictures below right show the Saatchi Gallery.

## INFO London Duck tours

Making a splash on London's tourist scene, this tour – in one of the historic amphibious vehicles used for the D-Day landings – takes you along the South Bank by road and river.
*55 York Road, Lambeth; Tel (020) 7928 3132; reservation advisable; Underground: Waterloo.*

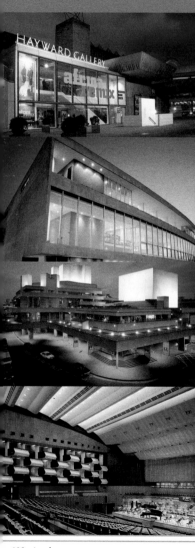

# THE SOUTHBANK CENTRE 27

The Southbank Centre is Europe's biggest cultural complex. The first of its major buildings to be completed was the 2,900-seat Royal Festival Hall, originally built for the Festival of Britain in 1951. The Queen Elizabeth Hall and the Hayward Art Gallery – the location of some highly regarded contemporary art exhibitions – completed the Southbank Centre. Next door, the National Film Theatre (home of the London Film Festival) and the three auditoriums of the National Theatre were added to the South Bank's list of cultural attractions. A little further south, meanwhile, County Hall – housing both a perma- nent exhibition on Salvador Dalí and the London Aquarium – is yet another tourist magnet. The Queen's Walk connects all the buildings between Lambeth Bridge and Tower Bridge, offering great views across the River Thames to the historic buildings on the north bank opposite.

# THE HIGHLIGHTS:
# THE SOUTH BANK

**TIP** The King's Arms

Looking out over London from the London Eye, it's not just the height that makes you go weak at the knees, but also the impression you get of the city's true size. Over 50 of the capital's biggest attractions are – usually – clearly recognizable, Westminster Palace (main picture) among them.

Locals have been enjoying a quiet pint in this charming pub for over a century. It also offers a tasty traditional Sunday lunch, as well as more exotic dishes.

*25 Roupell Street, Lambeth; Tel (020) 7207 0784; Mon–Sat 11.00–23.00; Sun 12.00–22.30; Underground: Waterloo.*

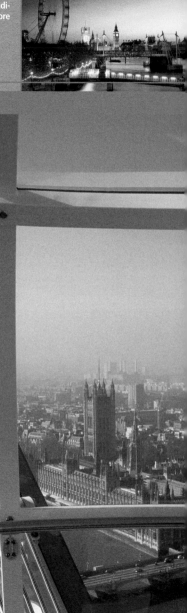

Opened amid great fanfare on New Year's Eve 1999, the 135-m (443-foot) London Eye is the world's biggest big wheel. Located between County Hall and the Southbank Centre, it has become one of London's most popular tourist attractions. The wheel turns in a slow, continuous motion, taking about 30 minutes to complete a full rotation. Passengers are able to board one of the 32 capsules without the wheel having to stop. Fixed to the outside of the main rim, the fully glazed capsules afford visitors a commanding panoramic view over London and – in good weather – as far beyond the city as Windsor Castle. A basic ride on the wheel is fairly pricey, but for a wider outlay you can officially celebrate your birthday on board, or even get married. Though the London Eye was originally only intended to remain on the river for five years, it has proved such a success that it is now due to stay in place for some time to come.

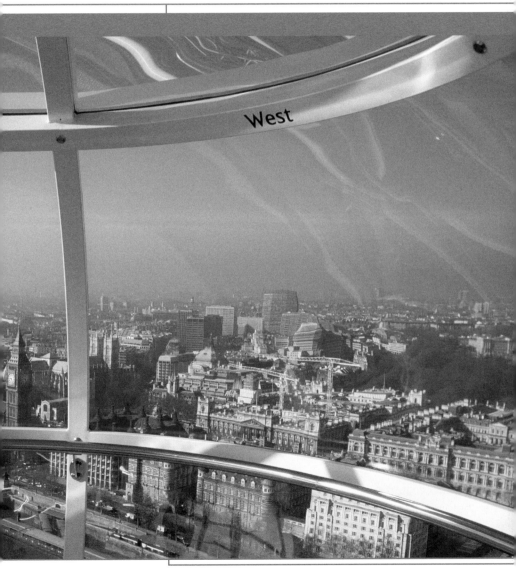

# THE HIGHLIGHTS: THE SOUTH BANK

Tate Modern is a unique venue for some truly innovative art. The gallery dominates the view across the Millennium Bridge from the north bank of the Thames (main picture). One of its main attractions is the giant turbine hall (far left in the series below), for which a major new installation is commissioned every year.

## TIP Café 2 and Tate Modern Restaurant

Café 2 serves good, simple dishes, while the seventh-floor restaurant boasts a great view over the Thames.

*Bankside Power Station, 25 Sumner Street, Southwark; Tel (020) 7401 5014 (Café 2), (020) 7401 5020 (Restaurant); Sun–Thurs 10.00–18.00; Fri–Sat 10.00–23.00; Underground: Southwark.*

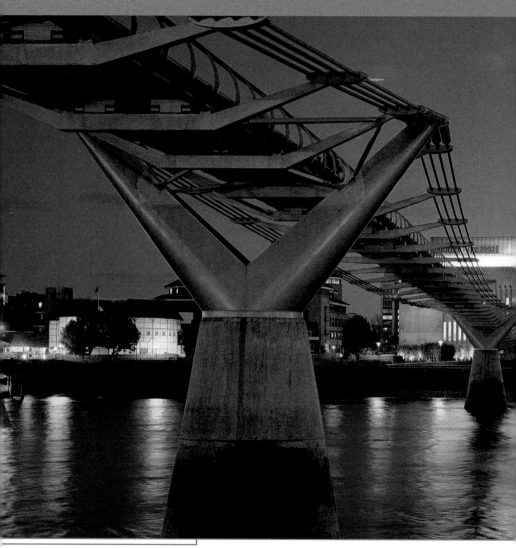

Situated right on the banks of the Thames, the Tate Modern building – with its 99-m (325-foot) high tower – is an attraction in itself. Built after World War II, the building was originally a power station. Its transformation into a spectacular gallery of modern and contemporary art began in 1995, costing well over a hundred million pounds before the new gallery finally opened its doors in 2000. The turbine hall, which rises over five floors high, is both an imposing entrance and a place to display commissions created specially for the space. Works by some of modern and contemporary art's most important artists are on show on the various gallery floors, including world-famous paintings by Picasso, Matisse, Mondrian, and Dalí. There's also an incredible view over the Thames from the Tate's seventh-floor restaurant, looking out toward the City and St Paul's Cathedral on the opposite bank (see p. 172).

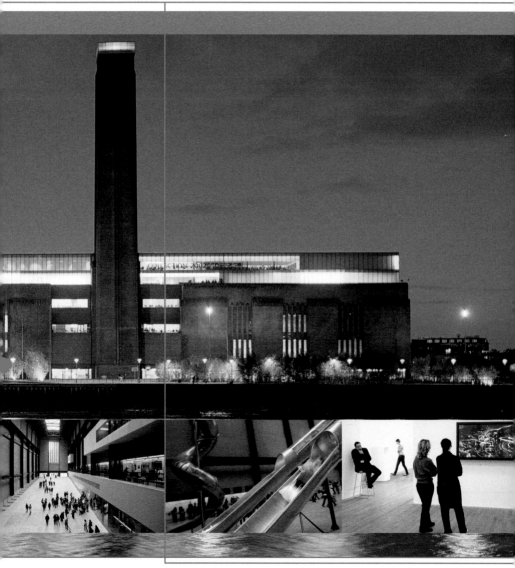

In Shakespeare's day, plays were still considered to be a lowly form of popular amusement, and certainly not something to which the educated classes would deign to pay attention. Today, the modern Globe Theatre continues to present Shakespeare's plays in this original spirit. *A Midsummer Night's Dream* and *Romeo and Juliet* are the big crowd-pleasers, while film crews (below, from top) make good use of the Globe's authentic Shakespearian backdrop.

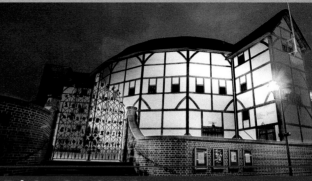

# SHAKESPEARE'S GLOBE

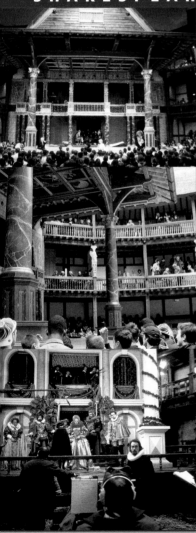

The American actor-director Sam Wanamaker had been either starring in or directing Shakespeare productions on the English stage since the 1960s. Realizing that there was no longer any trace of the great dramatist on the site of the original Globe Theatre, Wanamaker first took up the cause of building a new Globe in the 1970s. It was 1997 – four years after Wanamaker's death – before the Globe finally reopened just 200 m (270 yards) from its original site (New Globe Walk, Bankside; Underground to London Bridge, Cannon Street, or Southwark). Its architecture, which is largely true to that of the original, and its productions, stripped of "educated" interpretation, make a profound impression on its modern-day audience. The new Globe was constructed according to the original Elizabethan plans, so looks very much as the original would have done. The polygonal structure is almost circular, and the inner court is covered by the first and only thatched roof to have been laid in London since the Great Fire of 1666. Beneath it, there is a small covered stage and balcony, with three tiers of seating running around the inside of the structure. It is standing room only in the pit, the central part of the auditorium which is open to the elements. Ticket prices are consequently cheaper and the "groundlings", as members of the audience in the pit are known, are permitted to come and go during the performance.

The spire of Southwark Cathedral rises majestically over London Bridge (right). The fascinating nave features an early Gothic ribbed vault (main pictures). St George – the patron saint of England – as well as numerous tombs and memorials are a reminder of a glorious early history (below, from top).

**TIP** Fish!

Only the best fish makes it onto the menu at this comfortable and affordable diner, housed in a glass pavilion by Borough Market.

*Cathedral Street, Borough Market, Southwark; Tel (020) 7836 3236; Mon–Thurs 11.30– 23.00; Fri–Sat 12.00–23.00; Sun 12.00–22.30; Underground: London Bridge.*

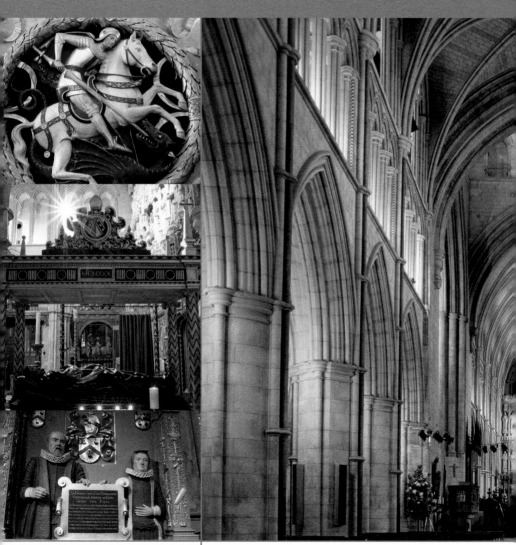

# SOUTHWARK CATHEDRAL 30

Southwark Cathedral is just a few steps from London Bridge, and parts of its structure are among the oldest church buildings in London. The choir and its ambulatory, as well as the lower sections of the spire, date from the early 12th century. The choir, built around 1270, was a particularly important fea-

ture of the former minster, while the high altar was added in the 15th century. The many tombs are a reminder of the church's early history, before it became the Anglican cathedral of the Diocese of Southwark in 1905. English poet and writer John Gower (14th C.) and Shakespeare's brother Edmund are

both buried here. Shakespeare himself is commemorated by a monument erected in the south aisle in 1912. Near the cathedral, Borough Market is another enticing attraction, particularly for those interested in food. The market halls date from the mid-19th century, but the market itself is about as old as the church.

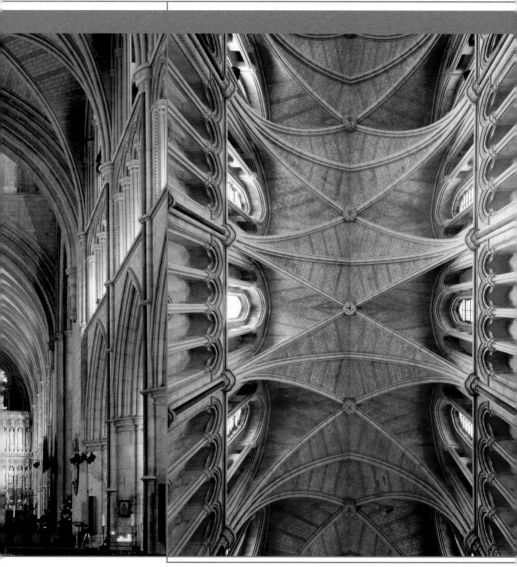

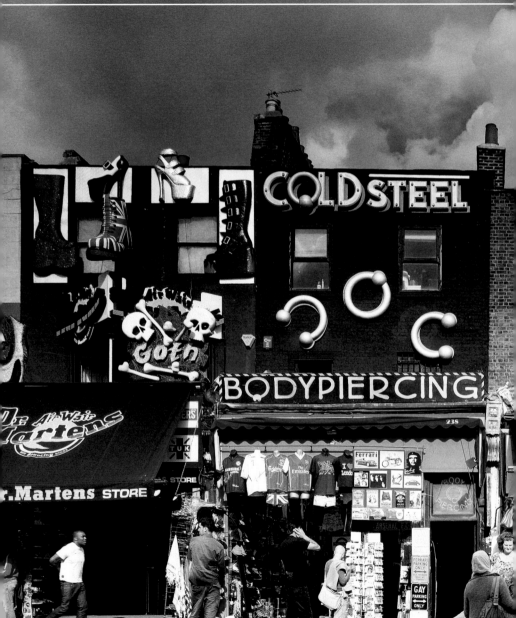

# BLOOMSBURY
# AND CAMDEN

No other part of inner London is as diverse as this area. Blooms-
bury, one of central London's greener residential areas, and parts
of the area south of Regent's Park together form London's main
academic district, home to numerous university colleges and the
world-famous British Museum. Camden Town is a less expensive
area that has been adopted by the city's student fraternity, evi-
denced by the area's many alternative bars and venues. Refined
and elegant, Regent's Park, on the other hand, is surrounded by the
finest terraced townhouses in England, designed by John Nash, the
eminent architect responsible for much of Regency London.

**31** The British Museum

**32** The British Library

**33** Regent's Park

**34** Camden Town

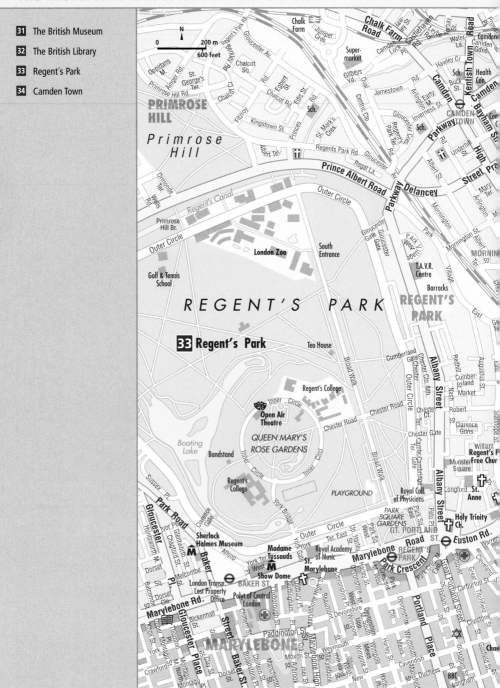

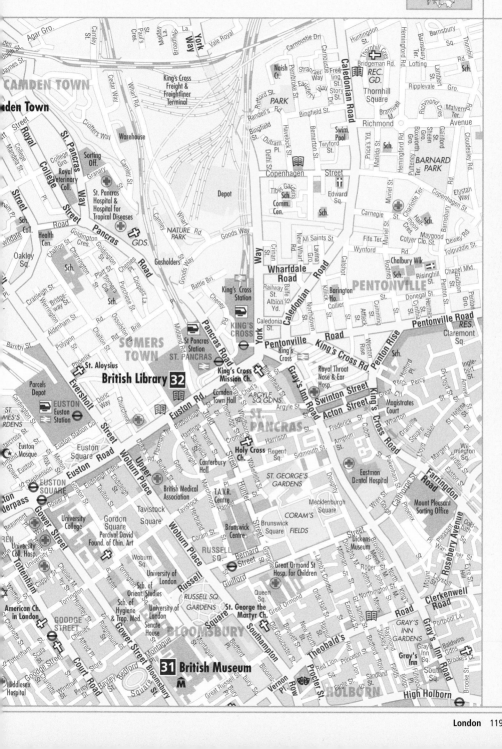

# THE HIGHLIGHTS: BLOOMSBURY AND CAMDEN

The British Museum's Great Court (below left) is the largest covered square in Europe, and Karl Marx wrote his greatest work, *Das Kapital,* in the Reading Room (right). The museum is also famous for its collection of Egyptian mummies and the Elgin Marbles, including sculptures from the Parthenon frieze in Athens.

## TIP The Lamb

A historic pub built in the 1720s but redesigned in the Victorian era. Dark wood, leather sofas, sepia photographs, and Victoriana all help to create a nostalgic atmosphere.

*92 Lamb's Conduit Street, Bloomsbury; Tel (020) 7405 0713; Underground: Russell Square, Holborn.*

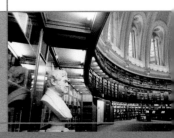

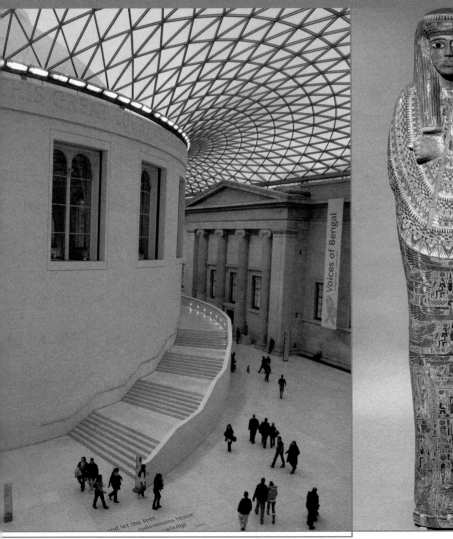

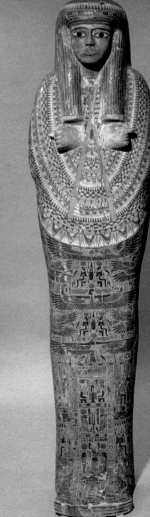

Of Scottish and Irish descent, Sir Hans Sloane was a passionate collector of scientific specimens since childhood. Upon his death, Sloane bequeathed his entire collection – comprising over 70,000 items – to King George II for the nation. In 1753, this collection became the foundation of a museum that was the first of its kind anywhere in the world, containing objects from every academic field and every country. Today, the museum's holdings encompass millions of items and include some of the world's most famous treasures, like the Elgin Marbles from the Acropolis and the Rosetta Stone. The museum had already outgrown its original premises by the 19th century, and the current building dates from 1825. It boasts an imposing neoclassical façade, and has recently been made even more impressive by the addition of Sir Norman Foster's glass roof over the Great Court (see p. 178).

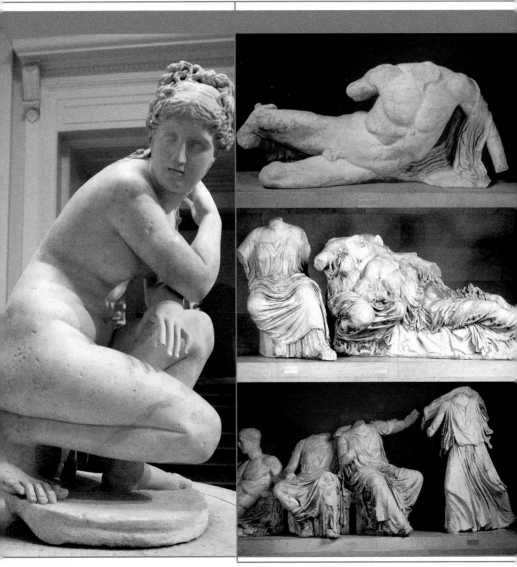

# THE HIGHLIGHTS: BLOOMSBURY AND CAMDEN

## TIP The Betjeman Arms

A sculpture by Eduardo Paolozzi (right) greets visitors to the British Library. Below, from left: The King's Library contains some 65,000 volumes collected by King George III (18th C.); they include the medieval *Historia Anglorum* (13th C.), with its depiction of King William II; and a 14th-century chronology depicting Henry III.

This stylish pub located within the Eurostar terminal makes an ideal stop for a traditional English all-day breakfast.

*St Pancras International Station, Euston Road, Camden; Tel (020) 7837 0522; Mon–Fri 7.30–23.00; Sat 8.30–23.00; Sun 8.30–22.30; Underground: King's Cross.*

The 625 km (388 miles) of shelving at the British Library increase by 12 km (7 miles) each year. The library holds printed and handwritten documents from every historical period, including an original copy of the Magna Carta and two Gutenberg Bibles. These, together with an audio collection of some three million recordings, help make the British national library one of the biggest and most important archives in the world. Situated between King's Cross and Euston stations, the library has occupied its functional modern premises since 1998. The library itself is only open to holders of a reading pass, but some of its treasures are displayed in a public gallery. Among other unique documents, you'll find Captain Cook's journal, Charlotte Brontë's *Jane Eyre*, the original lyrics of the Beatles' song *Yesterday*, the celebrated first edition of the complete works of Shakespeare, and Lenin's application for a British Library pass.

Madame Tussaud (whose own wax effigy is shown below left) will forever be associated with the practice of creating incredibly lifelike wax models of famous contemporary figures, and this fascinating idea continues to draw in the crowds. King Henry VIII and his wives (right), the present queen and her family, the Beatles, Queen Elizabeth I, and the great artist Pablo Picasso are just some of the top attractions (below right, from top).

# MADAME TUSSAUDS

Most mere mortals rarely get the chance to come face to face with the world's biggest celebrities, but in the world-famous galleries of Madame Tussauds those very same distant celebrity stars are suddenly near enough to give you a friendly smile – albeit a slightly stiff one. Almost all the most famous faces of modern history are represented, from pop idols to sporting champions and politicians. Displayed in their respective native surroundings, the figures are incredibly lifelike, and are periodically updated to keep pace with their increasing age. Not that it's all harmless, friendly faces – serial killers, tyrants, and gangsters are all here too, presented in a wide array of thematic displays. Born Marie Grosholtz in 18th-century Strasbourg, the museum's founder started her collection in pretty gruesome circumstances herself when, shortly after the French Revolution, she was charged with making death masks for the victims of the Parisian guillotine. Years later, Tussaud moved to London's Baker Street, where she put her collection of waxworks on public display. In the 19th century, Tussaud's grandson moved the by then expanded collection to its current home on Marylebone Road (Underground to Baker Street).

The collection is changed regularly to keep up with times, with new figures replacing those relegated to the storeroom because they have dropped out of the public eye.

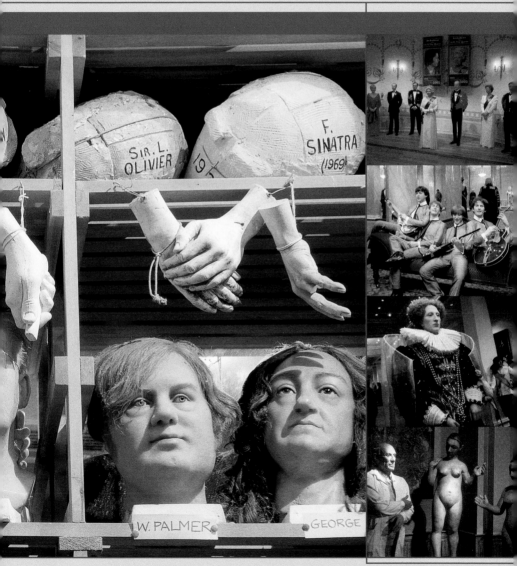

# THE HIGHLIGHTS: BLOOMSBURY AND CAMDEN

## TIP The Garden Café

In the heart of London, herons (below right) have taken up residence in the well-maintained greenery of Regent's Park. For stressed Londoners, the park is a refuge from the hustle and bustle of city life – all year round. On the edge of the park, the residents of Primrose Hill are particularly privileged – they get a fantastic view of the city (right).

This airy café in the middle of Regent's Park is not just a place to shelter from the rain. It's always worth popping in for breakfast, lunch, or afternoon tea.

*Inner Circle, Regent's Park, Westminster; Tel (020) 7935 5729; 10.00–sunset, daily; Underground: Regent's Park.*

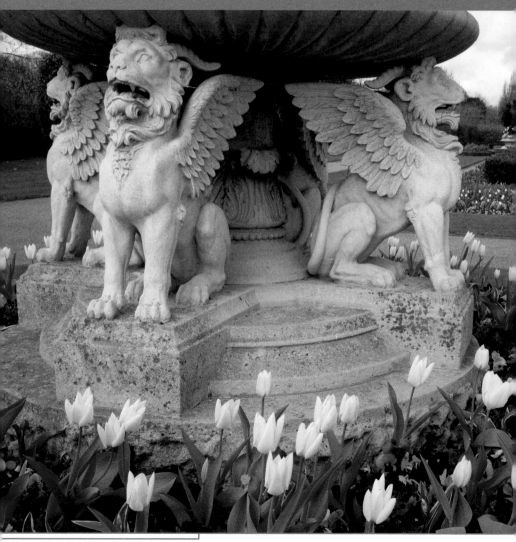

In 1818, the entire area of Regent's Park very nearly became a massive building site when the prince regent and future King George IV commissioned the architect, John Nash, to come up with a plan to develop this royal park. Nash designed a palace for his royal client, as well as handsome houses for the prince regent's friends, all to be surrounded by grand terraces that would complement the main buildings perfectly. The plan was only partially realized. Just eight of the proposed 56 houses were built, but the work did create the splendid park, 166 ha (410 acres) in size, we know today. It is the scene of all sorts of leisure activities, and home to some really noteworthy attractions. In its north-eastern corner, London Zoo is the oldest scientific zoo in the world. A canal marks the park's northern boundary, with Nash's elegant terraces lining its remaining sides.

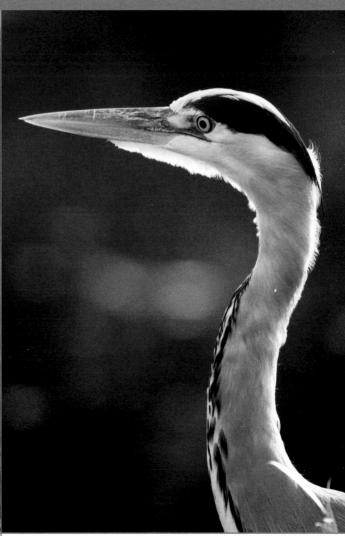

# THE HIGHLIGHTS: BLOOMSBURY AND CAMDEN

TIP Fogg's Restaurant

This cosy restaurant pays tribute to Jules Vernes' fictional hero with its menu of international dishes – served in far fewer than 80 days.

*18 Chalk Farm Road, Camden; Tel (020) 7428 0998; Mon–Thurs 17.00–22.15; Fri 12.00–23.00; Sat 8.15–23.00; Sun 8.15–21.45; Underground: Camden Town.*

Camden Lock is still operated manually (right). In Camden Town, you'll find a pub at almost every turn, alongside famous venues like the Electric Ballroom. The area's main attraction, however, is still its bright and buzzing markets selling all kinds of merchandise.

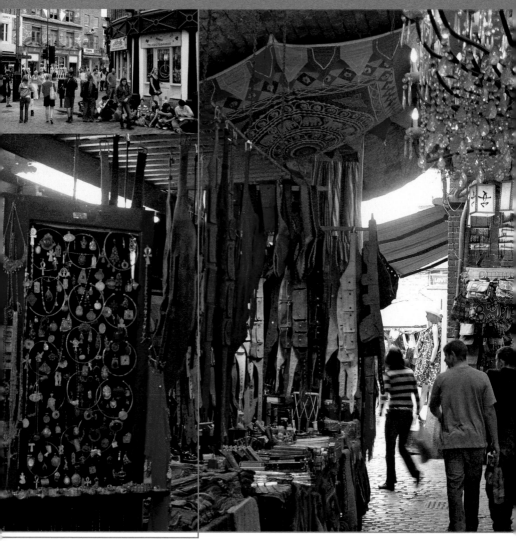

From punks to hippies and goths, Camden Town is paradise for fans of any weird and wonderful cultural scene. Located just off the Regent's Canal, this small area, once home to Irish immigrants and until recently a hotspot of the Britpop scene, has become a really trendy part of town. Today, Camden Town's markets and music clubs make it a destination in its own right. In among the piles of tacky tourist merchandise, you'll find alternative fashion (including lots of unique garments), crafts, bric-a-brac, and everything in between. When the market started in 1974, it was no more than a few arts and crafts stalls. Today, the stalls stretch from Camden Lock right into the side streets, sharing the space with countless restaurants and food stands that together represent every ethnic cuisine. At weekends, the crowds get so big that passengers at the Underground station have to be directed by officials.

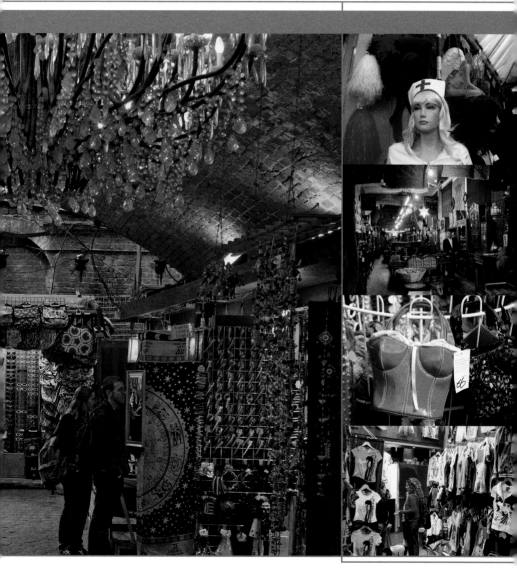

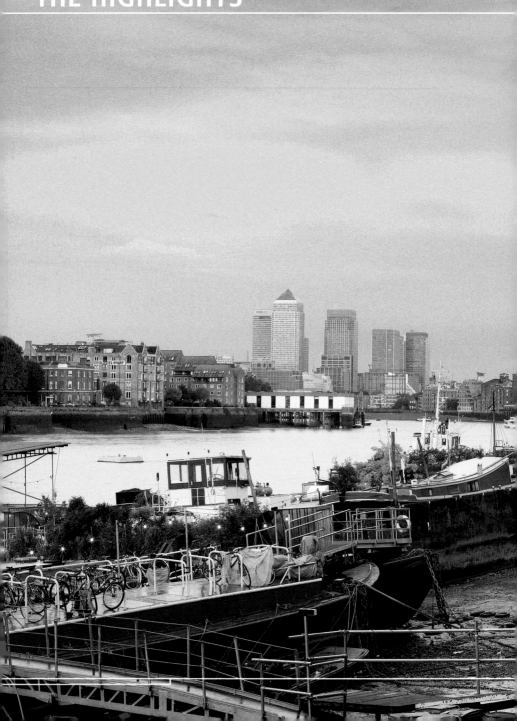

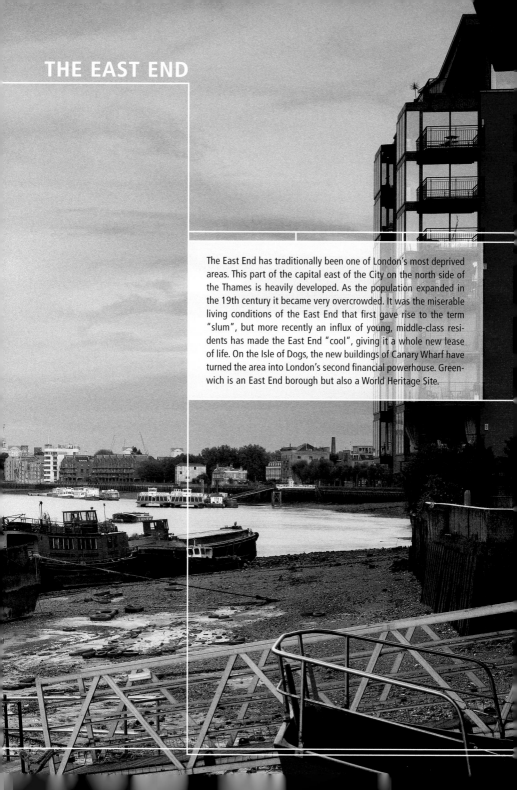

# THE EAST END

The East End has traditionally been one of London's most deprived areas. This part of the capital east of the City on the north side of the Thames is heavily developed. As the population expanded in the 19th century it became very overcrowded. It was the miserable living conditions of the East End that first gave rise to the term "slum", but more recently an influx of young, middle-class residents has made the East End "cool", giving it a whole new lease of life. On the Isle of Dogs, the new buildings of Canary Wharf have turned the area into London's second financial powerhouse. Greenwich is an East End borough but also a World Heritage Site.

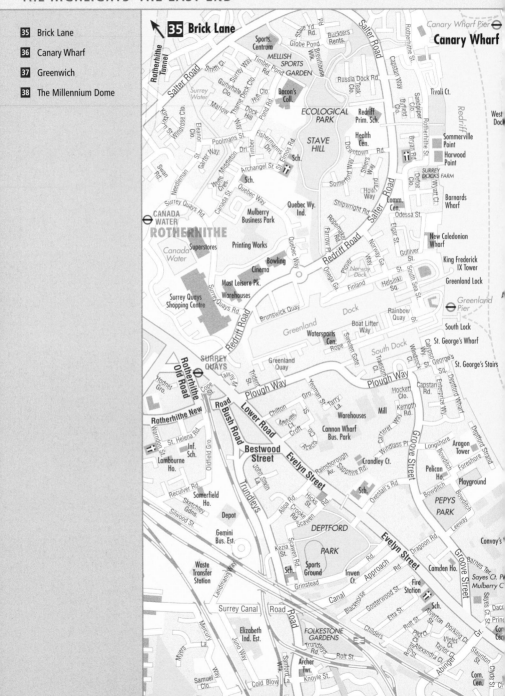

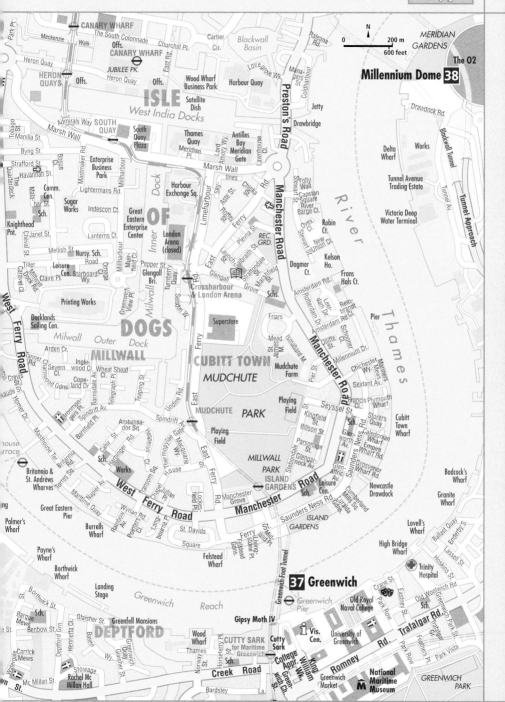

MERIDIAN GARDENS

The O2

**Millennium Dome 38**

CANARY WHARF
The South Colonnade
CANARY WHARF
JUBILEE PK.
Offs.
Heron Quay
Offs.
Mackenzie
Walk
Churchill Pl.
Cartier Cir.
Blackwall Basin
Raleana Rd.
Managers
St.
Coldharbour
Lovegrove Wk.
Drawbridge
Jetty
Drawdock Rd.

HERON QUAYS
Offs.
Heron Quay

ISLE
West India Docks

Wood Wharf Business Park
Harbour Quay
Preston's Road

Delta Wharf
Works
Blackwall Tunnel

Tobago St.
Admirals Way
SOUTH QUAY
Marsh Wall
Manilla St.
Byng St.
Strafford St.
Havannah St.
The Quarterdeck

South Quay Plaza

Thames Quay
Meridian Pl.
Lord Amory Wy.
Antilles Bay
Meridian Gate
Skylines
Chipka St.
Aste St.

Tunnel Av.
Tunnel Avenue Trading Estate

Tunnel Approach

Comm. Cen.
Malabar Ct.
Sch.
Sugar Works
Indescon Ct.

Enterprise Business Park
Lightermans Rd.

Marsh Wall

Victoria Deep Water Terminal

Knighthead Pnt.
Cheval St.
Janet St.
Tiller Rd.
Mellish St.
Nursy. Sch.
Leisure Cen.
Starboard Wy.

Harbour Exchange Sq.

Great Eastern Enterprise Center
Lanterns Ct.

London Arena (closed)

Plevna St.
Stewart St.
Byng
St.

River Thames

Robin Ct.
Kelson Ho.
Frans Hals Ct.

Caravel Cl.
Claire Pl.

Millharbour
Mur-.
Onega Gate

Pepper St.
Glengall Bri.

REC. GRD.

Strattondale
Marshfield
Grove
Schs.

Dagmar Ct.

New Union St.
Rembrandt
Cl.

Pier

Printing Works

Millwall
Inner Dock

Crossharbour & London Arena

Launch St.
Galbraith St.
Glengall
Grove

Friars
Mead St.
Amsterdam Rd.
Amsterdam Rd.
Rotterdam Dr.
Schooner
Cl.

DOGS
MILLWALL
Outer Dock

Docklands Sailing Cen.

Superstore

Ferry St.

Ferry St.

Mudchute Farm

Manchester Road

Isambard Pl.
Cliffe St.
Millennium Dr.
Chichester Wy.

Pier St.

Marsh Wall

CUBITT TOWN

MUDCHUTE

Francis
Plymouth
Wharf

Cubitt Town Wharf

Arden Cr.
Inglewood Cl.
Wheat Sheaf Cl.
Severn Cl.
Charnwood Gdns.
Copeland St.
Teaping St.
Telegraph Pl.

MUDCHUTE
PARK

Playing Field

Seyssel St.

Sextant Av.

Storers Quay

Ambassador Sq.
Spindrift Av.
Barnfield Pl.
Cahir St.
Harbinger Rd.
Macquarie
Wy.

East Ferry Rd.

Undine Rd.

Playing Field

Kingfield St.
Billson St.

Sch.
Rd.
Caledonian
Wharf
Empire
Wharf Rd.
Grosvenor
Wharf Rd.

Crews St.
Tanner St.
Homer Dr.
Spindrift Av.
Masthouse Ter.
Britannia Rd.
Thermopylae Gate
House

Chapel
House
St.

MILLWALL
PARK

Parsonage
St.
Glengarnock Av.
Stebondale
St.

Leisure Cen.

Cumberland
Mills Sq.
Lydia
Gdns.

Newcastle Drawdock

Badcock's Wharf

Britannia & St. Andrews Wharves
Torres St.
Maritime Quay
Napier Av.
Wynan Rd.
Rotherhithe
Transom Sq.
Lockesfield Pl.

ISLAND GARDENS

Manchester Grove

Saunders Ness Rd.
Sch.

Granite Wharf

Great Eastern Pier
Burrells Wharf
Rainbow Av.
Porters Rd.
Langbourne
Av.
St. Davids Square

West Ferry Road

Manchester Road

ISLAND GARDENS

Lovell's Wharf

Ballast Quay

Palmer's Wharf
Payne's Wharf
Borthwick Wharf

Landing Stage

Ferry St.
Living-
stone Pl.
Felstead Gdns.
Felstead Wharf

High Bridge Wharf

Enderby St.
Lassell St.

Greenwich Reach

Greenwich Foot Tunnel

**37 Greenwich**

Trinity Hospital

Hoskins St.

Borthwick St.
Sch.
Barque Mews
Benbow St.
Glaisher St.
Greenfell Mansions
Greenwell Mansions
Bisson

Greenwich Pier
Gipsy Moth IV

Old Royal Naval College
Crane St.
Park Row
Old Woolwich Rd.
Park Row

Trafalgar Rd.

Carrick Mews
Mc Millan St.
Stowage
Rachel Mc Millan Hall

DEPTFORD

Wood Wharf
Thames
St.
Norway
St.

CUTTY SARK for Maritime Greenwich
Cutty Sark

Vis. Cen.
University of Greenwich

King William Wk.
College Appr.

Romney Rd.
Park Vista
Feathers Pl.

Creek Road
Bardsley La.

Greenwich Market
National Maritime Museum

GREENWICH PARK

## THE HIGHLIGHTS: THE EAST END

The smell of curry wafts along Brick Lane. This is where the Occident meets the Orient head-on – a meeting that is sometimes accompanied by social tensions. Markets, buskers, graffiti, and women in bright clothes and headscarves dominate the urban scenery. It's a wonderful place to explore.

**TIP** Clifton Restaurant

With an abundance of curry houses round here, this one stands out for its stylish décor and the exceptional quality of its Bangladeshi dishes.

*1 Whitechapel Road, Tower Hamlets; Tel (020) 7377 5533; Sun–Wed 12.00–0.00; Thurs–Sat 12.00–1.00; Underground: Aldgate East.*

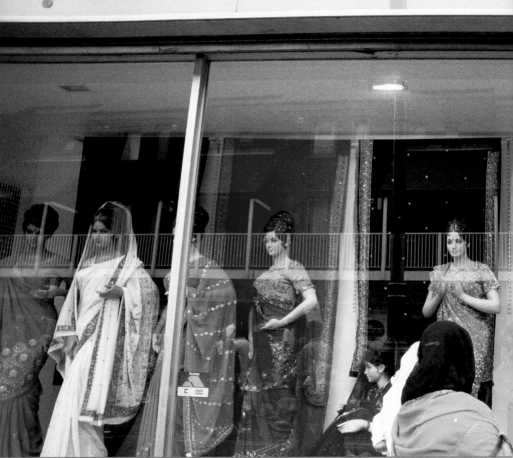

The vibrant cultural mix of many parts of the East End is thanks to the people who settled here from former British colonies, including India, Pakistan, and Bangladesh. Forced to find accommodation in the city's cheapest areas, they imbued them with their own culture and a touch of the exotic, enlivening London's drab streets. Locals call the area around Brick Lane, for example, Banglatown, in recognition of the area's large Bengali community. Today, this lengthy thoroughfare is a curry lover's paradise, its row of balti, tandoori, and curry restaurants interrupted only by a selection of sari stores, Asian grocery shops, and import-export businesses. Brick Lane's Sunday market is a much-loved haunt for anyone hunting down unusual items, and if it's independent young designer fashion you're after, then this multicultural street is an equally rewarding treasure trove.

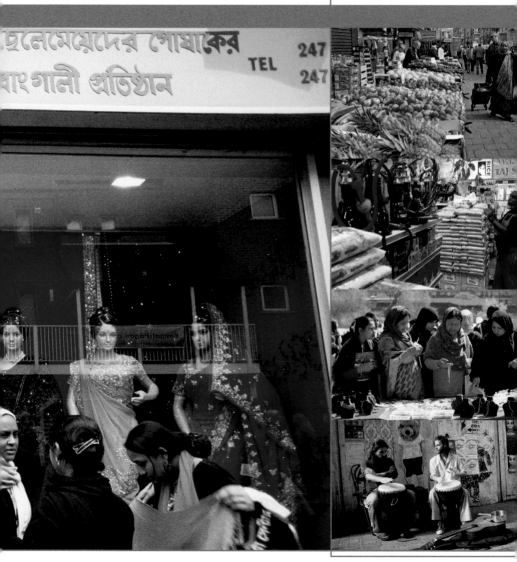

# THE HIGHLIGHTS: THE EAST END

## TIP Plateau

The three tallest skyscrapers in Britain form the heart of Canary Wharf: One Canada Square rises 235 m (771 feet) into the sky, while the HSBC Tower and Citigroup Centre are both 199 m (653 feet) high (main picture). Like the nearby Underground station (right), they are examples of London's most modern architecture.

The view from the fourth floor of One Canada Square is simply awesome, thanks to the glass walls. The modern French cuisine is a treat, too.

*Canada Place, Tower Hamlets; Tel (020) 7715 7100; Mon–Fri 12.00–15.00 and 18.00–22.30; Sat 18.00–22.30; Underground: Canary Wharf.*

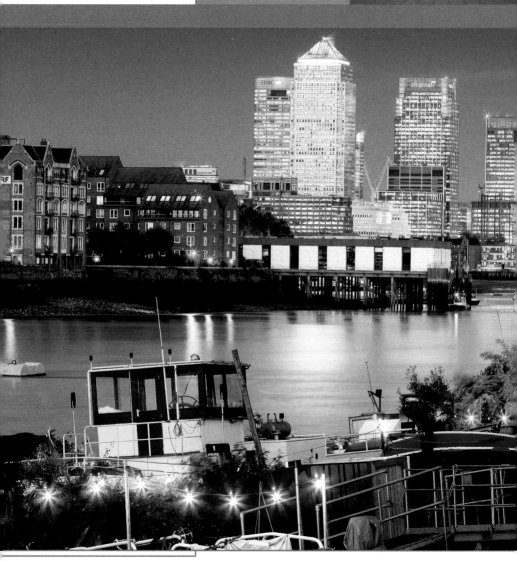

For nearly 200 years, the Isle of Dogs – the protruding section of land in a large meander of the River Thames – was London's busiest port. The area was not spared the destruction of World War II, and the docks – together with their rich heritage – were devastated in the bombing. But it was the introduction of containerization that was to be the final nail in the coffin of the docks. The end of the 20th century saw a dramatic rise in demand for modern office space and in 1988 – despite significant opposition – the construction of Canary Wharf on the run-down area of docklands commenced. The cluster of post-modern buildings would provide a new home for both international banks and leading media organizations. Today, it is not only a symbol of a resurgent world business power, but also an image of London's future – a must-see for all architecture enthusiasts.

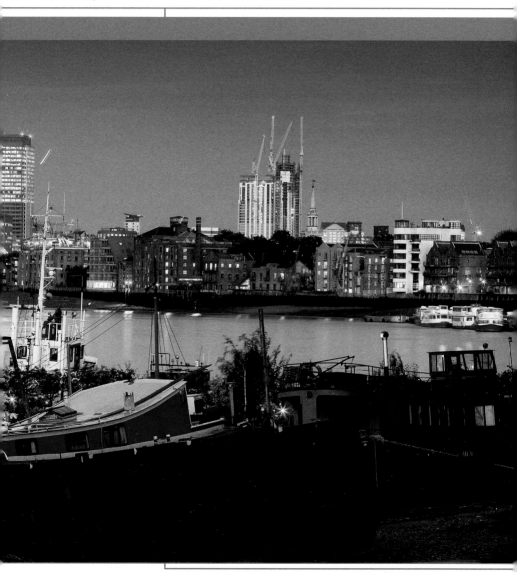

# THE HIGHLIGHTS: THE EAST END

## TIP The Trafalgar Tavern

From Greenwich Park, you can see over the Queen's House all the way to Canary Wharf (right). The zero meridian (below middle) runs through the Royal Greenwich Observatory (below left), which is now part of the National Maritime Museum. The Old Royal Naval College is open to the public (below right).

This old tavern is a sort of Victorian mini-castle, complete with a pleasant bar, good food, and a riverside terrace looking out to Canary Wharf.

*Park Row, Greenwich (train to Maze Hill); Tel (020) 8858 2909; Mon–Thurs 12.00–23.00; Fri–Sat 12.00–0.00; Sun 12.00–22.30.*

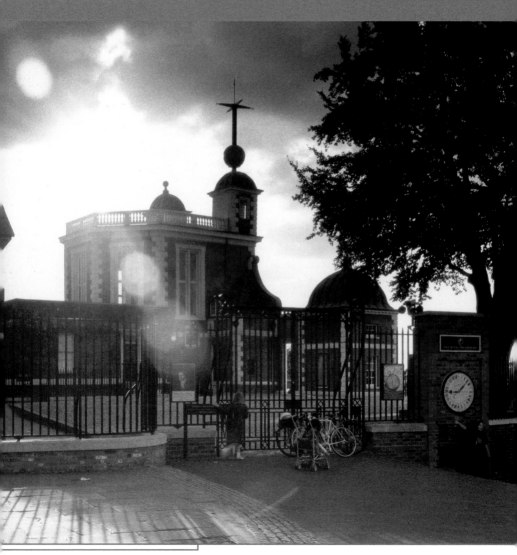

Greenwich is most famous for the zero meridian, which runs straight through the middle of the Royal Greenwich Observatory as if drawn with a ruler. Since 1 January 1885, this longitude has been the internationally recognized reference point for measuring time, and all longitude lines are also calculated to the east and west of Greenwich. But Greenwich's real claim to fame is really as a delightful little town within south-east London, declared a World Heritage Site in recognition of its great historic buildings. The British astronomer and architect Sir Christopher Wren built the Old Royal Naval College in the 17th century, and Greenwich soon became a popular summer haunt among the upper classes of the day. Over the centuries, the mansions, villas, and fine townhouses were built that still lend Greenwich its charming, informal elegance today.

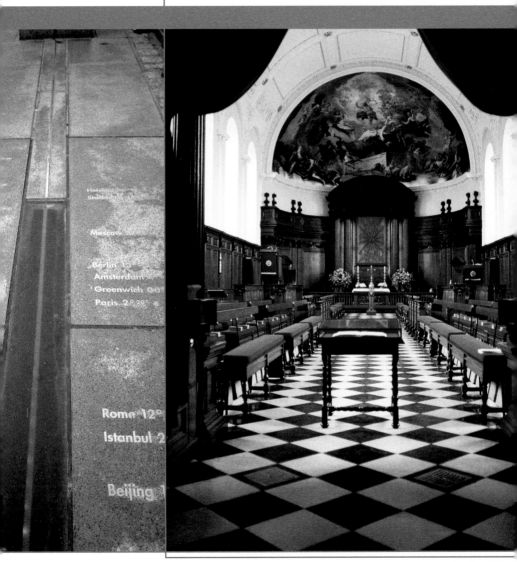

# THE HIGHLIGHTS: THE EAST END

**TIP** Gaucho O$_2$

The Millennium Dome lies on the Greenwich peninsula like a beached whale. It is a venue for spectacular concerts by some of the world's biggest pop stars. The Dome's major special exhibitions – such as the one on Tutankhamen in 2008 – are equally impressive, as, of course, are the sporting events held here.

There are many places to eat in the arena, but the Gaucho is without doubt the most stylish, and its Argentinean steaks and other meat dishes come highly recommended.

*The O$_2$ (Millennium Dome), Peninsula Square, Greenwich; Tel (020) 8858 7711; 12.00–0.00, daily; Underground: North Greenwich.*

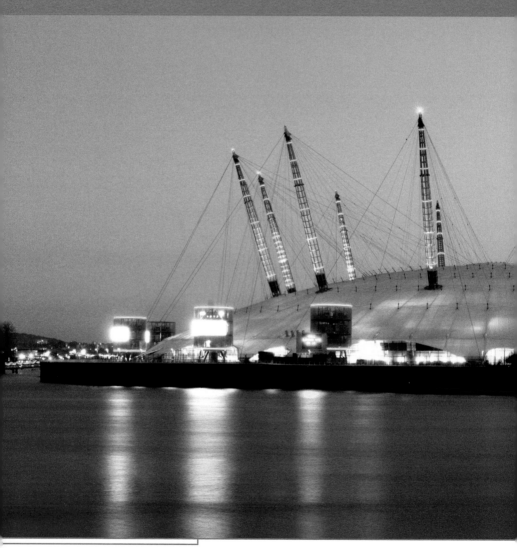

This huge tent-like building is – seen from the air, at least – one of the city's most recognizable landmarks. Located on the Thames, the Millennium Dome was the third of the three Millennium projects with which London marked the beginning of the 21st century, along with the London Eye big wheel and the Millennium Bridge. When it first opened, the world's biggest dome turned out to be a bit of a flop. The exhibition of mankind that it hosted – exploring our identity, actions, and habitat – closed after just one year, and nobody really knew quite what would become of the Dome until 2007, when a new name and role for the building was finally settled upon. The $O_2$ (named after its sponsor, the mobile phone network) is now London's biggest entertainment complex, combining exhibition space with an 11-screen digital cinema and a multi-purpose arena.

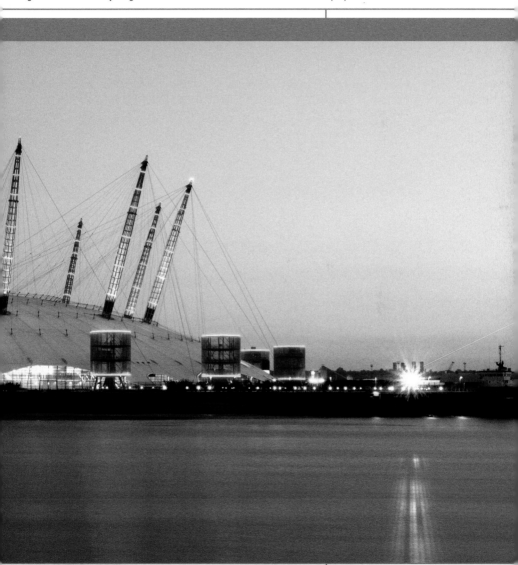

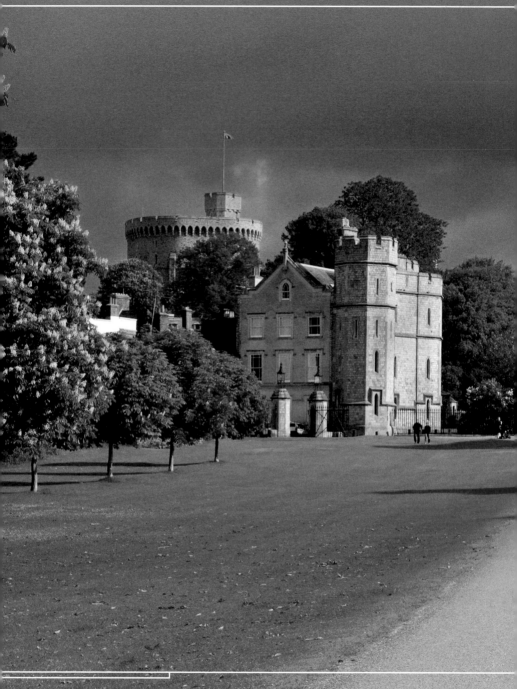

# BEYOND LONDON

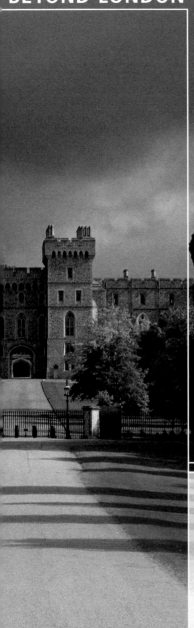

Beyond London lies a network of castles, houses, and estates, from grand palaces to modest mansion houses. Not all of these splendid buildings are open to the public – the British nobility is, after all, still very much in residence. The royal palaces, however, are at least partly accessible to visitors – the buildings are more than big enough for the royals' privacy to be maintained! Hampton Court has been little occupied by British kings and queens since the latter half of the 18th century, but Windsor Castle has been inhabited by royalty since the Middle Ages. The queen decided to make the castle her main weekend home when she came to the throne in 1952; it is often also now used for state banquets.

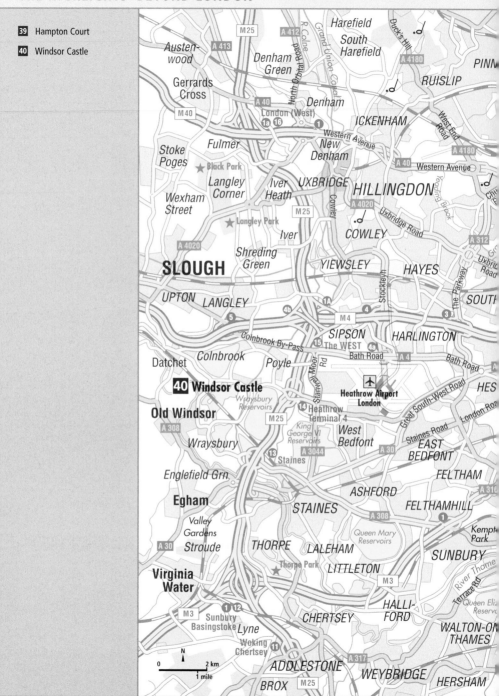

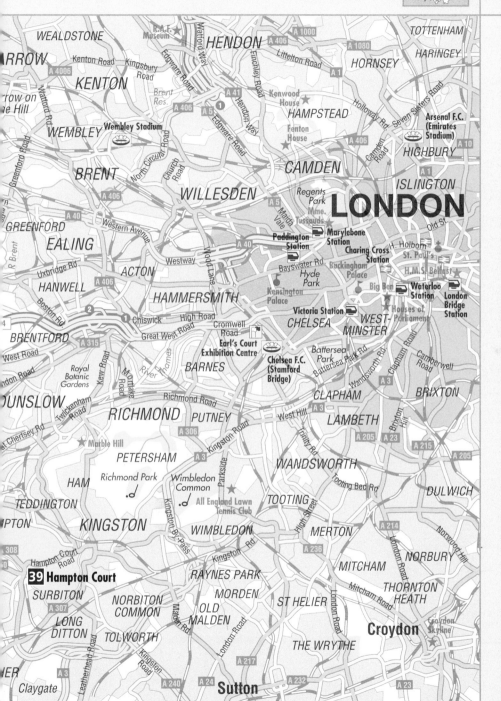

# THE HIGHLIGHTS:
BEYOND LONDON

The western façade of this Tudor palace represents English architecture at the height of its glory (right). The chapel (main picture) is still used for services today. The hallways, staircases, and the bedroom of Queen Mary, wife of William III of Orange, were designed by Sir Christopher Wren (pictures, below right).

**INFO** Concerts in the palace

**Every June, Hampton Court Palace provides the grand backdrop to the Hampton Court Festival. The event attracts top performers from the worlds of opera, classical music, jazz, rock, and the shows.**
*Hampton Court Palace (train to Hampton Court from Waterloo); for tickets, Tel (0844) 847 1638.*

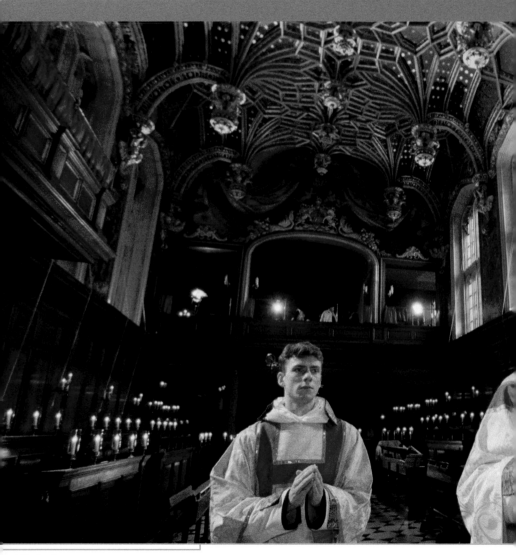

Like so many English palaces, Hampton Court was not originally built as a royal residence, but was instead later taken over by the crown. Over the centuries, various monarchs commissioned splendid extension and restructuring schemes to create what is now considered to be one of the most beautiful historic palaces in the London area. Cardinal Wolsey, Henry VIII's Lord Chancellor, acquired the 14th-century estate in 1514 and set about transforming it into a great Renaissance palace. When Wolsey later fell from grace, Henry VIII took Hampton Court for himself and extended and redesigned it in the Tudor style. Later, new wings were added, designed by the British architect Sir Christopher Wren. Among the palace's attractions are the Great Hall, which dates from 1532, the astronomical clock at the Anne Boleyn Gatehouse, the huge kitchens, and the Royal Tennis Court – not to mention the odd ghost or two.

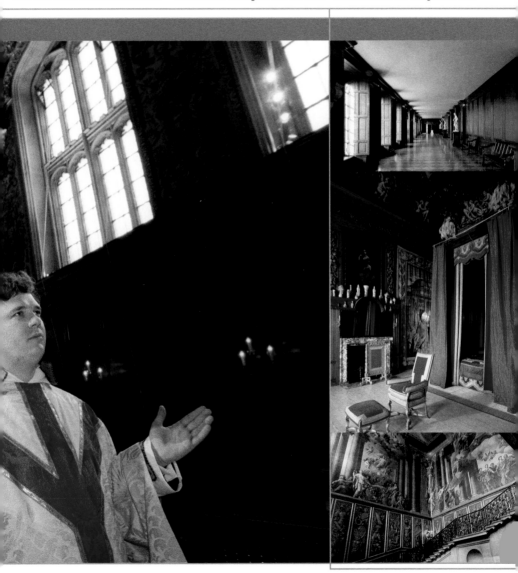

Queen Elizabeth II has been the head of state since 1952. At state occasions, a gold coach (below middle) transports the queen from Buckingham Palace (right). The ceremonial palace guards wear "bearskins", as their tall helmets made from the fur of Canadian bears are known (below right). At the Tower, the crown jewels are guarded by the Yeoman of the Guard, or "Beefeaters" (below left).

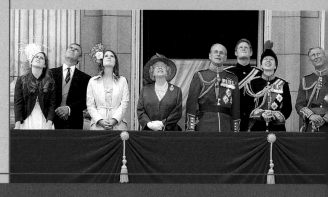

# THE ROYALS

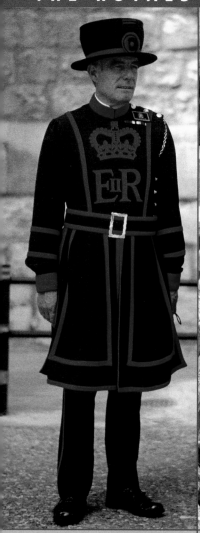

The 11-hour-long coronation ceremony of Queen Elizabeth II was the first major event to be watched by millions of television viewers across Europe. Since then, the British royal family has lost none of its fascination. Stories and scandals involving the royals always get people talking – giving the tabloid press a reliable circulation boost in the process. Events have certainly shaken the royal family's understanding of its place in British society, but the media is far from bringing down the House of Windsor. The queen has combined her adherence to rigid protocol with increasing efforts to appear less aloof. One example of this was the decision to put part of the royal art collection on public display in the newly renovated and expanded Queen's Gallery. Located within the south wing of Buckingham Palace, this rich collection includes paintings by Rembrandt, van Dyck, Canaletto, Titian, and Vermeer. In summer, some of the palace's living areas are also opened to visitors, with a collection of the queen's dresses on display. This charm offensive seems to have worked, and these glimpses behind palace doors saw top fashion magazine *Vogue* declare Queen Elizabeth one of the world's 50 most glamorous women. That said, the focus of press interest is increasingly on the young Prince William and his brother Harry, Prince Charles' sons from his marriage to Diana, Princess of Wales, who tragically died in a car crash in Paris in 1997.

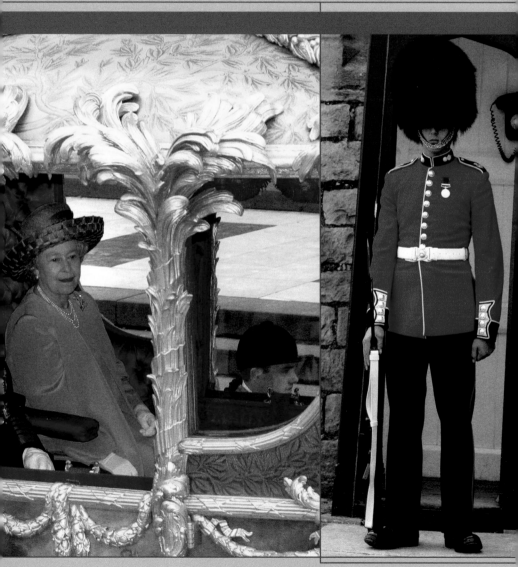

# THE HIGHLIGHTS:
## BEYOND LONDON

## TIP Windsor old town

St George's Chapel (right) is more reminiscent of a cathedral, and is a masterpiece of the late English Gothic. The splendid decoration of the imposing castle's rooms – including the Green Drawing Room (main picture), ballroom (below right, top), and Waterloo Chamber (below right, bottom) – is simply quite magnificent.

The splendid old town in Windsor boasts cobblestones, narrow streets, comfortable pubs, and the splendid Crooked House, complete with English Tea Room. It is as much of an attraction as the castle itself!
*Windsor Castle, Windsor Station (from Waterloo or Paddington Station).*

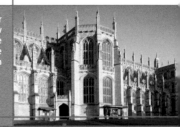

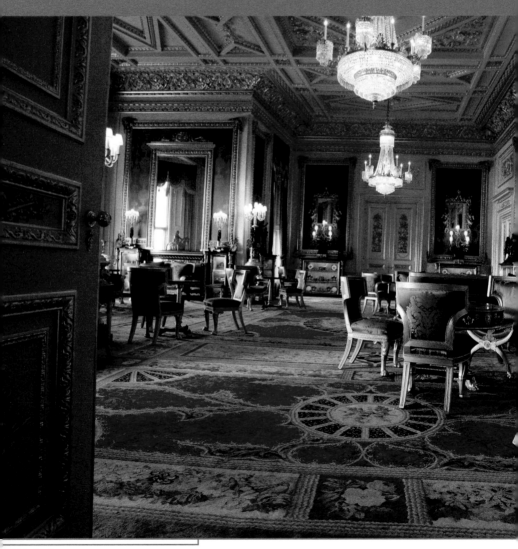

When the royal family needed a new name, it was to Windsor Castle that they turned for inspiration. Britain's oldest castle, it is also the one that has been occupied without interruption for the longest period. It has stood on this spot, to the west of London, for nearly a thousand years. Originally built as a fortress by William the Conqueror around 1070, Windsor has been extended, altered, and inhabited by a succession of kings, who variously used it as a fortress, prison, and garrison. The structure we see today mostly dates from the 14th century, when Edward III added the State Apartments, Round Tower, and Norman Gateway. The last major restructuring of the palace took place at the beginning of the 19th century, under King George IV. Alongside Holyrood in Edinburgh and Buckingham Palace in London, Windsor Castle is still one of the three official royal residences, and is Elizabeth's II preferred weekend retreat.

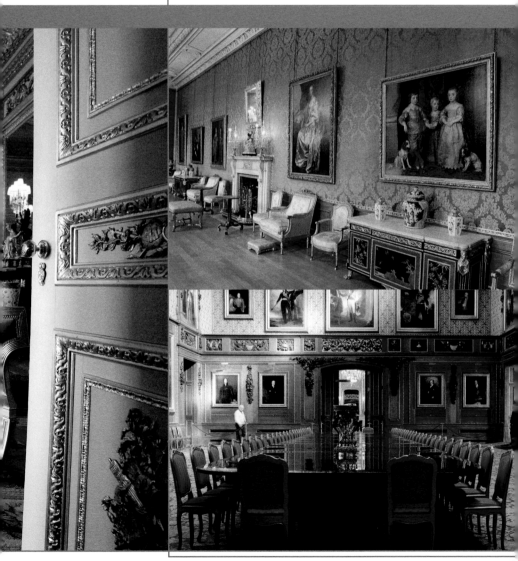

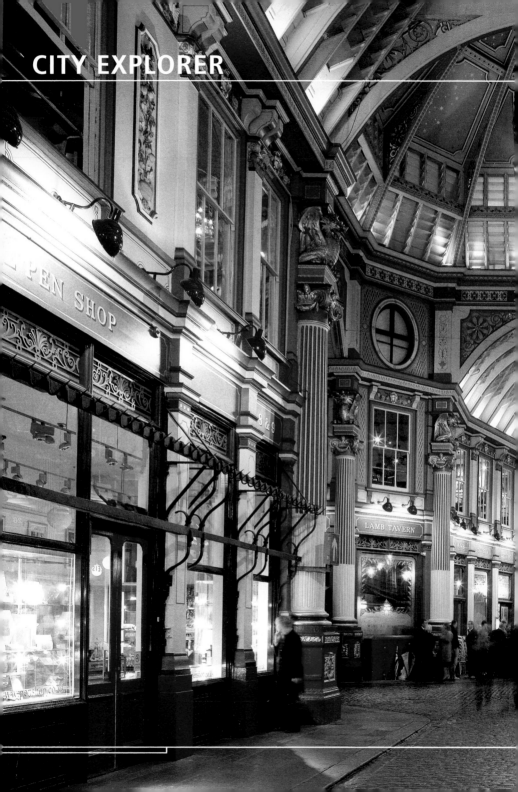

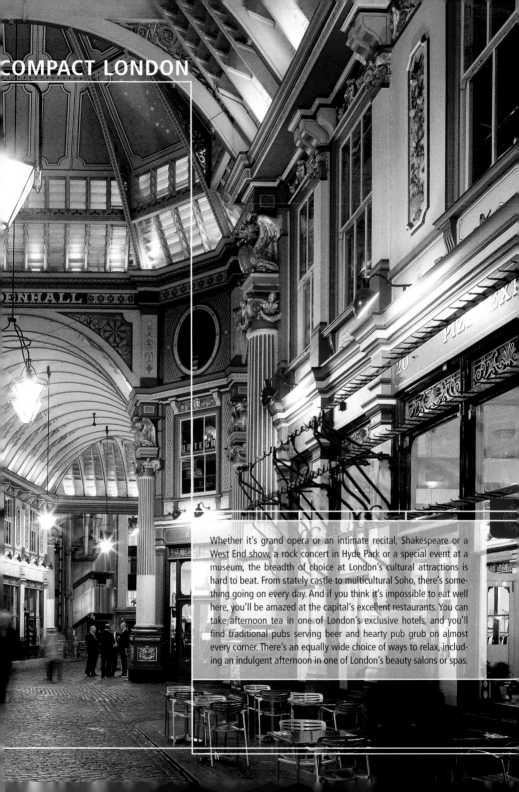

# COMPACT LONDON

Whether it's grand opera or an intimate recital, Shakespeare or a West End show, a rock concert in Hyde Park or a special event at a museum, the breadth of choice at London's cultural attractions is hard to beat. From stately castle to multicultural Soho, there's something going on every day. And if you think it's impossible to eat well here, you'll be amazed at the capital's excellent restaurants. You can take afternoon tea in one of London's exclusive hotels, and you'll find traditional pubs serving beer and hearty pub grub on almost every corner. There's an equally wide choice of ways to relax, including an indulgent afternoon in one of London's beauty salons or spas.

**Architectural contrasts: Leadenhall Market**

## Museums, music, and drama

### Dr Johnson's House
Samuel Johnson (1709–1784) is, after Shakespeare, one of the most quoted figures of English literature, and the author of the first English dictionary. Built in 1700, his former home is one of the oldest houses in the City. The memorabilia displayed inside and, above all, the faithfully restored décor of the house itself are well worth a visit.
*17 Gough Square,*
*Tel 7353 3745,*
*Mon–Sat 11.00–17.30;*
*11.00–17.00 in winter*
*www.drjohnsonshouse.org*

### Guildhall Art Gallery
Housed in the historic Guildhall, this gallery is home to an interesting collection of London-related paintings dating from the 17th century to the present day. There are also changing temporary exhibitions. One attraction you really shouldn't miss is located down in the basement: the fascinating remains of a Roman arena, discovered in 1988.

*Guildhall Yard,*
*Tel 7332 3700,*
*Mon–Sat 10.00–17.00;*
*Sun 12.00–16.00.*
*www.guildhall-artgallery.*
*org.uk*

### The Tower of London
The attractions on offer at the Tower of London are so riveting that you can easily spend a whole day here. You'll get an insight into the history of Britain since William the Conqueror, as well as a look inside the medieval palace and its gloomy dungeons – where numerous famous historic figures were once imprisoned. The Tower is also home to the famed British Crown Jewels (see p. 30).
*Tower Hill; Tel 7709 0765;*
*1 March–31 Oct Tues–Sat*
*9.00–17.30; Sun–Mon*
*10.00–17.30; 1 Nov–29 Feb*
*Tues–Sat 9.00–16.30;*
*Sun–Mon 10.00–16.30.*
*www.hrp.org.uk/*
*toweroflondon*

## Festivals and events

### City of London Festival
This wide-ranging festival, which includes performances of music, art, film, drama, and dance, takes place in various locations across the City – London's historic financial district – during June and July, attracting crowds of visitors as well as many renowned performers.
*Tel 7796 4949.*
*www.colf.org*

### Lord Mayor's Show
In 1215, the Magna Carta of King John gave Londoners the power to elect their own mayor. The chosen candidate was required to swear allegiance to the sovereign, and this tradition has been maintained on the second Saturday in November every year since that time, when the mayor proceeds to the Royal Courts of Justice on the Strand in order to swear the oath. Although the mayor still dons full regalia and rides in a state carriage with great ceremony for the show, the event is now more carnival than state occasion.
*www.lordmayorsshow.org*

## Shopping

### Antique Watch Repair
They've been selling and repairing watches here for more than 200 years. You'll find old and classic timepieces by top watchmakers like Breitling, Rolex, Porsche, Eberhard, Longines, Cartier, Heuer, and others. The watches in the shop's bargain corner, meanwhile, are less glamorous, but still of equally high quality. But it is watch repair and cleaning that is the shop's primary focus – whatever the make.
*19 Clerkenwell Road,*
*Tel 7250 3734.*
*www.antiquewatchcouk.com*

### Barbican Chimes Music Shop
This independent music shop places great importance on the quality of its service and the breadth of its range. You'll find musical instruments, books, and sheet music for everyone from amateurs to concert virtuosos.
*Cromwell Tower, Silk Street,*
*Tel 7588 9242.*
*www.chimesmusic.com/*
*barbican*

### Precious
That this little boutique is as precious as its name suggests is evidenced by the fact that it only opens for a few hours every Sunday. The shop sells the very best in designer fashion, alongside a selection of carefully chosen accessories. The service is extremely personal, the staff knowledgeable and friendly.
*98 Columbia Road,*
*Tel 7377 6668,*
*Sun 9.30–15.00.*

### Source Lifestyle
It's everything that a woman doesn't really need, but can't quite resist. Accessories from bags to shoes and costume jewelry, home furnishings, and gift items are all here. Some are mass-produced; others are individual pieces, but all have bright and original design in common.
*6 Market Street,*
*Tel 7377 6382,*
*Mon–Fri 9.00–17.30.*
*www.sourcelifestyle.com*

## Eating and drinking

### New Armouries Restaurant
It's not exactly gourmet dining, but this restaurant does offer relatively good value refreshments inside the

# THE CITY OF LONDON

In this section, you'll find additional insider tips about the sights featured in the Highlights chapter (see pp. 24–49). (For London numbers dial 020.)

Tower. On the menu are salads, sandwiches, and a selection of hot snacks. It's an ideal place for a break after a long visit to the Tower.
*Tower of London, Tower Hill, March–Oct 10.00–17.00, daily; Nov–Feb 10.00–16.00, daily.*

### Bonds
This chic restaurant located in the financial district attracts an equally trendy – and suitably wealthy – clientele. The restaurant's opening times match the working patterns of the City, and early-risers are just as well catered for as diners coming in for a business lunch or full evening meal. The cuisine is modern French and always makes a point of using the freshest local ingredients.
*5 Threadneedle Street, Tel 7657 8090, Mon–Fri 6.30–10.00, 12.00–14.30, and 18.00–22.00; Sat–Sun 7.30–11.00 and 18.00–22.00.*
*www.theetoncollection.com/restaurants/bonds*

### Browns Bar and Brasserie
Browns serves the City with a menu of good, unpretentious, mostly English dishes. Children and diners on a tighter budget will also feel at home.
*8 Old Jewry, Tel 7600 5359, Mon–Fri 8.00–22.00; Sat 15.00–18.00 (afternoon tea only).*
*www.brownsrestaurants. com/menu-oldjewry.php*

### Paul
Another eating option within the Tower. Paul is a French café chain, serving cakes, pastries, and – of course – coffee.

Alternatively, choose from Paul's salads, baguettes, and various hot snacks.
*Tower Wharf, 8.00–18.00, daily.*

### Refettorio
The restaurant's refectory-style dining table is the focal point of its stylish, elegant dining area. The table is ideal for large groups, or anyone seeking to strike up conversation with strangers, but if you prefer a little more privacy there are smaller tables to the side. On the menu, you'll find the finest in Italian cuisine.
*Crown Plaza, 19 New Bridge Street, Tel 7438 8052, Mon–Fri 12.00–14.30 and 16.00–22.30; Sat 18.00–22.30.*
*www.refettorio.com*

### The Chancery
This is one of the City's more exclusive restaurants, popular with City lawyers. The atmosphere may be a little stiff and corporate for some tastes, but the food is exquisite. Don't miss the seafood and traditional English desserts.
*9 Cursitor Street, Tel 7831 4000, Mon–Fri 12.00–14.30 and 18.00–22.30.*
*www.thechancery.co.uk*

## Accommodation

### 196 Bishopsgate
This small but perfectly formed aparthotel combines the independence of having your own small apartment with the convenience of full hotel service – they'll even buy your groceries for you. Located in the heart of the financial district, close to the City sights, it caters for tourists as well as business visitors.

*196 Bishopsgate, Tel 7621 8788.*
*www.196bishopsgate.com*

### Grange City Hotel
This chic and modern 5-star hotel boasts over 300 rooms, a fitness suite, swimming pool, and several restaurants. Moments away from Tower Bridge, the hotel's guests also enjoy a fantastic view over both the bridge and other nearby sights.
*8–14 Cooper's Row, Tel 7863 3700.*
*www.grangehotels.co.uk*

### The King's Wardrobe by BridgeStreet
This aparthotel is situated on a quiet square just behind St Paul's Cathedral. Light and airy, the stylish apartments also come with round-the-clock service and covered parking.
*6 Wardrobe Place, Carter Lane; Tel (0845) 2269 831;*
*www.citybaseapartments. com*

### Threadneedles
Housed in a 19th-century banking hall, this is a real gem of a hotel. A hand-painted glass dome is the crowning glory of the hotel's spectacular lobby, and its 70 generously proportioned rooms all provide 5-star comfort with an individual touch. Breakfast is fantastic, too – whether English, American, or continental.
*5 Threadneedle Street, Tel 7657 8080.*
*www.theetoncollection.com*

## Nightlife

### Fabric
This London superclub is among the city's finest. Every

weekend, its large rooms play host to the best gigs and parties featuring both new and established artists. Be prepared for long queues at the door.
*77A Charterhouse Street, Tel 7336 8898, Fri–Sun 22.00–5.00.*
*www.fabriclondon.com*

### Jamaica Wine House
This site in the oldest part of London was once home to England's very first coffee house. The coffee house was burnt down in the Great Fire, and the Victorian building that now stands here houses a lively pub with a typically British atmosphere.
*12 St Michael's Alley, Tel 7626 9496, Mon–Fri 11.00–23.00.*

### Vertigo 42
England's highest bar occupies the 42nd floor of Tower 42, and offers a commanding view over the city beneath – especially seen from the building's south side. At the bar, the rich and powerful enjoy cocktails, champagne, and oysters. Reservation is essential – not to mention deep pockets.
*25 Old Broad Street, Tel 7877 7842, Mon–Fri 12.00–15.00 and 17.00–22.00.*

### Ye Olde Cheshire Cheese
A wonderful old 17th-century pub on a narrow City lane. The building is a charming maze of rooms, and its vaulted cellars – unfortunately not open to the public – date back even further.
*145 Fleet Street, Mon–Fri 11.00–23.00; Sat 12.00–23.00; Sun 12.00–17.00.*

## Museums, music, and drama

### Adelphi Theatre
Few West End venues boast a heritage as rich as that of the Adelphi, which has been welcoming audiences for 200 years. Today, it stages mostly comedies and musicals.
*Strand; Tel 7344 0055.*
*www.adelphitheatre.co.uk*

### The National Gallery
Works by more than 2,000 of Europe's greatest painters are on display here, including world-famous masterpieces such as van Gogh's *Sunflowers* and Monet's *Water-Lilies* (see p. 62 and p. 170).
*Trafalgar Square,*
*Tel 7747 2885,*
*Thurs–Tues 10.00–18.00;*
*Wed 10.00–21.00.*
*www.nationalgallery.org.uk*

### The National Portrait Gallery
A visual *Who's Who* of British history. From kings to poets, heroes, and villains, you can put a face to them all here (see p. 62).
*St Martin's Place,*
*Tel 7306 0055,*
*Sat–Wed 10.00–18.00;*
*Thurs–Fri 10.00–21.00.*
*www.npg.org.uk*

### Handel House Museum
Composer George Frideric Handel lived in this house for 36 years until his death in 1759. The rooms have been carefully restored and now house an exhibition of letters, sculptures, and other items.
*25 Brook Street,*
*Tel 7495 1685,*
*Tues–Sat 10.00–18.00;*
*Thurs 10.00–20.00; Sun 12.00–18.00.*
*www.handelhouse.org*

### The Queen's Gallery
Art and ornaments from the collections of four centuries of British monarchs are displayed in the regal surroundings of Buckingham Palace.
*South wing,*
*Buckingham Palace,*
*Tel 7766 7300,*
*10.00–16.30, daily.*
*www.theroyalcollection.com*

### St Martin's Theatre
A cult destination for fans of a good murder mystery, Agatha Christie's *The Mousetrap* has been playing here for over 56 years – a world record 23,000 performances.
*West Street; Tel 7836 1443.*
*www.the-mousetrap.co.uk*

### The Royal Opera House
John Gay's *Beggar's Opera* was first performed in the original opera house here in 1728, with Handel's oratorios following later. Since then, this has become one of the world's leading opera houses.
*Bow Street; Tel 7304 4000.*
*www.roh.org.uk*

### Theatre Royal Drury Lane
Dating from 1663, London's oldest playhouse was, in the 18th century, also one of its most important. It now belongs to Andrew Lloyd Webber.
*Catherine Street; Tel 7494 5060; www.theatreroyal-drurylane.co.uk*

### Theatre Royal Haymarket
London's second oldest playhouse dates from 1720, and is a must for keen playgoers.
*Haymarket; Tel (0870) 901 3356; www.trh.co.uk*

### London Transport Museum
From horse-drawn coaches to London black cabs, the first Underground train, and the famous red double-decker buses – the museum is a chance to admire and even climb aboard all sorts of vehicles used by London's public transport network.
*Covent Garden Piazza,*
*Tel 7379 6344,*
*Sat–Thurs 10.00–18.00;*
*Fri 11.00–18.00.*
*www.ltmuseum.co.uk*

## Festivals and events

### Beating the Retreat
Over two successive evenings at the beginning of June, this ceremony at Whitehall marks the return of the queen's mounted guards to their barracks. It's an occasion of great pomp, accompanied by military bands.

### Chinese New Year
Each year around the end of January, London's Chinese community celebrates Chinese New Year with a spectacular parade.
*www.chinatownonline.co.uk*

### London Parade
On New Year's Eve, half the population of London seems to converge on Trafalgar Square to ring in the new year. Then at midday on New Year's Day, Europe's biggest street parade sets off from Parliament Square, ending up at Piccadilly.
*www.londonparade.co.uk*

### Pride
London's annual gay and lesbian parade through the West End takes place around the end of June and beginning of July. With its extravagant costumes, the event brims with an unfettered zest for life.
*www.pridelondon.org*

### Soho Festival
Held in the middle of July, this is, by London standards, a relatively small-scale festival. You'll find lots of market stalls, all sorts of entertainment, and plenty to eat and drink.
*www.thesohosociety.org.uk*

### Trooping the Colour
Trooping the Colour takes place on the second and third Saturday in June to mark Queen Elizabeth II's official birthday (her actual birthday is in April). The main event is a military parade before the queen herself.
*www.royal.gov.uk*

## Sport, games, and fun

### Hyde Park Stables
Discover Hyde Park on horseback. There are some 8 km (5 miles) of bridle paths and riding lessons are available, boots and riding hats provided.
*63 Bathurst Mews, Hyde Park; Tel 7723 2813.*
*www.hydeparkstables.com*

### Somerset House
Every winter, the courtyard of Somerset House is transformed into a festive ice rink.
*The Strand; Tel 7845 4600.*
*www.somersethouse-icerink.org.uk*

## Health and beauty

### Aveda Institute
Aveda specializes in holistic beauty treatments using botanically based products. The institute offers hairdressing, massage, and facials as well as beauty and relaxation treatments.
*174 High Holborn, Covent Garden; Tel 7759 7355,*

From left: The Palace of Westminster; horseback statue and fountain on Trafalgar Square; the fountains in the central inner courtyard of Somerset House; the Royal Opera House.

In this section, you'll find additional insider tips about the sights featured in the Highlights chapter (see pp. 50–81). (For London numbers dial 020.)

*Mon–Wed 9.00–19.00;*
*Thurs–Fri 8.00–20.00; Sat*
*9.00–18.30; Sun 11.00–16.00.*
*www.aveda.co.uk*

### Relax
Whether it's for tired feet or a tense back, you can choose from over 20 different types of massage therapies at Relax – the perfect antidote to a stressful day's sightseeing.
*65 Brewer Street, Soho,*
*Tel 7494 3333,*
*Mon–Sat 10.00–21.00;*
*Sun 12.00–20.00.*
*www.relax.org.uk*

### The Porchester Spa
Enjoy the facilities of this art deco spa – they include a swimming pool, gym, Finnish sauna, steam rooms, and an ice-cold plunge pool.
*Porchester Centre,*
*Queensway, Westminster,*
*Tel 7792 3080,*
*10.00–22.00, daily; women*
*Tues, Thurs, and Fri; men*
*Mon, Wed, and Sat*

### The Sanctuary
A women-only spa in the heart of town, offering a swimming pool, sauna, massage, and beauty treatments.
*12 Floral Street, Soho,*
*Tel (0870) 770 3350,*
*Mon–Tues 9.30–18.00;*
*Wed–Fri 9.30–22.00; Sat–Sun*
*9.30–20.00.*
*www.thesanctuary.co.uk*

## Shopping

### Burlington Arcade
Built in 1819, this is the world's first – and Britain's most beautiful – shopping arcade.
*Piccadilly,*
*Mon–Fri 9.30–17.30;*
*Sat 10.00–18.00.*
*www.burlington-*
*arcade.co.uk*

### Covent Garden Market
Formerly London's fruit and vegetable market, the present hall houses a wide range of shops and boutiques (see p. 56)
*Covent Garden,*
*Mon–Sat 10.00–19.00; Sun*
*11.00–18.00; bars, cafés,*
*and restaurants 9.30–23.00.*
*www.coventgardenmarket.*
*co.uk*

### James Smith & Sons
This London umbrella store is steeped in tradition, with a fine range of handmade umbrellas to choose from.
*53 New Oxford Street,*
*Mon–Fri 9.30–17.30;*
*Sat 10.00–17.30.*
*www.james-smith.co.uk*

### R. Twining & Company
A quintessentially British tea-shop, selling a huge variety of teas since 1706.
*216 The Strand.*
*www.twinings.com*

### Topshop
The popular young fashion store. If it appears on the world's catwalks, you'll find an affordable version on sale here shortly afterward.
*36–38 Great Castle Street.*
*www.topshop.co.uk*

### Vintage House
A family business stocking 1,400 types of Scottish malt whisky and 30 types of Irish whiskey.
*42 Old Compton Street,*
*Mon–Wed and Fri–Sat*
*9.00–20.00; Thurs 9.00–21.00;*
*Sun 12.00–18.00.*
*www.vintagehouse.co.uk*

### Vivienne Westwood
This boutique showcases the latest garments by the fashion icon and one-time punk, Vivienne Westwood (see p. 94).

*44 Conduit Street,*
*Mon–Sat 10.00–18.00;*
*Thurs 10.00–19.00.*
*www.viviennewestwood.com*

## Eating and drinking

### Back to Basics
A menu of fish, fresh every day and prepared with aplomb.
*21a Foley Street, Soho,*
*Tel 7436 2181,*
*Mon–Sat 12.00–15.00 and*
*18.00–22.30.*
*www.backtobasics.uk.com*

### The Ivy
This unpretentious-looking restaurant has been *the* place for celebrities for years, and you'll often find the paparazzi hanging around outside.
*1 West Street, Covent Garden;*
*Tel 7836 4751; 12.00–15.00*
*and 17.30–0.00, daily.*
*www.the-ivy.co.uk*

### Lindsay House
Housed in an 18th-century building, this restaurant serves sophisticated British cuisine.
*21 Romilly Street, Soho,*
*Tel 7439 0450; Mon–Fri*
*12.00–14.30 and 18.00–23.00;*
*Sat 18.00–23.00.*
*www.lindsayhouse.co.uk*

### Veeraswamy
The oldest Indian restaurant in London, opened in 1926, its clients include aristocrats, politicians, and movie stars.
*99 Regent Street, Soho,*
*Tel 7734 1401,*
*Mon–Sat 12.30–14.15 and*
*17.30–22.30; Sun 12.30–*
*14.30 and 18.00–22.00.*
*www.veeraswamy.com*

## Accommodation

### Courthouse Hotel Kempinski
This elegant building was once a courthouse. Today it is

a sophisticated luxury hotel.
*19–21 Great Marlborough*
*Street, Soho; Tel 7297 5555.*
*www.courthouse-hotel.com*

### The Ritz
The Ritz has been synonymous with grandeur and luxury for over a century – so much so, in fact, that "ritzy" has entered the language to describe something expensively stylish (see p. 78).
*150 Piccadilly, Mayfair,*
*Tel 7493 8181.*
*www.theritzlondon.com*

### The Rookery
A cozy hotel that combines beautiful Victorian decor with all modern comforts.
*Peter's Lane, Cowcross*
*Street; Clerkenwell;*
*Tel 7336 0931.*
*www.rookeryhotel.com*

### Zetter
A stylish, charmingly extravagant hotel on the nothern boundary of the West End.
*86–88 Clerkenwell Road,*
*Clerkenwell; Tel 7324 4444.*
*www.thezetter.com*

## Nightlife

### Freud
Spoil yourself with a delicious cocktail in this cellar bar. The building once provided Sigmund Freud with his first London home.
*198 Shaftesbury Avenue,*
*Covent Garden; Mon–Wed*
*11.00–23.00; Thurs 11.00–*
*1.00; Fri 11.00–2.00; Sat*
*11.00–1.00; Sun 12.00–22.30.*

### Salt Whisky Bar
An elegant bar serving a selection of fine whiskies and whisky cocktails.
*82 Seymour Street, Mayfair,*
*Mon–Sat 18.30–0.00.*

# CITY EXPLORER: COMPACT LONDON

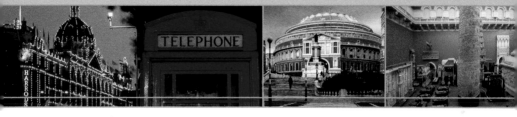

## Museums, music, and drama

### The Royal Albert Hall
This grandiose circular hall is a venue for a wide range of events, from rock and pop to opera, symphonies, ballet, tennis, and banquets. The famous Proms – a series of classical concerts – take place from the end of July to the middle of September each year, culminating in the famous "Last Night of the Proms" – a lively national spectacle (see p. 92).
*Kensington Gore,*
*Tel 7838 3105.*
*www.royalalberthall.com*

### Opera Holland Park
Each year, from June to August, opera productions are performed under a giant tent in one of London's most desirable areas. In contrast to the opera houses, the atmosphere is really relaxed – you can even have a picnic.
*Holland Park,*
*Tel (0845) 230 9769.*
*www.operahollandpark.com*

## Festivals and events

### Chelsea Flower Show
In the last week of May, the grounds of the Royal Hospital Chelsea are transformed into a work of horticultural art, with gardeners from far and wide competing for the hotly-contested top prizes.
*www.rhs.org.uk*

### Notting Hill Carnival
August bank holiday weekend – the last Sunday and Monday of August – sees Notting Hill come alive with a spectacular and exuberant display of Afro-Caribbean life and culture that leaves no street in this highly desirable area untouched by the party spirit.
*www.nottinghillcarnival.org.uk*

## Sport, games, and fun

### Canal Side Activity Centre
Hire a boat, kayak, or canoe, and use on the Grand Union Canal. There are also numerous courses for children.
*Canal Close, North Kensington; Tel 8968 4500.*

### The Westway Climbing Wall
Situated beneath the Westway overpass in west London, this is Britain's biggest climbing complex. It's set over an area of 2,000 sq m (21,528 sq yards).
*1 Crowthorne Road, Kensal Green; Tel 8969 0992.*
*www.westway.org/sports/wsc/climbing*

## Health and beauty

### Bliss London
Stayed out too late? Cellulite starting to show? First signs of wrinkles? These and other problems are tackled with massages, oils, and other treatments at Bliss. Professional hand and foot care is also available.
*60 Sloane Avenue, Chelsea, Tel 7584 3888,*
*Mon–Fri 9.30–20.00 (12.30–20.00 every other Wed); Sat 9.30–18.30; Sun 12.00–18.00.*
*www.blisslondon.co.uk*

### Earthspa
There's a Moroccan twist to the treatments awaiting stressed-out customers in search of rejuvenation and pampering at Earthspa. Mud baths, massages, beauty therapies, and other treatments work with the relaxing atmosphere to recharge body and soul alike.
*4 Eccleston St, Belgravia, Tel 7823 6226,*
*Mon–Fri 10.00–20.00; Sat 10.00–17.00.*
*www.earth-spa.co.uk*

### Elemis Day Spa
This luxury spa boasts several themed areas, including therapy rooms inspired by the cultures of Bali and Morocco. Facilities and services include comprehensive beauty care, steam baths, massages, fango packs, and much more besides. The spa specializes in treatments for couples.
*2–3 Lancashire Court, Mayfair; Tel 8909 5060;*
*Mon–Sat 9.00–21.00; Sun 10.00–18.00.*
*www.elemis.com*

### Hydrohealing
This plain but elegant spa is dedicated to the healing power of water. Treatments include mud and algae baths, floatation tanks, and steam scrubs.
*216 Kensington Park Road, Notting Hill; Tel 7727 2570;*
*Mon–Thurs 10.00–21.00; Fri–Sat 10.00–20.00; Sun 11.00–18.00.*
*www.hydrohealing.com*

### Spa Illuminata
It's not exactly cheap, but it is practically guaranteed to relax you – thanks in no small part to the extremely stylish presentation. Alongside body and facial treatments, you can also let the salon's beauticians apply the perfect make-up for a special occasion.
*63 South Audley Street, Mayfair; Tel 7499 7777;*
*Mon 10.00–18.00; Tues 10.00–19.00; Wed–Thurs 10.00–21.00; Fri 10.00–19.00; Sat–Sun 10.00–18.00.*
*www.spailluminata.com*

## Shopping

### Antiquarius
This former gentlemen's club is a sort of antique shopping arcade. You'll find books, art, clothes, furniture, jewelry and watches, household items, and collectables. It's all top quality, so expect top prices.
*131–141 King's Road, Mon–Sat 10.00–18.00.*
*www.antiquarius.co.uk*

### Lulu Guinness
Star designer Lulu Guinness creates fashionable handbags with that little extra something – more playful than practical. The shop also sells a range of original accessories.
*3 Ellis Street,*
*www.luluguinness.com*
*Mon–Fri 10.00–18.00; Sat 11.00–18.00*

### Rococo
English chocolate? The phrase tends to conjure up images of bars made with everything but real cocoa. That's not the case at Rococo. The shop sells a wide range of the finest chocolate creations, from Swiss truffles to English classics like lavender and violet creams.
*321 King's Road, Mon–Sat 9.00–19.00; Sun 12.00–18.00.*
*www.rococochocolates.com*

### Stella McCartney
Stella McCartney, daughter of Beatle Paul, designs stylish and wearable women's fashion that flatters every body shape without losing its unique edge. It's worth a visit

PORTOBELLO ANTIQUE STORE

From left: the Harrods department store; the Royal Albert Hall; the Victoria and Albert Museum; and Portobello Road in Notting Hill.

# NOTTING HILL, KENSINGTON, AND KNIGHTSBRIDGE

In this section, you'll find additional insider tips about the sights featured in the Highlights chapter (see pp. 82–101). (For London numbers dial 020.)

just to experience the atmosphere in the shop.
*30 Bruton Street,*
*Mon–Sat 10.00–18.00;*
*Thurs 10.00–19.00.*
*www.stellamccartney.co.uk*

## Eating and drinking

**Amaya**
Easily one of the best Indian restaurants in the city. If you're watching your figure, try the 400-calorie three-course set lunch. The stylish decor makes a real impact by combining cool hues with the occasional bright, vivid decorative feature.
*Halkin Arcade, 19 Motcomb Street, Knightsbridge;*
*Tel 7823 1166;*
*Mon–Sat 12.30–14.15 and 18.30–23.30; Sun 12.45–14.45 and 18.30–23.30.*
*www.realindianfood.com*

**The Cow**
This old pub has been turned into a great gastropub by Tom Conran, son of designer Terence. Sophisticated, more expensive dishes are served in the dining room, while simpler, but no less tasty, Anglo-European fare is served in the bar.
*89 Westbourne Park Road,*
*Bayswater; Tel 7221 5400;*
*Mon–Fri 19.00–23.00;*
*Sat 12.00–15.00 and 19.00–23.00; Sun 12.00–15.00 and 19.00–22.30.*
*www.thecowlondon.co.uk*

**Geales**
This attractive restaurant serves a superb interpretation of the classic British dish, fish and chips. Choose from a variety of fish – all freshly caught – and some fine sauces. Fresh Cornish oysters are served at the champagne bar.

*2 Farmer Street, Notting Hill; Tel 7727 7528; Mon–Fri 12.00–15.00 and 18.00–23.00; Sat 12.00–23.00; Sun 18.00–22.30.*
*www.geales.com*

**Tom Aikens**
The subtle, elegant decor is a perfect complement to the outstanding and delicately prepared cuisine, which combines influences from almost every European country. The heavenly desserts are highly creative yet pleasingly simple.
*43 Elystan Street, Chelsea,*
*Tel 7584 2003,*
*Mon–Fri 12.00–14.30 and 18.45–23.00.*
*www.tomaikens.co.uk*

**Zuma**
This Japanese restaurant boasts a minimalist yet original decor, and a seemingly endless menu that leaves customers spoiled for choice. It includes both traditional Japanese dishes and innovative, contemporary creations. The sushi is really tasty, but the less familiar options will positively bowl you over.
*5 Raphael Street, Knightsbridge; Tel 7584 1010;*
*Mon–Thurs 12.00–14.15 and 18.00–23.00; Fri 12.00–14.45 and 18.00–23.00; Sat 12.30–15.15 and 18.00–23.00; Sun 12.30–15.00 and 18.00–22.00.*
*www.zumarestaurant.com*

## Accommodation

**Aster House**
This bed and breakfast is quintessentially English – from the chintzy décor to the flower arrangements and pot plants. However, its facilities and location mean its prices compare with a mid-range hotel.

*2 Sumner Place, Kensington,*
*Tel 7581 5888.*
*www.asterhouse.com*

**B&B Belgravia**
This bed and breakfast is arguably more like a chic hotel, boasting contemporary décor, Internet access, guest lounges, and a breakfast bar. And for the area, it's pretty good value.
*64–66 Ebury Street,*
*Belgravia; Tel 7730 8513.*
*www.bb-belgravia.com*

**The Dorchester**
This hotel on the edge of Hyde Park is the very epitome of luxury. It's a splendid place where the rich and beautiful come to have their every wish fulfilled.
*Park Lane, Mayfair,*
*Tel 7629 8888.*
*www.dorchesterhotel.com*

**Portobello Hotel**
An enchantingly furnished hotel with four-poster beds, lots of cushions, indulgent bathrooms, and a 24-hour bar. Popular with rock stars, film stars, and supermodels.
*22 Stanley Gardens,*
*Notting Hill; Tel 7727 2777.*
*www.portobellohotel.co.uk*

**The Sanctuary House**
A snug hotel in the middle price bracket that still boasts all the modern comforts you could need. Located a few minutes from Westminster Abbey.
*33 Tothill Street,*
*Westminster; Tel 7799 4044.*
*www.fullershotels.com*

## Nightlife

**Coopers Arms**
A Victorian pub at the upper end of the market, attracting

plenty of regulars with its good ale and fine food.
*87 Flood Street, Chelsea,*
*Mon–Sat 11.00–23.00; Sun 12.00–22.30.*

**Earl of Lonsdale**
The best thing about this unassuming, traditional pub is the intimate compartments where you and your fellow drinkers can give the fine ale the attention it deserves.
*277–281 Westbourne Grove,*
*Notting Hill; Mon–Sat 12.00–23.00; Sun 12.00–22.30.*

**Market Bar**
This attractive corner bar is a popular destination for market shoppers, turning into a lively party pub at the weekend. Then, it hosts DJs and on Sundays, live jazz.
*240a Portobello Road,*
*Notting Hill; Mon–Sat 12.00–23.00; Sun 12.00–22.30.*

**Star Tavern**
A very pleasant pub with a long history. Originally built for domestic staff employed in the surrounding great households, the pub is now a pretty noble address itself – noted for its good food. It's said that the Great Train Robbery was planned here.
*6 Belgrave Mews West,*
*Belgravia; Mon–Sat 11.00–23.00; Sun 12.00–22.30.*

**Windsor Castle**
With its open fire, this historic pub makes a supremely cozy winter retreat, and in the summer its lush beer garden is an equally inviting place to enjoy a pint of quality ale and a plate of bangers and mash.
*114 Campden Hill Road,*
*Notting Hill; Mon–Sat 12.00– 23.00; Sun 12.00–22.30.*

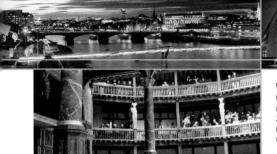

**Popular entertainment at the Globe Theatre.**

## Museums, music, and drama

### Dalí Universe
Europe's most extensive collection of works by the Catalan surrealist Salvador Dalí is diplayed in a suitably atmospheric gallery. The museum shop stocks a large range of posters and other Dalí-related items.
*County Hall, Westminster Bridge Road; Tel 7520 2720; 10.00–17.30, daily.*
*www.daliuniverse.com*

### Fashion and Textile Museum
The museum's bright orange building is quite a sight in itself, but it's the exhibition inside that will really set fashionistas' hearts racing, offering a fascinating insight into the world of contemporary British fashion.
*83 Bermondsey Street, Tel 7403 0222, Tues–Sun 11.00–17.15. www.ftmlondon.org*

### National Theatre
Britain's foremost arts complex boasts three stages upon which the country's greatest actors perform both classic and contemporary drama.
*South Bank, Tel 7452 3000. www.nationaltheatre.org.uk*

### The Old Vic
Steeped in tradition, the Old Vic enjoys great popularity among Londoners. It puts on exciting productions and sets affordable ticket prices. The current artistic director is American actor Kevin Spacey.
*Waterloo Road, Tel (0870) 060 6628. www.oldvictheatre.com*

### Shakespeare's Globe
The new Globe building is, architecturally, almost completely faithful to its historic forerunner, and William Shakespeare's classics are performed here exactly as they would have been when their author was alive – with all the noise and heckling that entails, and stripped of all extraneous, educated interpretation (see p. 112).
*21 New Globe Walk, Tel 7902 1500, Guided tours May–Sept 9.00–12.00 and 12.30–17.00, daily; Oct–April 10.00–17.00, daily. www.shakespearesglobe.org*

### Tate Modern
The building itself – a former power station overlooking the Thames – is as much an attraction as the modern art displayed inside. The collection includes works by the likes of Joseph Beuys, Andy Warhol, and Roy Lichtenstein (see p. 110 and p. 172)
*Bankside; Tel 7887 8888; Sun–Thurs 10.00–18.00; Fri–Sat 10.00–22.00. www.tate.org.uk*

## Festivals and events

### Carnaval del Pueblo
Britain's biggest Latin American festival is a showcase for the best in Latin American music, and artists come from far and wide especially to take part. Representatives of 11 Latin American countries take part in the highlight of the festival – a procession from City Hall to London Bridge, Elephant & Castle, and Burgess Park.
*www.carnavaldelpueblo. co.uk*

### London Film Festival
In the last two weeks of October, the National Film Theatre presents over a hundred new films from Britain and beyond, many of them screened in the presence of their directors, leading stars, and celebrities.
*www.lff.org.uk*

### London International Festival of Theatre
This multinational drama festival at the Southbank Centre begins around the middle of April and continues throughout the summer.
*www.liftfest.org.uk*

### London Lesbian & Gay Film Festival
This two-week festival of gay and lesbian cinema features hundreds of films from across the world. It all happens at the National Film Theatre on the South Bank.
*www.llgff.co.uk*

### The Mayor's Thames Festival
Possibly Europe's largest street party, the Thames Festival takes place over a weekend in mid-September. A celebration of the Thames, the festival takes place along the river – from the South Bank to Bankside and features street performers, markets, and music. It ends with a firework display between Waterloo and Blackfriars Bridge.
*www.thamesfestival.org*

## Sport, games, and fun

### Brockwell Lido
An open-air community lido. Alongside floodlit night swimming and barbeques, there's also the chance to take part in yoga, tai chi, and meditation sessions.
*Tel 7274 3088, Mid-June–Aug Mon–Fri 6.45–20.00; Sat–Sun 12.00–18.00; other times dependent on the weather. www.brockwell-lido.com*

### Tate-to-Tate Boat
The boat connects the two riverside Tate galleries, stopping off at Blackfriars and the Savoy along the way.
*www.tate.org.uk/tatetotate*

### Tooting Bec Lido
Located in the south of the city, this swimming pool is some 90 m (98 yards) long and 30 m (33 yards) wide. It was London's first open-air pool and, with its art deco architecture, is also one of the capital's most beautiful.
*Tooting Bec Road, Streatham; Tel 8871 7198; End May–31 Aug 6.00–20.00, daily; September 6.00–17.00, daily.*

From left: The Millennium Bridge across the Thames; the Queen Elizabeth Hall; the London Eye, a London landmark; and Southwark Cathedral.

# THE SOUTH BANK

In this section, you'll find additional insider tips about the sights featured in the Highlights chapter (see pp. 102–115). (For London numbers dial 020.)

## Health and beauty

### The Stress Exchange
Full body care from head to toe. This health and beauty salon offers Swedish massage, body packs, reflexology, pedicures, manicures, make-up, and body hair removal. As for the hair on your head, that's looked after by the salon's own hair stylists.
*130 Tooley Street, Southwark; Tel 7357 7006; Mon 8.00–18.00; Tues–Fri 8.00–20.00; Sat 9.00–18.00; Sun 11.00–18.00.*
*www.stressexchange.co.uk*

## Shopping

### Borough Market
This huge market is often referred to as "London's larder". It truly is the place to find the freshest produce, most exotic delicacies, and generally best-quality groceries that the city has to offer. The market stalls and shops start around Crown Square on Southwark Street, and run all the way up to Southwark Cathedral. With trade thriving, it's a tight squeeze!
*Thurs 11.00–17.00; Fri 12.00–18.00; Sat 9.00–16.00.*
*www.boroughmarket.org.uk*

### Cockfighter of Bermondsey
The shop's original T-shirts, with their quirky prints, are worn by celebrities and rising pop stars. There's also a wide range of accessories.
*96 Bermondsey Street Tues–Fri 11.00–19.00; Sat 12.00–18.00.*
*www.cockandmagpie.com*

### Oxo Tower
The lower floors of this trademark tower are home to a range of shops selling fashion and accessories, jewelry, and high-end homewares.
*Bargehouse Street.*
*www.coinstreet.org*

## Eating and drinking

### Anchor & Hope
Rich and robust and quite simply delicious. That's the best way to describe the food at the Anchor & Hope, where snails, pigeon, pig's heart, potato salad with bone marrow, and plenty of hearty roasts are all staples. Reservations are sadly not accepted, so getting a table requires either a stroke of luck or a willingness to wait your turn.
*36 The Cut, South Bank; Tel 7928 9898; Tues–Sat 12.00–14.30; Mon–Sat 18.00–22.30; Sun 12.30–17.00.*

### Baltic
This modern restaurant is dedicated to the cuisine of eastern Europe, from borscht to blinis, pierogi, goulash, and Wiener schnitzel. That said, most dishes also have an English or international twist.
*74 Blackfriars Road, Tel 7928 1111, 12.00–15.30 and 18.00–23.15, daily.*
*www.balticrestaurant.co.uk*

### Garrison
A cozy, relaxed gastropub serving a good selection of traditional English dishes, expertly made. The real showstopper, however, is the tiny basement cinema, which locals book for private parties – food and drink included.
*99 Bermondsey Street, Tel 7089 9355.*
*Mon–Sat 12.30–15.30 and 18.30–22.00; Sun 12.30–16.00 and 18.30–21.30.*
*www.thegarrison.co.uk*

### Oxo Tower Restaurant
Part of the luxury Harvey Nichols group, the restaurant boasts a magnificent view across the Thames to the City and West End. At night the view is spectacular, when the cityscape becomes a sea of glittering lights.
*Oxo Tower Wharf, Bargehouse Street; Tel 7803 3888; Mon–Sat 12.00–14.30 and 18.30–23.00; Sun 12.00–15.00 and 18.30–22.00.*
*www.harveynichols.com*

## Accommodation

### London Marriott County Hall
This 5-star hotel occupies the former home of London's city government, and the elegant, formal atmosphere certainly lives up to the setting. The hotel offers every luxury, but its most exciting feature is the view toward Westminster – Big Ben is almost close enough to touch.
*Westminster Bridge Road, Tel 7928 5200.*
*www.marriott.co.uk*

### The Mad Hatter Hotel
Behind the charming, old-fashioned façade of this 19th-century building lies a comfortable, modern, small hotel. Just a stone's throw from Tate Modern and Shakespeare's Globe, the hotel has its own small restaurant, serving English dishes.
*3–7 Stamford Street, Southwark; Tel 7401 9222.*
*www.madhatterhotel.com*

### Southwark Rose Hotel
Though the immediate area isn't the prettiest, the hotel is in easy reach of many of the city's main sights. Rooms are small, but the modern décor makes good use of the space, with Internet connection, a telephone, and a flat-screen television.
*43–47 Southwark Bridge Road; Tel 7015 1480.*
*www.southwarkrosehotel.co.uk*

## Nightlife

### Anchor Bankside
Multiple bars and several open fireplaces make this 17th-century pub a really cozy retreat, despite its more recent extensions. Whatever the weather, this is a real little gem – and if the sun's out, the great view from the riverside terrace is hard to resist.
*34 Park Street, Mon–Sat 11.00–23.00; Sun 12.00–22.30.*

### George Inn
This former coaching house near London Bridge is the city's only 17th-century pub to have retained its balconies. Thanks to its listed building status, there are many more wonderful original details to admire inside.
*Talbot Yard, 77 Borough High Street; Mon–Sat 11.00–23.00; Sun 12.00–22.30.*

### Wine Wharf
This trendy wine bar is not far from Borough Market, so it can get pretty busy on market days. Its range of wines is phenomenal, encompassing carefully selected vintages from almost every wine-growing region in the world. They also serve a selection of tasty morsels, and there's live jazz every Monday from around 19.00.
*Stoney Street, Mon–Sat 11.00–23.00.*
*www.winewharf.co.uk*

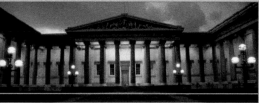

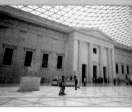

Spring in Regent's Park: tulips in all their glory.

## Museums, music, and drama

### The British Museum
One of the oldest museums in the world, the British Museum houses over seven million treasures, including many treasures acquired during the former British empire. The Great Court, the museum's inner courtyard, is the largest covered public space in Europe (see p. 120 and p. 178).
*Great Russell Street, Tel 7323 8000, Sat–Wed 10.00–17.30; Thurs–Fri 10.00–20.30; Great Court: Sun–Wed 9.00–18.00; Thurs–Sat 9.00–23.00. www.thebritishmuseum.ac.uk*

### Freud Museum
Sigmund Freud lived in this house from 1938 to his death the following year, when it passed to his daughter Anna. The family moved all of Freud's furniture – including his famous couch – to London.
*20 Maresfield Gardens, Tel 7435 2002, Wed–Sun 12.00–17.00. www.freud.org.uk*

### Madame Tussauds
This display of waxworks is among London's most famous attractions. It features not only historical figures, but almost anyone lucky enough to have enjoyed their 15 minutes of fame (see p. 124).
*Marylebone Road, Tel (0870) 400 3000, Mon–Fri 9.30–17.30; Sat–Sun 9.00–18.00. www.madametussauds.com*

### Sherlock Holmes Museum
A recreation of the fictional house that Arthur Conan Doyle's detective Sherlock Holmes shared with Dr Watson. There are also depictions of scenes from the books.
*221b Baker Street, Tel 7935 8866, 9.30–18.00, daily. www.sherlock-holmes.co.uk*

## Festivals and events

### London Art Fair
A wide range of galleries put their modern and contemporary works of art on show at the Business Design Centre, Islington.
*52 Upper Street, Islington. www.londonartfair.co.uk*

### Rise Festival
Originally called Respect, this outdoor festival was first started to make a stand against racism. The event is a celebration of multicultural London, featuring music by representatives of all the city's ethnic groups. Above all, however, this is a real family festival. It all happens in Finsbury Park on the third Sunday in July.
*www.risefestival.org*

## Sport, games, and fun

### Alexandra Palace Ice Rink
In north London, there's more than ice-skating on offer at Alexandra Palace. But for all the bungee jumping, circuses, balloon rides, and funfairs, it is one of London's few permanent ice rinks – open all year round – and really steals the show.
*Alexandra Palace, Wood Green; Tel 8365 2121. www.alexandrapalace.com*

### Hampstead Heath
Set over 320 ha (791 acres) of north London, Hampstead Heath – with its woods, meadows, and hills – is London's most popular day out. The park's attractions include bathing lakes, football and cricket pitches, tennis courts, cycle routes, plenty of picnic spots, and a great view over almost the entire city from Parliament Hill.

### London Waterbus Company
Take an idyllic boat trip up the Regent's Canal from Camden Town, past London Zoo, and on to Little Venice, with its pretty canal boats.
*www.londonwaterbus.com*

### Middlesex County Cricket Club
There's no more English sport than cricket. To the uninitiated, the game can frequently seem boring, but there's no better place to get to grips with its subtleties than Lord's – one of the most famous cricket grounds in the world.
*Lord's Cricket Ground, St John's Wood; Tel 7616 8500. www.lords.org*

### Regent's Park
Architect John Nash was responsible not only for the elegant park, but also for the grand townhouses that surround it. There's no shortage of things to do. London Zoo lies in the park's north-east corner, and there's also an open-air stage that puts on Shakespeare productions in the summer, football pitches, boating on the lakes, and all sorts of other outdoor activities (see p. 126).

### Regent's Park Tennis Centre
These fine tennis courts are situated on the western edge of the park. They are open to the public, and court fees are reasonable.
*Regent's Park, Westminster; Tel 7724 0643.*

## Health and beauty

### Angel Therapy Rooms
A tranquil refuge, tastefully done. Various massage therapies are on offer, alongside hot stone treatments, reiki, reflexology, acupuncture, and nutrition advice.
*16b Essex Road, Islington, Tel 7226 1188, Tues and Thurs 12.00–20.00; Fri 11.00–19.00; Sat 11.00–18.00; Sun 11.00–17.00. www.angeltherapyrooms.com*

### Ironmonger Row Baths
This wonderful, old-fashioned Turkish bathhouse does with-

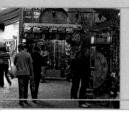

From left: The British Museum; Madame Tussauds waxworks; the British Museum in Bloomsbury; market traders in trendy Camden Town.

# BLOOMSBURY AND CAMDEN

In this section, you'll find additional insider tips about the sights featured in the Highlights chapter (see pp. 116–129). (For London numbers dial 020.)

out all the usual beauty therapies. Instead, there's a swimming pool, sauna, steam room, tanning beds, and gym. Massages are available by appointment.
*1–11 Ironmonger Row, Islington; Tel 7253 4011; Mon–Fri 6.30–21.00; Sat 9.00–18.00; Sun 10.00–18.00. www.aquaterra.org/ ironmonger-row-baths.aspx*

## Ki Mantra Urban Life Spa
Ki Mantra specialize in yogic massage, which mixes massage with yoga stretches designed to restore the body's natural balance. Other services include facials and Thai and traditional massage.
*5 Camden Passage, Islington; Tel 7226 8860, Mon 12.00–20.00; Tues–Sat 10.00–20.00; Sun 10.00–18.00. www.kimantra.com*

## Shopping

### Camden Market
There are in fact six separate markets, some covered, others exposed to the elements. While each has its particular forté, you'll find clothing, handicrafts, ornaments, and general bric-a-brac almost everywhere. There are also food stands, pubs, and restaurants. The boutiques dotted around the market mainly cater to specific scenes, with punks, goths, and hippies all trawling the area for the perfect outfit. The markets are open daily, and while exact opening times may vary, the stalls generally trade from 10.00–17.30.
*Camden High Street/ Buck Street. www.camdenlock.net*

### Penny Burdett
Designer knitwear with real style, from trendy knitted jackets to shawls, dresses, suits, and even knitted pictures. The shop also takes on bespoke commissions.
*48 Upper Walkway, West Yard, Camden Lock Place, Chalk Farm Road; Mon–Fri 11.30–17.30; Sat–Sun 10.30–18.00. www.pennyburdett.co.uk*

## Eating and drinking

### Eat & Two Veg
A relaxed and entirely vegetarian restaurant that's open for breakfast, lunch, and dinner. You'll find a full English breakfast on the menu, but there won't be any meat in the bacon. The same applies to the schnitzel and the sausages in the bangers and mash.
*50 Marylebone High Street, Marylebone; Tel 7258 8595; Mon–Sat 9.00–23.00; Sun 10.00–22.00. www.eatandtwoveg.com*

### El Parador
The huge selection of tapas served at this pleasant and relaxed family-run restaurant is a real treat. It's best enjoyed in a large group with a bottle of fine Spanish wine – that way, you can really work your way through the menu.
*245 Eversholt Street, Camden; Tel 7387 2789; Mon–Thurs 12.00–15.00 and 18.00–23.00; Fri 12.00–15.00 and 18.00–23.30; Sat 18.00–23.30; Sun 18.30–21.30. www.elparadorlondon.com*

### Mango Room
This isn't exactly London's swankiest district, but the Mango Room, exuding

Caribbean charm, is a bright and welcoming oasis in its midst. The restaurant serves Caribbean food toned down to European tastes, with fantastic cocktails and soothing reggae in the background.
*10 Kentish Town Road, Camden; Tel 7482 5065; Mon–Fri from 18.30; Sat–Sun from 17.30. www.mangoroom.co.uk*

### Orrery
This friendly, airy Conran restaurant has been awarded a Michelin star. While the food tends toward French cuisine, it also incorporates influences from other European countries. The cheese selection is probably unrivalled anywhere else in London.
*55 Marylebone High Street, Marylebone; Tel 7616 8000; Sun–Wed 12.00–14.30 and 18.30–22.30; Thurs–Sat 12.00–15.00 and 18.30–23.00. www.conran.com*

## Accommodation

### Colonnade Town House
A pretty little hotel not far from the houseboats moored on the canal that leads to Regent's Park. The spacious and comfortable rooms are in the mid-price sector.
*2 Warrington Crescent, Little Venice; Tel 7286 1052. www.theetoncollection.com*

### Danubius Hotel
The 376 rooms of this 4-star hotel all boast modern and elegant furnishings with every conceivable comfort. You can see Regent's Park from the window, and the many leisure activities it offers are all within walking distance. Alternatively, if it's

raining, enjoy the hotel's daily afternoon tea instead.
*18 Lodge Road, St John's Wood; Tel 7722 7722. www.danubiuslondon.co.uk*

### Dorset Square Hotel
This stylish hotel was converted from two beautiful Georgian townhouses. It's decorated in typically English country house style.
*9–40 Dorset Square, Marylebone; Tel 7723 7874. www.dorsetsquare.co.uk*

## Nightlife

### Bartok
This cozy little bar is named after the Hungarian composer Béla Bartók – whose works, alongside jazz and world music, you are more than likely to hear playing in the background.
*78–79 Chalk Farm Road, Mon–Thurs 17.00–3.00; Fri 17.00–4.00; Sat 13.00–4.00; Sun 13.00–3.00. www.bartokbar.com/ www.biteus.com*

### Jerusalem Tavern
In the 18th century, this was one of the London coffee houses frequented by George Frideric Handel. Today, it's a really cozy little pub.
*55 Britton Street, Clerkenwell; Mon–Fri 11.00–23.00.*

### Museum Tavern
A good pint of ale and a portion of fish and chips await visitors to this 18th-century pub, located opposite the British Museum. Karl Marx was once a regular.
*49 Great Russell Street, Bloomsbury, Mon–Sat 11.00–23.00; Sun 12.00–22.30.*

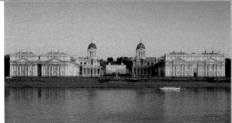

The Royal Naval College in Greenwich.

## Museums, music, and drama

### The Museum of Childhood, Bethnal Green
This small, fun museum is part of the famous Victoria and Albert Museum on the other side of town. It features toys and other childhood objects from the 17th century to the present day, and there are also special play areas for children to enjoy.
*Cambridge Heath Road (corner of Old Ford Road), Tel 8983 5200, 10.00–17.45, daily www.museumofchildhood. org.uk*

### Geffrye Museum
This house and its fine gardens are a real gem in the otherwise uninspiring urban landscape that surrounds them. The exhibition uses fully furnished period rooms to depict the living quarters of the English middle class since the 17th century. The modern loft is a particularly amusing touch – filled with Ikea furniture and charming, familiar details.
*136 Kingsland Road; Tel 7739 9893; Tues–Sat 10.00–17.00; Sun and public holidays 12.00–17.00. www.geffrye-museum. org.uk*

### Museum of London Docklands
Housed in a 200-year-old warehouse, this museum documents the development of London as a port from the times of the Roman settlement right up to the transformation of the former docks into the city's modern financial hub. The museum also hosts special exhibitions, tours, and events.
*Warehouse No 1, West India Quay, Tel (0870) 444 3857, 10.00–17.30, daily. www.museumindocklands. org.uk*

### Whitechapel Art Gallery
One of London's most innovative cultural institutions, the Whitechapel Art Gallery provides space for experimental, extraordinary, and often extremely interesting work. Young artists and independent film-makers show their latest pieces here, and the gallery also hosts musical events, including pop and world music concerts. There are also poetry readings, comedy shows, and much more besides.
*80–82 Whitechapel High Street; Tel 7522 7888; Wed–Sun 11.00–18.00; Thurs lectures until 21.00; Fri music until 23.00. www.whitechapel.org*

## Festivals and events

### Greenwich and Docklands Festival
Held at the end of June, this free arts festival showcases a variety of music, dance, and drama from around the world. It also features traditional markets and a fireworks display.
*www.festival.org*

### Spitalfields Festival
This music festival takes place over three weeks in June with a one-week winter festival in December. It consists of classical concerts featuring music and choral performances from all historical periods, as well as jazz and world music – all performed in churches and other local venues.
*www.spitalfieldsfestival. org.uk*

## Sport, games, and fun

### Dockland Sailing & Watersport Centre
A day membership at this award-winning, purpose-built facility buys you access to every imaginable type of boating experience and instruction – from powerboats to sailing. There's also changing room facilities, a well-stocked bar with an excellent view over the dock, and a balcony that provides an ideal place for barbecues on long summer evenings.
*235a Westferry Road, Millwall Dock, Canary Wharf; Tel 7537 2626. www.dswc.org*

### Revolution Karting
London's fastest go-karting track is floodlit and remains open late into the night. It's the scene of some really exciting races!
*Arches 422–424, Mile End Park; Tel 7538 5195. www.revolutionkarting.com*

## Health and beauty

### Bodywise
If it's good for the body, mind, or soul, then you'll find it among the many services provided here. Alongside all the usual healing therapies – from Thai massage to Ayurveda – they also provide courses in t'ai chi, yoga, bellydancing, and pilates.
*119 Roman Road, Bethnal Green; Tel 8981 6938; Mon–Fri 9.00–20.30, Sat 9.00–14.30. www.bodywisehealth.org*

## Shopping

### Beyond Retro
One of London's biggest vintage clothing stores. Many of the garments come from America, including everyday wear, evening wear, accessories, and more – for both men and women.
*112 Cheshire Street, 10.00–18.00, daily. www.beyondretro.com*

### Burberry Factory Shop
This classic English label has recently enjoyed a fashion renaissance. At this store, Burberry sells factory rejects and last season's leftovers for up to 70 percent off the normal price.
*29–53 Chatham Place, Mon–Fri 11.00–18.00; Sat 10.00–17.00; Sun 11.00–17.00.*

### Laden Showrooms
This is where celebrities like Victoria Beckham, the contro-

# THE EAST END

In this section, you'll find additional insider tips about the sights featured in the Highlights chapter (see pp. 130–141). (For London numbers dial 020.)

versial singer Pete Doherty, and Oasis guitarist Noel Gallagher shop. The shop stocks fashionable street and party wear, alongside the very coolest of accessories.
*103 Brick Lane,*
*Mon 12.00–18.00; Tues–Sat 11.00–18.30; Sun 10.30–18.00.*
*www.laden.co.uk*

## Spitalfields Market
Now housed in its own market hall, this traditional market has been trading for centuries. As well as fruit and vegetables, there are all sorts of other things on sale – from eco-clothing to ornaments.
*Commercial Street,*
*Mon–Fri 10.00–16.00;*
*Sun 9.00–17.00.*

## Eating and drinking

### Fifteen
From television shows to magazines and cookbooks – celebrity chef Jamie Oliver is everywhere. At this restaurant, a group of the superstar chef's young apprentices – 15 at a time – learn their trade from the bottom up. The food is typically Jamie: stripped of the frills but prepared with real skill. It's a little bit pricey, but at least the profits go to a good cause.
*15 Westland Place, Shoreditch; Tel (0871) 330 1515;*
*Mon–Sat 7.30–11.00 and 12.00–15.00; Sun 9.00–11.00 and 12.00–15.30;*
*18.00–21.30, daily.*
*www.fifteen.net*

### L'Eau à la Bouche
This place is at its best – although unfortunately also at its fullest – on Saturdays, when Broadway Market is in full swing. Then, you can sit at

one of the tables outside and watch the hustle and bustle of the market go by as you enjoy your choice of quiche, ciabatta, pastry, and coffee. Inside, the delicatessen sells tasty Mediterranean- and French-inspired morsels to take away.
*49 Broadway Market, Hackney; Tel 7923 0600;*
*Mon–Fri 8.30–19.00; Sat 8.30–17.00; Sun 10.00–16.00.*

### Little Georgia
A cozy little café by day, Little Georgia becomes a lively restaurant at night, with a distinctive menu and wine list. You don't find Georgian cuisine everywhere, but this is a restaurant where you can enjoy its unusual delicacies in style.
*87 Goldsmiths Row, Bethnal Green; Tel 7249 9070;*
*Mon–Sun 9.00–18.00;*
*Wed–Sun 9.00–22.00.*

### The Spread Eagle
What looks from the outside like a typical pub is in fact a rather fine French restaurant, masterfully mixing a wide range of classic French dishes with influences from around the world.
*1 Stockwell Street,*
*Tel 8853 2333,*
*Mon–Sat 12.00–15.00 and 18.00–22.00; Sun 12.00–16.00 and 18.00–22.00.*

### The Hill
The Hill has transformed itself from a regular pub into a pleasant gastropub. The food draws on influences from various European cuisines, but fish and chips and the traditional English Sunday roast are – of course – staples.
*89 Royal Hill, Greenwich, Tel 8691 3626,*

*Mon–Wed 18.00–22.00;*
*Thurs–Sat 12.00–15.00 and 18.00–22.00; Sun 12.00–16.00 and 18.00–21.00.*

### Ubon by Nobu
This high-end Japanese restaurant is located on the fourth floor of Canary Wharf. Glazed on all sides, it offers spectacular views over the river and the city. Far more than just sushi, the food is Japanese cooking at its very finest – not to mention its most expensive.
*34 Westferry Circus, Canary Wharf; Tel 7719 7800;*
*Mon–Fri 12.00–14.00;*
*Mon–Sat 18.00–22.00.*

## Accommodation

### Britannia International Hotel
This luxury hotel enjoys great views over the city, and the stylishly decorated rooms are a cut above your average, rather impersonal, hotel accommodation. The hotel also boasts a gym, swimming pool, restaurant, and well-stocked bar.
*Marsh Wall, Canary Wharf, Tel (0871) 222 0042.*
*www.britanniahotels.com*

### Crowne Plaza
Formerly the Saint Gregory Hotel, this hotel is now part of the Crowne Plaza chain. It's still as cool, elegant, and ultra modern as ever, though. Alongside all the usual facilities, rooms feature a WLAN Internet connection, and a proper desk and chair. On the top floor, diners at the Globe Restaurant are afforded a fantastic view over the city.
*100 Shoreditch High Street, Tel 7613 9800.*
*www.hotelsaintgregory.co.uk*

### Hamilton House Hotel
This magical hotel occupies a Georgian townhouse not far from the Royal Observatory. There are only nine rooms, but they are all incredibly cozy and – by London standards – are pretty good value, too. Some even have four-posters beds.
*14 West Grove, Greenwich, Tel 8694 9899.*

## Nightlife

### George & Dragon
The interior may be a little bit kitsch, but you can't fault the atmosphere. It's relatively quiet during the week, but at the weekend the DJ's choice of music ensures that this pub is frequently full to bursting.
*2 Hackney Road, Shoreditch, Mon–Sat 12.00–23.00;*
*Sun 12.00–22.30; open late for special events.*

### The George Tavern
The side rooms of this charming, old-fashioned pub often become a venue for special events, including concerts by local indie and rock groups, as well as alternative drama.
*373 Commercial Road, Whitechapel,*
*Mon–Sat 12.00–23.00; Sun 12.00–22.30; open late for special events.*

### The Mayflower
This 16th-century pub is named after the ship that carried the Pilgrim Fathers to the new world. You'll find cloudy, yeasty real ale and a charming riverside terrace – an ideal place to while away a summer's evening.
*117 Rotherhithe Street, Docklands,*
*Mon–Sat 12.00–23.00;*
*Sun 12.00–22.30.*

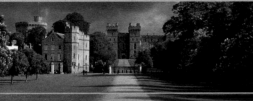  

Hampton Court: for many, the most beautiful of the castles.

## Museums, music, and drama

### Garrick's Temple to Shakespeare

The actor David Garrick built this enchanting 18th-century temple to commemorate Shakespeare. Inside, there's a life-sized statue of the great playwright and poet, as well as memorabilia relating to Garrick himself.
*Garrick's Temple, Hampton, Middlesex,*
*April–Sept, every Sun.*
*www.garrickstemple.org.uk*

### Hampton Court

With its Tudor façade, Hampton Court is one of England's most beautiful palaces. Originally built by Cardinal Thomas Wolsey between 1514 and 1520, it was later taken over and restructured by Henry VIII. Today, it's both a museum and a venue for numerous events (see p. 146).
*Hampton Court Palace, Surrey; Tel (0844) 482 7777; End March–End Oct 10.00–18.00, daily; End Oct–End March 10.00–16.30, daily.*
*www.hrp.org.uk/hampton-courtpalace*

### Syon House

This elegant house, originally an abbey, has been the London home of successive dukes of Northumberland for over 400 years. In the 19th century, the entire estate was redesigned in the neoclassical style. It boasts some of the grandest and most spectacular stately rooms in England.
*Syon Park, Brentford, Middlesex; Tel 8560 0881; End March–End Oct, Wed, Thurs, Sun, and public holidays 11.00–17.00.*
*www.syonpark.co.uk*

### Windsor Castle

Dating back some 900 years, Windsor Castle is one of the queen's official residences. The largest and oldest occupied castle in the world, it houses many great treasures, including paintings by Rubens, Holbein, and van Dyck. The staterooms are open to the public (see p. 150).
*Windsor Castle, Windsor, Berkshire; Tel 7766 7304; March–Oct 9.45–17.15, daily; Nov–March 9.45–16.15, daily.*
*www.royalcollection.org.uk*

## Festivals and events

### Great River Race

On the second Saturday in September, more than 300 boats crewed by some 2,000 amateur sailors from around the world make their way down the Thames from Ham in Surrey to Greenwich. All sorts of vessels take part, from small, simple boats and barges to Viking ships and dragon boats. More than just a sporting event, the race is a real spectacle.
*www.greatriverrace.co.uk*

### Hampton Court Palace Flower Show

Every year at the beginning to middle of July, the grounds of this historic palace are in bloom as enthusiastic gardeners put their latest creations on display.
*www.rhs.org.uk/hampton-court*

### Royal Windsor Horse Show

For five days in May, the park of Windsor Castle is given over to horses and equestrian sports. This prestigious event, in which both members of the aristocracy and the royal family take part, is also the public's only chance to visit the queen's private "garden".
*www.rwhs.co.uk*

## Sport, games, and fun

### Beckenham Place Park

This wonderful 18-hole golf course on London's southeastern fringe is part of a magnificent park. Beginners and non-members are welcome, but make sure you book a tee time at weekends!
*Beckenham Hill Road, Beckenham, Kent, Tel 8650 2292.*
*www.glendale-golf.com*

### Cabair Helicopters

Admire London from the air: Cabair offers 30-minute helicopter flights over central London, with commentary. Flights take off from a small airfield north of the city.
*Elstree Aerodrome, Borehamwood, Tel 8953 4411.*
*www.cabairhelicopters.com*

### Kew Gardens

Among the botanic gardens' main attractions are the splendid Palm House and the other glasshouses, filled with rare plants. There are also the lushly planted park areas and numerous notable buildings, such as Pagoda, Queen Charlotte's Cottage, and Kew Palace.
*Royal Botanic Gardens, Kew, Richmond, Surrey; Tel 8332 5655; 30 March–30 Aug Mon–Fri 9.30–18.30; Sat–Sun 9.30–19.30; 31 Aug–25 Oct 9.30–18.00, daily*
*www.rbgkew.org.uk*

### Legoland Windsor

This theme park is dedicated to the famous toy bricks. There's something to keep all the family entertained, including spectacular stunt displays or a trip through the Lego landscape in a Viking boat.
*Legoland Windsor, Winkfield Road, Windsor, Berkshire; Tel (0871) 222 2001; March–Oct 10.00–18.00, daily; July–Aug 10.00–21.00, daily.*
*www.legoland.co.uk*

### Stockley Park Golf Club

This fine golf course is located on London's western fringe, just north of Heathrow airport. It spans nearly 100 ha (247 acres) of parkland, landscaped to American standards. Players need not be club members.
*The Clubhouse, Stockley Park, Uxbridge; Tel 8813 5700.*
*www.stockleyparkgolf.com*

From left: Windsor Castle; horse-racing at Ascot; the Green Drawing Room at Windsor Castle; and Queen Elizabeth II in her gold state coach, en route to festivities for her golden jubilee.

# BEYOND LONDON

In this section, you'll find additional insider tips about the sights featured in the Highlights chapter (see pp. 142–151). (For London numbers dial 020.)

## Thames River Boats
Boat trips up river from the mooring point opposite the Palace of Westminster to Kew and Hampton Court operate from April to October. The journey takes around three hours, departing from Westminster at 10.30, 11.00, 12.00, and 14.00, and from Hampton Court at 15.00 and 17.00.
*WPSA, Westminster Pier, Tel 7930 2062. www.wpsa.co.uk*

## Wimbledon Tennis Club
The famous Wimbledon tennis tournament takes place at the end of June and beginning of July each year. Essentially a sporting event, it's also a huge fixture in the London social calendar. To see a match on the world-famous Championship courts, you'll either have to have secured a ticket in the previous year's ballot or take your place in the seemingly endless queue that forms outside the ground. Be prepared for a wait!
*Church Road, Wimbledon, Tel 8946 2244. www.wimbledon.org*

## Eating and drinking

### Bluebeckers at Hampton Court
This informal restaurant takes you on a whistle-stop tour of world cuisine, with dishes from Britain, the Mediterranean, North Africa (Morocco), and the Far East. The food is all good, but the real highlight is the splendid view over the Thames and Hampton Court Palace.
*3 Palace Gate, Hampton Court; Tel 8941 5959; Mon–Thurs 10.00–22.00; Fri–Sat 10.00–22.30; Sun 10.00–21.30.*

A Royal Guardsman.

### The Crooked House
This tiny, crooked house is one of historic Windsor's most delightful attractions. Dating back over 400 years, the building is now a popular café restaurant, serving typically English dishes for breakfast, lunch, and afternoon tea.
*51 High Street, Windsor, Tel (01753) 857 534, Mon–Fri 10.30–18.00; Sat–Sun 10.00–19.00. www.crooked-house.com*

### The House on the Bridge
This extremely attractive restaurant lies right on the banks of the Thames, next to the Eton College boathouse – used by the renowned public school. There's also a good view of Windsor Castle, especially from the terrace and balcony. On the menu, you'll find expensive but excellent international cuisine.
*Windsor Bridge, Eton; Tel (01753) 860914; 12.00–14.30 and 18.00–23.00, daily. www.house-on-the-bridge. co.uk*

### Waterside Inn
This is one of the most enchanting restaurants in the entire area around London. Located in a 16th-century village between Maidenhead and Windsor, it offers both a romantic riverside setting and first-class French cuisine.
*Ferry Road, Bray, Tel (01628) 620 691, Wed–Sun 12.00–14.00 and 19.00–22.00; June–Aug also Tues 19.00–22.00; closed Jan. www.waterside-inn.co.uk*

## Accommodation

### Carlton Mitre Hotel
Like Hampton Court Palace opposite, this 17th-century house on the banks of the Thames was once used by the monarchy. The rooms are beautifully decorated in Tudor-inspired style, and the restaurant is one of the best in the region.
*Hampton Court Road, Hampton Court; Tel 8979 9988; www.carlton.nl/mitre*

### The Oakley Court
This grandiose neo-Gothic country house dates from the 19th century. Set in a large park, it boasts luxurious and generously proportioned rooms – some with four-poster beds – as well as extensive health and beauty facilities. The stylishly decorated restaurant makes an extremely elegant dining place.
*Windsor Road, Water Oakley, Windsor; Tel (01753) 609988. www.oakleycourt.com*

### Sir Christopher Wren's House
This elegant 17th-century townhouse between the Thames and Windsor Castle was once home to the architect of St Paul's Cathedral. Designed by Wren himself, the building is now a luxury hotel. It offers beautiful and individually furnished rooms, a spa, and two restaurants.
*Thames Street, Windsor, Tel (01753) 861 354. www.sirchristopherwren. co.uk*

### The Kings Arms Hotel
The luxurious, romantic decor of this magical hotel is true to the style that would have been in fashion when this 17th-century building was constructed. Internet access is provided.
*2 Lion Gate, Hampton Court Road, Hampton Court; Tel 8977 1792; www. hamptoncourthotel.com*

## Nightlife

### Havana
This stylish bar attracts a mixed crowd of young and older party-goers. London-based DJs take to the decks at weekends, and there are jam sessions on Wednesdays.
*3 Goswell Hill, Windsor; Tel (01753) 832 960. www.havanawindsor.com*

### The Cardinal Wolsey
This beautiful 18th-century pub located near Hampton Court is a great place for a pint and a good meal. There's live music in the evenings (Thurs–Mon), featuring pop, rock, and blues bands.
*The Green, East Molsey; Tel 8487 3651. www.thecardinalwolsey.com*

### Vanilla
A stylish, exclusive nightclub frequented by the rich and beautiful. There's a disco, live music, and a cocktail bar.
*15a Royal Windsor Station, Goswell Hill, Windsor; Tel (01753) 831 122. www.vanillabar.com*

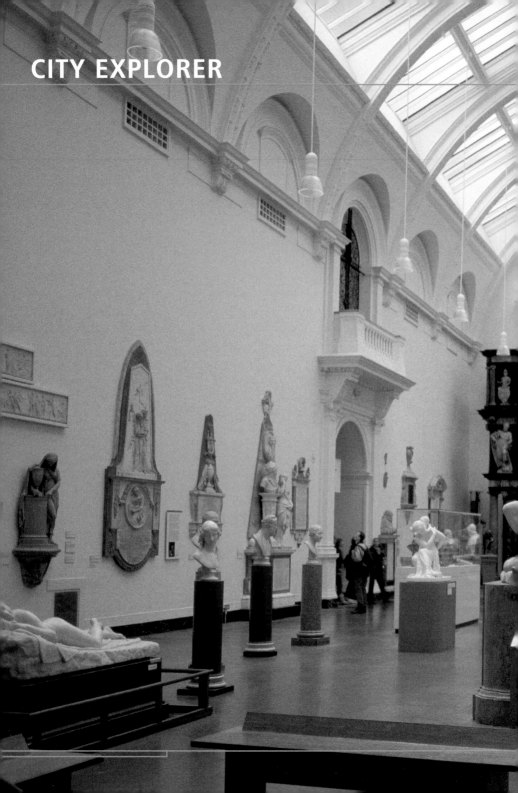

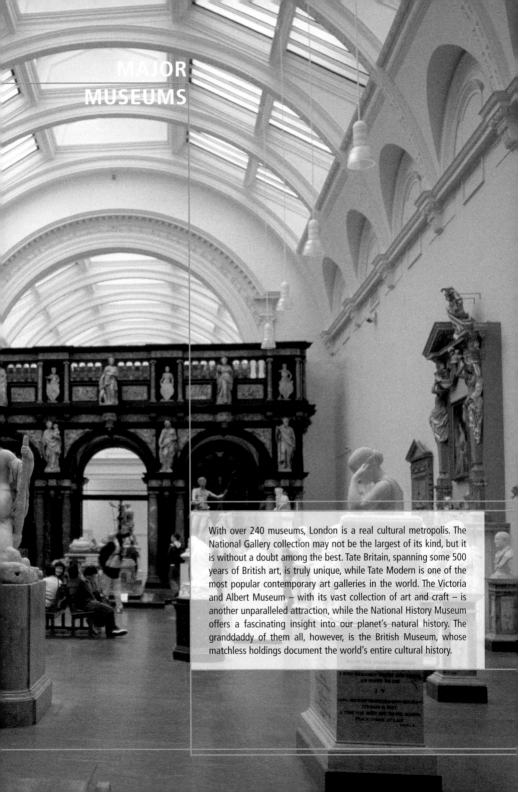

# MAJOR MUSEUMS

With over 240 museums, London is a real cultural metropolis. The National Gallery collection may not be the largest of its kind, but it is without a doubt among the best. Tate Britain, spanning some 500 years of British art, is truly unique, while Tate Modern is one of the most popular contemporary art galleries in the world. The Victoria and Albert Museum – with its vast collection of art and craft – is another unparalleled attraction, while the National History Museum offers a fascinating insight into our planet's natural history. The granddaddy of them all, however, is the British Museum, whose matchless holdings document the world's entire cultural history.

The original National Gallery building was heavily criticized for being ill-proportioned and far too small for its proposed purpose. Today, the gallery's elegant Trafalgar Square façade conceals a building whose successive restructuring has resulted in a mix of styles. But it's precisely this stylistic melange that creates the museum's own architectural history.

**INFO**
*National Gallery,*
*Trafalgar Square,*
*Tel (020) 7747 2885,*
*Thurs–Tues*
*10.00–18.00;*
*Wed 10.00–21.00l.*
*www.nationalgallery.*
*org.uk*

## Constable's Hay Wain

The enchanting landscape *The Hay Wain*, by John Constable (1776–1837), was recently voted one of British culture's most iconic images, and is considered to be one of the country's best paintings. Working from sketches he had made at the scene, Constable painted the picture in London in 1821. In the foreground, it depicts a hay wain on the River Stour at Flatford, in the heart of Suffolk's Dedham Vale. In the background, a farmer harvests hay from the meadow. The house on

*The Hay Wain* by John Constable is considered to be the very epitome of the traditional English country idyll.

the left belonged to farmer Willy Lott. Today, Dedham Vale remains a typically English landscape, complete with all the idyllic elements found in Constable's pictures. The farmhouse still exists, and looks almost exactly as it does on the painting. The path that runs along the riverbank is also still there, albeit rather more overgrown.

## The Sainsbury Wing

Opened in 1991, the initially controversial extension is named after its benefactor, the supermarket magnate Lord Sainsbury. It is a fully equipped, modern building, with 12 computer terminals that allow you to locate the most important works and take a virtual tour of the entire collection before you see the real thing. Alongside temporary exhibitions, most of the wing is given over to the period 1250–1500. The works of the Italian masters dominate the exhibits, among them the oldest piece in the gallery's collection: Duccio's *Maestà* altarpiece from cathedral in Siena. Other highlights include a number of fine early Renaissance works, such as Jan van Eyck's famous *Arnolfini Portrait*, with its depiction of

Arnolfini's rotund but not – as is often assumed – pregnant wife, in her green dress. Botticelli's *Venus and Mars* (c. 1485) – showing the sleeping god of war, Mars, alongside a sprightly goddess of love, Venus – also pulls in the crowds. Giovanni Bellini's *Doge Leonardo Loredan* (c. 1501), meanwhile, is a fantastic example of a formal state portrait, imbued with all the rigidity that went with its subject's riches and power. Finally, the composition and visual style of Paulo Uccello's early battle scene *The Battle of San Romano* (c. 1438) recalls the *Bayeux Tapestry*, which depicts the Norman conquest of England by William the Conqueror.

Renaissance, 1500–1600. They include several paintings by the great master Leonardo da Vinci. One of them, *The Virgin of the Rocks*, has lately enjoyed new popularity thanks to its role in Dan Brown's *The Da Vinci Code*. The painting really does hold a secret – albeit not one related to some great conspiracy. Using the latest analytic techniques, gallery curators discovered a completely different drawing beneath the surface of the finished painting. It was, in fact, common practice for artists to sketch different designs as part of the creative process. An equally fascinating portrait is *The Ambassadors* (1533), by Hans Holbein the

A beardless Jesus created quite a stir in Caravaggio 's *Supper at Emmaus* (1601).

## The west wing

The west wing of the National Gallery is home to some great works of the late

Younger. It shows the young French ambassador at Henry VIII's court, depicted in the same year that Henry married Anne Boleyn and, in so doing,

# THE NATIONAL GALLERY

With a total of 2,300 paintings, the National Gallery may not be one of the world's biggest collections, but it is one of the greatest. In contrast to its continental European counterparts, the National Gallery was not built around a collection owned by the reigning monarch but was started with just three dozen paintings acquired by the government in 1824. The growing collection moved to its own building on Trafalgar Square in 1838 (see p. 62).

broke with the Catholic Church. Raphael's small painting of *La Madonna dei Garofani* (or *The Madonna of the Pinks*, *c.* 1506) also enjoys great popularity.

## The north wing

The north wing of the gallery houses paintings from 1600–1700. This time, it is the Dutch masters who dominate, although Flemish, Italian, French, and Spanish artists are also represented. Two whole rooms are given over entirely to Rembrandt. They mostly contain portraits, including one of the artist's wife, Saskia, and two self-portraits of the artist aged 34 and 63. Van Dyck, meanwhile, was once engaged as Charles I's court artist, and his equestrian portrait of the king dates from this period. In it, Charles, who was later executed in the Civil War, is depicted as a knight whose right to rule is firmly rooted in the grace of God. The work of Johannes Vermeer is represented by two paintings, both typical of the domestic scenes for which this Dutch master is best known. They provide a stark contrast to Rubens' luxuriant and intricately detailed depiction of *Samson and Delilah*. The most famous Rubens painting in the gallery's collection, however, is *Le Chapeau de Paille*, a tender portrait of the daughter of an Antwerp merchant. Another top attraction is Velázquez's *Rokeby Venus*. Much copied for its elegant depiction of its subject as seen from behind, it is the Spanish master's only surviving nude. Caravaggio's *Supper at Emmaus* is also

noteworthy – with its innovative depiction of a Bible scene, it is considered to be one of the artist's most striking works.

## The east wing

The east wing covers the period 1700–1900 and includes works by French Impressionists such as Gauguin, Cézanne, Monet, Degas, and Renoir. It is largely these works that have made this section of the gallery so popular with the viewing public. The real highlight of the collection, however, is van Gogh's *Sunflowers* – probably his most famous painting. There are several works by Claude Monet on display, including his famous *Water-Lilies*. Monet's two impressionistic depictions of the Palace of Westminster are particularly impressive, one engulfed in fog, the other gleaming in the sunset. The first of Henri Rousseau's famous jungle pictures is equally splendid. A visit to the galleries devoted to 18th-century art is rewarded with a glimpse of the world as seen through the romanticizing eyes of the rococo. The display includes work by the likes of Watteau, Boucher, and Chardin. The main highlights are early landscapes by Gainsborough, Constable, and Turner, as well as *Whistlejacket* – a legendary racehorse magnificently depicted by George Stubbs.

From top: Claude Monet's *Woman seated on a Bench* (on loan from the Tate) and Vincent van Gogh's *A Wheatfield, with Cypresses.*

Tate Britain is the more conventional of London's two Tate galleries. The paintings of William Turner, bequeathed to the nation by the artist himself, form the heart of the collection. Over at Tate Modern, the architecture of this converted power station – with its gigantic turbine hall and the popular Millennium Bridge outside – is a spectacular sight in itself.

**INFO**
*Tate Britain, Millbank;*
*10.00–17.40, daily;*
*Tate Modern,*
*Bankside; Sun–Thurs*
*10.00–18.00; Fri–Sat*
*10.00–22.00;*
*Tel (020) 7887 8888.*
*www.tate.org.uk*

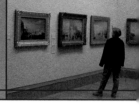

## The Turner Collection

Tate Britain houses the world's largest collection of the works of English Romantic painter, William Turner (1775–1851). There are over 300 oil paintings and some 30,000 drawings and watercolors in the Clore Gallery, while a further nine paintings are on show in the National Gallery, where they are displayed alongside works of other Romantic artists. Turner's style is unmistakable, with hazy landscapes and roughly sketched figures characterizing the later works. Turner's early

*A Music Party* (c. 1835), an uncompleted study: you can almost hear the music in the subtle hues.

landscapes and historical scenes, like *The Battle of Trafalgar*, are alive with movement and emotion. But the most powerful hues are reserved for the paintings that celebrate the mighty force of nature.

## Tate Britain

It's often not Tate Britain's impressive permanent collection, but its special temporary exhibitions that prove to be the gallery's most popular attractions. Equally important is the annual, often controversial Turner Prize for young British artists. The Tate Triennial, held every three years, is an even bigger highlight, exploring big topics like the contemporary meaning of "modern" – the theme of the 2009 exhibition.

Temporary exhibits aside, there is plenty to explore within the main gallery. The collection encompasses a total of 60,000 works, which are shared between the four Tate galleries (two in London, one in Liverpool, and one in St Ives). The works are presented in broadly chronologi-

cal order, starting with the Tudor period around 1500, and going all the way to the present day. Things begin to get really interesting in the 18th century, when English painting starts to develop its own unique style. The works of William Hogarth strike a lighter note, his portraits and, above all, drawings caricaturing and sharply criticizing English society of his day. Portraits by Gainsborough and Reynolds show another, more formal, side of English society at the time.

Another important focus of the collection is provided by its 19th-century landscapes. Alongside Turner, particular emphasis is placed on the work of John Constable and the animal paintings of George Stubbs, whose work concentrated on the depiction of horses and hunting

dogs. The section of the gallery devoted to the 19th-century Pre-Raphaelites, who applied modern painting techniques to mythical themes, is also well worth a visit. The modern art section covers the period 1900–1960, paying special attention to the sculpture of Henry Moore and, in particular, the paintings of Francis Bacon and Lucian Freud. The year 1960 marks a significant landmark in the history of British art. An entire room is devoted to pop art, whose main representatives are Peter Blake and David Hockney. The style was followed by the new conceptual art, which quickly gave rise to a completely new way of thinking about art itself. This climaxed in the "cool Britannia" of the Blair era, when the work of young

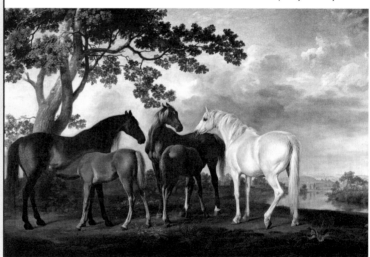

*Mares and Foals in a River Landscape* (1780) by George Stubbs, a popular artist of the nobility.

# TATE BRITAIN AND TATE MODERN

Until 2000, the exhibits now in Tate Britain and Tate Modern were all housed under one roof as the Tate Gallery. The two new galleries are without question London's greatest. While Tate Britain is home to the world's largest collection of British art, from the Tudor period to the present day, Tate Modern is dedicated to contemporary art from around the world – presented in an environment that feels like a work of art in its own right (see p. 74 and p. 110).

artists like Damien Hirst and Tracey Emin created a steady stream of controversy. Today, these artists have been all but adopted by the establishment under the banner of the Young British Artists (YBA), which provides a space for the often disturbing, but frequently astonishing creations of the country's contemporary artists.

## Tate Modern

Since its foundation in 2000, this gallery displaying international contemporary art from 1900 to the present day has really blossomed into one of the world's most popular modern art galleries – even if it has frequently been the focus of criticism. First, the gallery's detractors claimed that its building, a spectacular converted power station, would overpower the collection on show inside. Then there was the highly unconventional way in which the exhibits were initially presented, arranged not – as is generally expected – in chronological order, but according to subject area: Still Life / Object / Real Life, Landscape / Matter / Environment, Nude / Action / Body, and finally History / Memory / Society. Since then, the collection has been rehung, this time by artistic movements of the 20th century. Four wings on levels 3 and 5 are each arranged around one of four key periods, namely surrealism, minimalism, postwar innovations in abstraction and figuration, and the related cubist, futurist, and vorticist movements (vorticism being a specifically British form of modernism).

The works displayed within each theme have engaged with, developed, or actively opposed these key movements. Clearly, the new system is no more chronological than the one it replaces.

The gallery's oldest paintings belong to the fauvist movement, a French branch of expressionism whose exponents include Matisse, Braque, Dufy, and, of course, Picasso. Surrealism and its related movements are also prominent, most notably in the works of Salvador Dalí, Max Ernst, René Magritte, and Joan Miró. Abstract expressionism, meanwhile, is dominated by the movement's American pioneers – names like the action artist Jackson Pollock, as well as Willem de Kooning, Barnett Newman, and Mark Rothko. The latter is given a whole room, in which Rothko's nine Seagram Murals are on display. The pop art section is another highlight, featuring Roy Lichtenstein's comics alongside the equally fantastic works of Andy Warhol, Claes Oldenburg, and David Hockney. Minimalism is explored hand in hand with conceptual art, including works by one Joseph Beuys, the monochrome paintings of Yves Klein, and the three-dimensional images of Donald Judd.

The Tate Boat connects the two galleries, with services running every 40 minutes during gallery opening times.

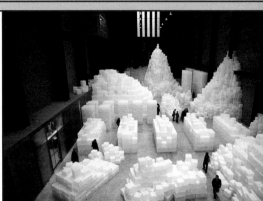

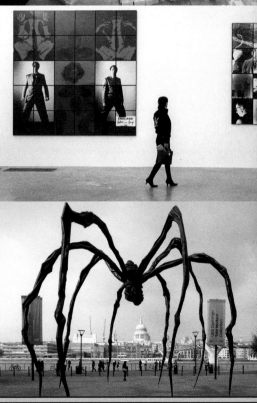

**A space for large-scale art (from top): installations, montages, and large scale sculptures on display in Tate Modern.**

The Victoria and Albert Museum has profited from continuous expansion almost since the day it opened in 1857. Both the museum's collection and its architecture are products of the Victorians' inventive genius and exuberance. Taken as a whole, the museum affords visitors a fascinating insight into a period of history when Britain was at the height of its power.

**INFO**
*Victoria and Albert Museum, Cromwell Road; Tel (020) 7942 2000; Sat–Thurs 10.00–17.45; Fri 10.00–22.00. www.vam.ac.uk*

## Exhibitions

The V&A's temporary exhibitions have proved extremely popular, and you'll find several taking place simultaneously on different floors of the museum. As well as being an opportunity for the V&A to show off the full breadth of its collection, these exhibitions are also a chance for the museum to work with other institutions and contemporary artists. Displays of contemporary Chinese design – timed to coincide with the Beijing Olympics – and the art of drinking are just two examples of the topics that the V&A has

Innovation from China: an example of contemporary Chinese design.

recently explored. Forthcoming exhibitions – all due to take place by 2010 – are set to investigate the magnificent world of the Indian maharajas, the baroque period, Russian tsars, and the triumphant rise of sportswear as a fashion statement.

## Organization of the museum

The museum's collection of historical treasures is displayed across several floors. The first floor galleries cover Asia and Europe until 1600, with additional rooms devoted to fashion, photography, and sculpture, among others. The basement galleries explore Europe from 1600–1800, while the second floor is home to British exhibits from 1500–1760. Metalwork, jewelry, musical instruments, and textiles can be found on the third floor, alongside displays exploring 20th-century modernism and the relationship between Europe and America from 1800–1900. The fourth floor has further British galleries – covering 1760–1900 – as well as displays devoted to architecture and glass. The fifth floor is reserved for seminars and lectures, while the sixth floor is given over to ceramics. Some of the main highlights are detailed below.

## Asia

The Asian galleries on the first floor contain the museum's collection of items from east Asia, south Asia, South-East Asia, and the Middle East. Among the most precious exhibits is the Ardabil carpet. Dating from 16th-century Persia, it is the oldest carpet in the world. The Japanese rooms contain a superb collection of kimonos, as well as some delicate cloisonné enamels. The Chinese displays, meanwhile, include a variety of superb objects for everyday and decorative use.

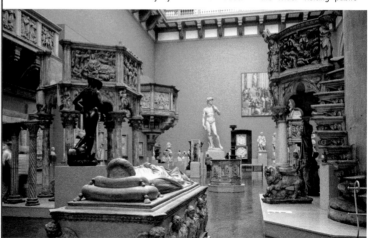

For those who can't see the real thing, cast copies provide a way to learn about historic pieces.

## British galleries

The second and fourth floors of the V&A display an extensive collection of British design. One of the most

ostentatious objects is surely the *Great Bed of Ware* – an imposing 16th-century bed measuring 3.6 m square (12 feet square). Some exhibits – such as King James II's wedding suit and the selection of rooms furnished in different period styles – provide a fascinating insight into the lifestyle of the English gentry. In all, these galleries really do bring the history of English style and design to life.

## Fashion and accessories

The V&A's fashion displays are popular not only with the city's designers, but also with the wider visiting public –

both male and female. The first floor showcases court garments of the 17th century, as well as some superbly decorated swords, early spectacles, and many other fine

# THE VICTORIA AND ALBERT MUSEUM

This superlative museum is home to the world's largest collection of art, craft, and design. Spanning more than 5,000 years, the collection comprises some 4.5 million objects. A mere 70,000 of these exhibits are displayed on regular rotation in the museum's 145 themed galleries. The displays are constantly being rearranged, so you may find that some rooms are closed during your visit (see p. 88).

items. No stylistic stone is left unturned, and you'll even find unconventional items like skirts for men. There are also drawings by the seminal modern designer Vivienne Westwood, and examples of the very latest in haute couture.

## Photography

The V&A's photographic archive dates back to 1852, and only a fraction of the museum's 500,000 pictures is on display in the first floor galleries. Each year, the exhibition focuses on a different period or theme; however, there is a permanent display devoted to the history of photography – a compelling look at the way we perceive and interpret photographic depictions of the world around us.

## Architecture

The fourth floor architecture galleries are home to architectural designs and models from different cultures and historical periods. Christopher Wren, John Nash, Ludwig Mies van der Rohe, Le Corbusier, Daniel Libeskind, and Norman Foster are just some of the great architects represented here. The display also incorporates examples of brilliantly designed objects – such as items by Walter Gropius – as well as replicas of details from some of the world's most famous structures.

## Metalwork

From fine gold and silver to iron, tin, and steel, decorative metalwork is characterized by its inexhaustible variety – and this third floor gallery is a treasure trove of examples. Exhibits range from an 11th-century Anglo-Saxon drinking horn and a 700-year-old bishop's crook, to radical 19th-century teapots designed by Christopher Dresser.

## Sculpture

Back on the first floor, the main feature of the V&A's sculpture galleries are its plaster casts of famous works of art. Mostly copied from European originals, the cast collection includes reliefs, sar-

cophaguses, church doors, and statues such as Bellini's *Perseus*. There are also original objects like the fig leaf designed by prudish Victorians for their cast of Michelangelo's *David*.

## Paintings and drawings

The paintings, drawings, and watercolors displayed on the third floor were mostly acquired in the 19th century. Among the essentially decorative oils and portrait miniatures there are some fine examples of the work of England's great Romantic landscape artist, John Constable.

## Textiles

Also on the third floor, the textile section boasts a breathtaking range of exhibits dating back over 2,000 years. Embroidery, antique silks and prints, and examples of lacework have been gathered from various countries and historical periods. A large space is given over to carpets and wall hangings, including a series of 15th-century hunting scenes.

## Jewelry

The third floor jewelry section is a unique and glittering highlight. With more than 3,500 objects, spanning some 800 years of history, the collection includes diamonds once owned by the tsarina Catherine the Great, as well as diadems, brooches, and necklaces that once belonged to various royal households. The galleries also showcase classic commercial designs by the likes of Lalique, Fabergé, and Cartier.

## Glass

There is a 4,000-year-old tradition of fine glasswork, represented on the fourth floor of the V&A by over 6,000 exhibits. They range from stained-glass windows (further examples of which can be found on the third floor) to historic items like the 13th-century *Luck of Edenhall* glass

**A long tradition of domestic art (from top): the Middle Eastern *Luck of Edenhall* glass, and a 19th-century French ceramic plate.**

(brought back by a crusader returning from Syria), right up to modern-day glass sculpture and installations.

## Ceramics

Housed on the sixth floor, the V&A's ceramics collection is without doubt one of the museum's most important single components. The collection displays fine examples of Meissen and Limoges porcelain alongside Delft tiles and antique pieces from Egypt and the Middle East. The exhibits include all sorts of pottery, and the occasional rather kitsch figurine.

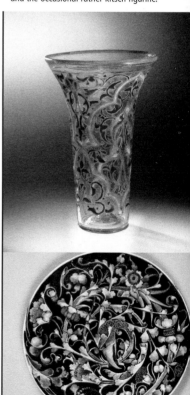

The Natural History Museum opened in 1881. The building's terracotta exterior is decorated with reliefs of both living and extinct flora and fauna, while its cathedral-like entrance hall – with its frescoes, sculptures, and grand staircase – is home to one of the museum's star attractions: an imposing 26-m (85-foot) long replica dinosaur skeleton.

**INFO**
*Natural History Museum,
Cromwell Road,
Tel (020) 7942 5000,
10.00–17.50, daily.
www.nhm.ac.uk*

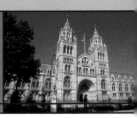

## Visions of Earth

Few museums can beat the impressive entrance to the Natural History Museum's Visions of Earth exhibition. It's a vivid and dramatic illustration of the very cornerstones of human existence. The exhibition opens with six key figures: God, who created the world and everything within it; Atlas, representing the exploration of the world; Medusa, symbolizing the formation of stone; Cyclops, representing the origins of man; an astronaut, allowing us to see the world from space; and finally a geologist discov-

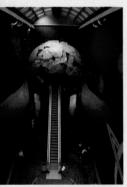

An exciting journey to our planet's inner secrets.

ering the planet's natural resources. An image of the universe is depicted on the wall, while the interplay between man and nature is explored through the display windows. An escalator takes you through a giant globe and into the exhibition proper.

## Blue Zone

This zone contains all the classic natural history exhibits you would expect of a museum such as this. From the tiniest invertebrate to the most giant of blue whales, the exhibition is testament to the diversity of life on earth. The 26-m (85-foot) long plaster skeleton of the *Diplodocus Carnegi* dinosaur – otherwise known as Dippy – makes a pretty big impression the moment you set foot in the entrance hall, but things really get scary when you come to the convincingly lifelike electronically animated *Tyrannosaurus Rex*.

The Human Biology gallery is a journey through the human mind and body. It's up-to-date with the latest advances in genetic science, and also makes good use of technology to help explain the exhibits.

You can listen to the noise a baby hears in its mother's womb, and, in the section on human perception, even experience firsthand how easily our senses can be deceived.

Large mammals are represented in all their fantastic, stuffed diversity. Among them, the polar bear is not quite as cute and cuddly as you might think. There are also skeletons of numerous extinct species.

The biggest mammal alive today is the blue whale, a life-sized model of which is one of the museum's most enduringly popular attractions. By contrast, the fish, amphibians, and reptiles, as well as the marine invertebrates, are of more specialist interest.

## Orange Zone

The Orange Zone combines the living wildlife garden with the rather more sober scien-

tific facilities of the Darwin Centre. Open 1 April–31 Oct, the wildlife garden recreates some of Britain's natural ecosystems – complete with hedgerows, fenlands, ponds, woodland, meadows, and heathland. It is a chance to see typical native plants whose natural habitat has been increasingly encroached upon. The garden is also home to many types of insect, and various species of farm and wild animals.

Situated right next to the garden, the Darwin Centre extension is a natural scientist's paradise. It houses the museum's entire specimen collection. Some date as far back as 1753, and each one is preserved in its own glass bottle. The best way to explore this curious chamber of horrors is to join one of the guided tours. Like the daily lectures on nature and evolu-

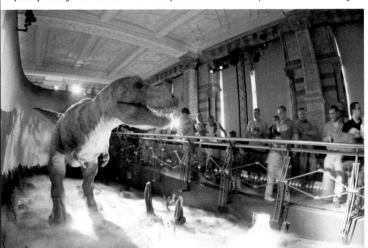

The electronically animated *Tyrannosaurus Rex* is enough to give you a real fright.

# NATURAL HISTORY MUSEUM

Natural history museums have something of a reputation as tired collections of old bones and dusty stuffed animals. But behind its neo-Gothic façade, London's Natural History Museum and the 70 million exhibits within it really do offer an astonishing, brilliantly presented insight into our planet and its natural environment – with no shortage of old bones and stuffed animals along the way (see p. 90)!

tion, the tour also provides a vivid introduction to the modern natural sciences.

## Green Zone

The Green Zone is spread over three floors of the museum. The fossil marine reptiles gallery, birds, insects, and the ecology section are all on the ground floor, with minerals, primates, plants, and mankind's place in the story of evolution explored on the first floor. Finally, you'll find a section of the trunk of a Californian Giant Sequoia tree on the second floor.

Also on display are some of the most extraordinary fossils ever found in England, many of them discovered along the beaches of the south-west coast. Insects are exhibited in their natural habitats, and preserved specimens are also on show in the birds gallery. The ecology section is a vivid and much more contemporary exploration of environmental processes. The display puts our own place in the ecosystem under the spotlight, showing how human intervention has disturbed a delicate natural balance that existed long before man arrived on the scene.

Lovers of jewels won't be the only ones to be enthralled by the mineral section, which delves beneath the surface to investigate just why we attach such high value to certain raw materials. The most precious stones and metals are displayed in the so-called Vault – some rough and unpolished, others glittering gems. The plant section, meanwhile, not only showcases the wide variety of plant life, but also highlights the value of plants as renewable raw materials – be they for food, cosmetic, or pharmaceutical use.

In the next section, the primates serve as a reminder that we are all, ultimately, related. The theme is continued in the gallery devoted to evolution. Though the presentation is a little dry, it nonetheless provides plenty of food for thought.

## Red Zone

The Red Zone gets its own dedicated entrance from Exhibition Road, and is without doubt the most exciting part of the whole museum. More than just a collection of exhibits, this zone is all about asking big questions about the world around us – from the big bang to the formation of our universe, all broken up into 25-million-year-long chunks. The earthquake simulator creates a chillingly realistic impression of what it is like to be caught up in an earthquake or volcanic eruption, and the display vividly illustrates the strains that such natural disasters place upon both man and his environment. Looking beyond natural disasters, the long-term effects of climate change and our pillaging of the planet are explored in the Earth Today and Tomorrow exhibition. It shows just how dependent upon the earth's natural resources we really are.

**All things that do creep and fly – and that are presented in the most modern of museum displays.**

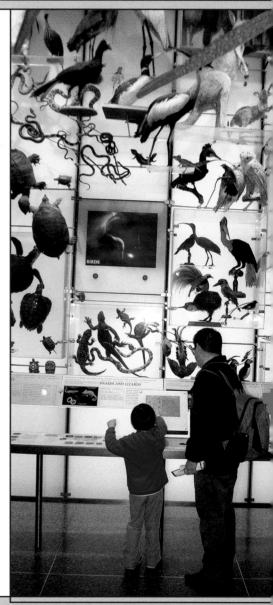

The British Museum's neoclassical façade is truly worthy of this veritable temple of culture. The central Great Court was conceived by top architect Sir Norman Foster in 2000, and is the largest covered square in Europe. The original circular reading room stands in the middle of the court, and is now open to the public.

INFO
*British Museum,
Great Russell Street,
Tel (020) 7323 8299,
10.00–17.30, daily.
www.britishmuseum.
org*

## The Parthenon

The marble sculptures and reliefs from the Parthenon frieze of the Acropolis in Athens continue to be a controversial feature of the British Museum's ancient Greek collection. The circumstances in which these exhibits came to England put the museum's legal and moral claim to them on a very shaky footing. Lord Elgin, British ambassador to the Ottoman Empire, of which Greece was then part, was given permission to remove the marble figures from the Parthenon and ship them to England in 1801 – an act that saw

The Parthenon frieze: a great example of ancient Greek relief.

him accused of vandalism even then. These great treasures were first put on show in the British Museum in 1816, and to this day, Britain and Greece are still arguing over who the Marbles really belong to.

## Ancient Egypt

This part of the collection is divided between the basement and ground floor. It is here, among the sculptures, that you'll find the most celebrated of the exhibits, namely the Rosetta Stone. Dating from the 2nd century BC, this stone fragment helped 19th-century researchers to decipher ancient Egyptian hieroglyphs for the first time. Further highlights are the wall paintings from the tomb of Nebamun, an Egyptian official who lived around 1400 BC. The paintings have now been brought together in one room, where they are displayed alongside related objects from the same period.

Mummies and sarcophaguses – including one of a cat – are an almost obligatory part of the exhibition, shown alongside some of the burial

objects that went with them. The next rooms document the development of Nubian culture along the Nile. Coptic Egypt and the early Christian civilization of Ethiopia are also explored.

## Ancient Greece and Rome

The British Museum is home to the world's biggest collection of items from ancient Greece and Rome, and the exhibits from this period form the largest single part of the museum, spanning all three floors. At the heart of the collection are the so-called Elgin Marbles, a group of marble figures taken from the

Life in ancient times: scenes from the tomb of Nebamun, Thebes, dating from around 1400 BC.

Parthenon (see box, left). The museum also boasts items from other famous buildings, including sculptures from both the mausoleum at

Halikarnassos and the temple of Artemis at Ephesus. The Roman collection, meanwhile, contains items dating from the foundation of Rome in the 8th century BC right up to the emergence of Constantinople as the new capital of Christendom in the 4th century. Finally, the Etruscan world is represented by some really quite incredibly beautiful items.

## The Middle East

This section contains ancient items from the modern-day Islamic world. It is another incredible attraction, and the most extensive collection of its kind in the world. The exhibits span the Assyrian,

Babylonian, and Sumerian eras, including items found in Persia, Mesopotamia, Arabia, Anatolia, the Caucasus, and other parts of the Middle East

# THE BRITISH MUSEUM

The British Museum, home to some 13 million exhibits documents man's entire cultural history. Its encyclopedic collection makes it the largest museum of its kind in the world and it was also the first museum to be opened to the public. Founded in 1753, the museum grew from a private collection owned by physician and naturalist Sir Hans Sloane. Today, the British Museum contains some of the greatest cultural treasures in the world (see p. 120).

**A gold pendant in the form of a crescent moon from the Kievan Rus (*c.* 1100).**

from prehistoric times to the beginnings of Islam in the 7th century. Most of the exhibits were brought to Britain in the 19th century, having been excavated by British archaeologists out in the field. The 22,000 inscribed clay tablets from the library of King Assurbanipal at Nineveh are among the most interesting items, providing an invaluable insight into the ancient cultures of the region.

## Asia

The Asian galleries cover the entire Far East region, from Neolithic times to the present day. They incorporate the world's greatest collection of Indian sculpture, and an equally wide-ranging selection of items relating to both Korean and Chinese culture – including some enchanting 4th-century paintings. You'll also find ancient lacquer work, jade, and porcelain. Japan's cultural heritage is represented by a selection of elegant decorative objects, dating from various historic periods up to the 19th century.

## America

The civilizations of North and central America are each given a room of their own. The North American collection contains items relating to the history of the Native North American peoples, with textiles, totem poles, clothing, splendid feather headdresses, and an 18th-century leather map among the exhibits. The everyday objects and works of art produced by Mexican societies were far more precious, and a number of exam-

ples are also on display here. They include a mask of the Aztec god Quetzalcoatl – covered entirely in turquoise mosaic pieces – as well as some spectacular Mayan items made from gold and jade.

## Africa

The so-called "dark continent" is the birthplace of numerous cultures, and the museum's African collection is accordingly diverse. The exhibits include both archaeological finds and contemporary items. One such highlight is the tree of life, a sculpture made from old weapons in 2004. The brass objects, earthenware, and intricately carved 16th-century ivory masks are also particularly noteworthy.

## Europe

The cultural history of Europe from around 4000 BC to the present day is explored in ten rooms. There are almost too many exhibits, but the scope of the collection allows you to make some extremely exciting connections. This journey through time begins with some of the oldest surviving relics of our early history, bearing witness to a time when the revolutionary social changes precipitated by the introduction of agriculture started to impact Europe's hunter-gatherer population. The Iron Age also brought significant progress, notably in the shape of new weapons and tools. The body of the 1st-century Lindow man is one of the exhibits. He is thought to have been murdered and thrown into a bog, where his remarkably well-preserved remains were discovered during peat-cutting works in 1984. An entire room is devoted to Roman Britain, with a rich collection of objects documenting the enduring legacy of Roman rule on the British Isles.

The early Middle Ages saw the collapse of the Roman Empire and, in its wake, a succession of conquerors each left traces of their own culture. Two particular treasures from this period are the Kells crozier, dating from Ireland in around 1000, and a

rich collection of items from an Anglo-Saxon ship-burial at Sutton Hoo in Suffolk. The gallery covering the late Middle Ages is due to reopen in 2009. Its exhibits include examples of Byzantine art, Romanesque and Gothic items, and some early scientific instruments. Fine examples of art and craftwork drawn from the rest of European history right up to the present day are arranged according to the stylistic periods to which they belong. The clocks and watches room is another interesting gallery, tracing the history of clock- and watch-making from the Middle Ages to the present.

**Indian deity: an intricately carved wooden figure of Krishna (*c.* 1780).**

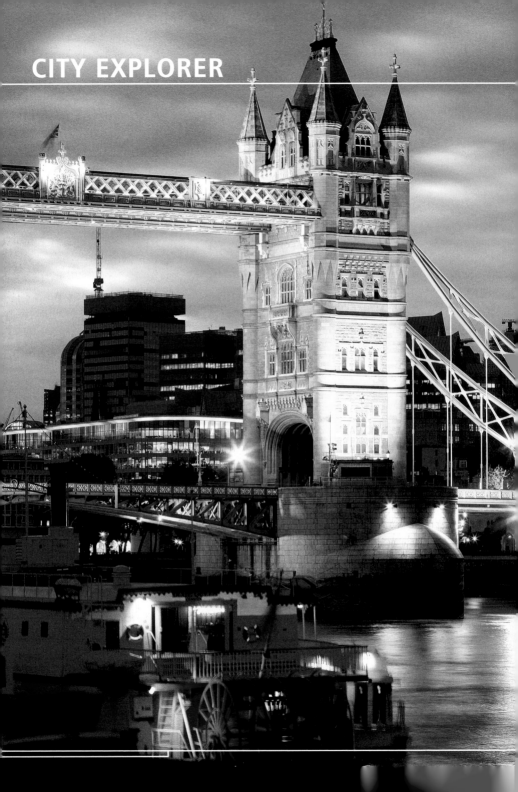

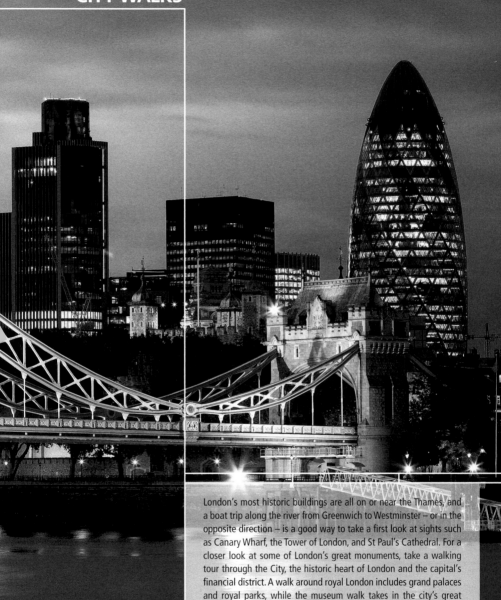

# CITY WALKS

London's most historic buildings are all on or near the Thames, and a boat trip along the river from Greenwich to Westminster – or in the opposite direction – is a good way to take a first look at sights such as Canary Wharf, the Tower of London, and St Paul's Cathedral. For a closer look at some of London's great monuments, take a walking tour through the City, the historic heart of London and the capital's financial district. A walk around royal London includes grand palaces and royal parks, while the museum walk takes in the city's great museums in one of its most exclusive districts. Finally the shopping walk should satisfy those visitors in need of a little retail therapy.

## Sights

### ❶ The Monument
This 61-m (202-foot) high Doric column with its crowning urn of gilded flames was built to commemorate the Great Fire of London of 1666. Built a few years after the fire, the Monument stands exactly 61 m (202 feet) from the spot in Pudding Lane where the catastrophic blaze started. A 311-step spiral staircase leads to the gallery at the top of the column, which has recently undergone extensive restoration work.

### ❷ St Stephen Walbrook
This little church was designed by architect Sir Christopher Wren and constructed between 1672 and 1679. It is best known for both its beautiful, airy interior and its unusual white altar, designed and carved by the sculptor Henry Moore. The telephone in a glass display case symbolizes the Samaritans telephone helpline, which was founded by the then vicar of St Stephen Walbrook in 1953.

### ❸ Mansion House
This 18th-century Palladian building has been the official residence of the Lord Mayor of London since the post was created, and its splendid decoration reflects the importance attached to the position. Though organized groups are admitted by prior arrangement, the building is unfortunately not open to casual visitors.

### ❹ The Bank of England
The Old Lady of Threadneedle Street – as the Bank of England is colloquially known – has been issuing bank notes in England and Wales for more than 300 years. Its imposing Threadneedle Street building exudes gravitas and power. Inside, the Bank of England's fascinating history is told by its own museum (see p. 34).

### ❺ The Royal Exchange
Trade and commerce have always played an important part in the prosperity of London, and from the 16th century most of that activity took place at the Royal Exchange. Today's Royal Exchange is the third exchange building to occupy this site. Although it has long since relinquished its role as the scene of important financial deals, the building continues to serve the City in the guise of a luxury shopping precinct (see p. 34).

### ❻ Guildhall
Parts of the Guildhall go back to the Middle Ages, making it the oldest secular building in London. Built as the town hall of the City of London, it is still used for ceremonial occasions and administrative offices today. It is also open to the public (see p. 38).

### ❼ The Museum of London
This fascinating museum draws on a collection of over one million exhibits to trace the development of London from prehistoric times to the present. Nearby, you'll also find the remains of the Roman city wall. The galleries covering the period after 1666 are closed for redevelopment work until 2010, however.

### ❽ St Paul's Cathedral
St Paul's, Christopher Wren's masterpiece, is well worth a longer visit. It is the most imposing church in London, and quite possibly in the whole of England. The interior is sumptuous yet still elegant, while the magnificent view from the dome is just breathtaking. Construction of the cathedral began in 1675 and was completed in 1710 (see p. 42).

### ❾ The Temple of Mithras
The remains of the 3rd-century Temple of Mithras were discovered during construction work in 1954. They are some of the oldest bits of historic London. The cult of Mithras is based on a Persian religion, and was very popular among Roman soldiers. Items found in the excavation of the remains can be viewed at the Museum of London.

The Royal Exchange is a symbol of London's wealth.

## Shopping

### ❶ Royal Exchange
Whether it's a Lulu Guinness handbag, a pair of Gucci shoes, a Hermès scarf, or perfume from Molton Brown or Penhaligon's, this luxury shopping complex will cater for your every material desire. Oysters and champagne are, of course, also in ample supply. Whether you consume them as refreshment, or to therapeutically soften the

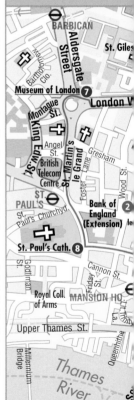

# HISTORIC LONDON

Despite the plethora of new buildings, central London has retained many historic gems. This tour cuts through the hustle and bustle of a thriving metropolis to uncover some of the city's most famous and less familiar buildings. (For London dial 020.)

blow of the luxury price tags, is up to you.
*Threadneedle Street, Mon–Fri 10.00–18.00. www.theroyalexchange.com*

**2 Thorntons**
This confectionery chain has branches across London. Just try to resist the traditional caramels, scrumptious truffles, fruit jellies, and luxury chocolates!
*43 Cheapside; Tel 7248 6776; Mon Fri 8.00–20.00;*

*Sat 9.00–16.00. www.thorntons.co.uk*

**3 Leadenhall Market**
It used to be meat and fish that were sold in this Victorian market hall. The market's beautiful, old-fashioned shop fronts now belong to restaurants, delicatessens, boutiques, and other stores.
*Whittington Avenue/ Gracechurch Street; Mon–Fri 7.00–16.00, www.leadenhallmarket.co.uk*

**4 Petticoat Lane Market**
Whether you're after a new outfit or some basic household goods, this is the place to come. You'll even see some designer names, but beware – not everything with a designer label or logo is the genuine article! That said, there are good buys to be had, including good-value clothing.
*Between Middlesex Street and Goulston Street; Sun 9.00–14.00; www. petticoatlanerentals.co.uk*

## Eating and drinking

**1 Lombard Street**
This Michelin-starred eatery is housed in a listed former banking hall. The bar and brasserie are relatively casual, but the restaurant is much more formal. The food is European in style, with tapas served at the bar. Prices are at the upper end of the market.
*1 Lombard Street; Tel 7929 6611; Mon–Fri: brasserie 7.30– 23.00; restaurant 12.00– 14.30 and 18.00–22.00; bar 11.00– 00.00 (tapas from 17.00). www.1lombardstreet.com*

**2 The Place Below**
Possibly the most atmospheric restaurant in town, The Place Below is located in the crypt of Christopher Wren's St Mary-le-Bow Church. It serves tasty, healthy vegetarian fare.
*St Mary-le-Bow, Cheapside; Tel 7329 0789; Mon–Fri 7.30–15.00. www.theplacebelow.co.uk*

**3 Ciro's Pizza Pomodoro**
Housed in a former Turkish bathhouse, this restaurant serves tasty pizza, pasta, and other Italian dishes at reasonable prices.
*7–8 Bishopsgate Churchyard; Tel 7920 9207;, Mon–Fri 12.00–0.00. www.ciros-bishopsgate.co.uk*

**4 Market Coffee House**
A cozy coffee house with an old-fashioned interior that provides a welcome respite from the décor of its trendy modern competitors.
*52 Brushfield Street; Tel 7247 4110; Mon–Fri 8.00–18.00; Sat 10.00–18.30; Sun 9.00–18.30.*

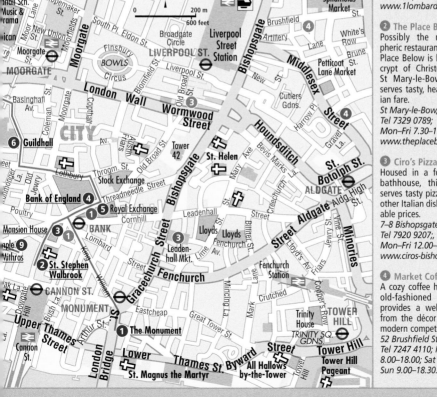

## Sights

### ❶ Marble Arch
Designed by John Nash in 1828, this modestly sized yet no less magnificent neoclassical arch is made of white marble. It originally stood outside Buckingham Palace, but was moved to its current position on the edge of Hyde Park in 1851 to make way for palace extensions. The area used to be known as Tyburn, when it was the infamous location of public executions.

### ❷ Speakers' Corner
Freedom of speech is taken very seriously indeed on this corner of Hyde Park. It's a place where you can argue almost any opinion, no matter how obscure or hard to fathom. The police only intervene when there is a complaint, or when speakers break the law (see p. 80).

### ❸ Oxford Street
Europe's biggest shopping street is in fact quite narrow, but still has what it takes to exhaust even the most determined shopper. The street is 2.5 km (1.5 miles) long and boasts over 300 shops. You'll find big name stores like Selfridges, Marks & Spencer, Debenhams, House of Fraser, Gap, and Topshop – as well as plenty of traffic and thousands of shoppers.

### ❹ Carnaby Street
In the 1960s, Carnaby Street was the capital of swinging London. Today, the area has been pedestrianized, with 12 streets of independent fashion boutiques and lifestyle stores to explore. Carnaby Street itself looks much as it did when designer Mary Quant invented the miniskirt, although its alternative credentials have long given way to mainstream status.

### ❺ Regent Street
John Nash designed Regent Street in the 19th century, adorning its architecture with many of his typically elegant signature features. The shops are equally high-end. Held at the beginning of June, the annual street festival is also noteworthy. Alongside music, it offers young designers a chance to display their latest fashions in the stores.

### ❻ Savile Row
The world's best-dressed moneyed gentlemen have been coming to this little shopping street since the 18th century. Savile Row is synonymous with fine, tailor-made men's suits. Many of the tailors based here count film stars and royalty among their customers.

### ❼ Soho
The odd brothel and strip club notwithstanding, Soho has long shed its reputation as a red-light district. Today, this multicultural area is the focal point of the city's nightlife. The area around Berwick Street is famous for its market and music shops, while Old Compton Street and the streets around it form the city's main gay area, with plenty of shops catering to the gay community.

### ❽ Chinatown
Still in Soho, Gerrard Street is the heart of London's Chinatown. It is essentially a shopping area, with lots of Chinese shops, supermarkets, and restaurants. The Chinese community puts on numerous festivals, but the biggest are the Chinese New Year celebrations in February and the dragon boat festival in June.

### ❾ Piccadilly
The street named Piccadilly is much more exclusive than the famous Piccadilly Circus. The jewel in Piccadilly's crown is the Ritz Hotel, and some of the shops here – notably Fortnum & Mason, founded in 1770 – boast royal warrants. You'll also find some big bookshops and the offices of numerous airlines (see p. 64).

## Shopping

### ❶ Selfridges
London's second biggest department store after Harrods is full of high-quality goods. The shop is famous for its striking displays and decor, as well as its unusual exhibitions. All in all, the world's first truly theatrical department store is as dramatic now as it has always been.
*100 Oxford Street, Tel 0800 123 400,*

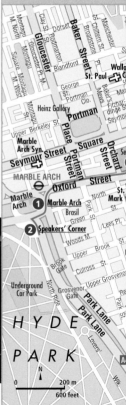

**There's no mincing of words at Speakers' Corner.**

# SHOPPING HEAVEN

London has always been a great shopping city. You'll find products from all over the world, and the range is really excellent. Starting from Marble Arch, this walk guides you through some of the main shopping areas. (For London dial 020.)

Mon–Wed 9.30–20.00;
Thurs–Sat 9.30–21.00;
Sun 12–18.00.
www.selfridges.com

**②** Grays Antique Market
This is one of the biggest antiques markets in the world. There are over 200 traders selling fine jewelry, rare books, puppets, clothing, furniture, and much more besides. Don't expect a bargain, but you can be sure that it's all genuine and original.

58 Davies Street,
Tel 7629 7034,
Mon–Fri 10.00–18.00.
www.graysantiques.com

**③** Liberty
More Tudor castle than department store, Liberty is a real feast for the eyes. From designer cutlery to Vitra furniture, only the very finest products make it into the store's home department. The legendary Liberty sale takes place at the end of June.

210–220 Regent Street;
Tel 7734 1234; Mon–Sat 10.00–21.00; Sun 12.00–18.00.
www.liberty.co.uk

**④** Berwick Street Market
This street market in the heart of Soho sells fruit and vegetables, household goods, fabrics, and clothing. A number of independent record shops add to the market's charm.
Berwick Street,
Mon–Sat 9.00–18.00.

## Eating and drinking

**❶** Gordon Ramsay at Claridge's
Assuming he's not busy filming a TV show, you might find celebrity chef Gordon Ramsay at work in the kitchen of one of London's most exclusive hotels. His top-quality food comes with top-quality prices.
Claridge's Hotel, 53 Brook Street; Tel 7499 0099; Mon–Fri 12.00–14.45 and 17.45–23.00; Sat 12.00–15.00 and 17.45–23.00; Sun 12.00–15.00 and 18.00–22.30.
www.claridges.co.uk
www.gordonramsay.com

**❷** Sacred Café
A New Zealand café in the middle of London. You'll find strong coffee and fine teas alongside soups, salads, sandwiches, and cakes – all served in a spiritually inspired setting.
13 Ganton Street, off Carnaby Street; Tel 7734 1415; Mon–Fri 8.00–20.00; Sat 10.00–20.00; Sun 11.00–18.00; www.sacredcafe.co.uk

**❸** Golden Dragon
More and more tourists are discovering this well-loved local restaurant. It serves the very best Chinese food, with dishes from across China.
28 Gerrard Street;
Tel 7734 2763; Mon–Thurs 12.00–23.30; Fri–Sat 12.00–0.00; Sun 11.00–23.00.

**❹** Bar Bruno
This unpretentious café comes close to being a true greasy spoon, its traditional fatty fare complemented by some healthier dishes. The real highlight, though, is the English all-day breakfast.
101 Wardour Street; Tel 7734 3750; 6.00–22.00, daily.

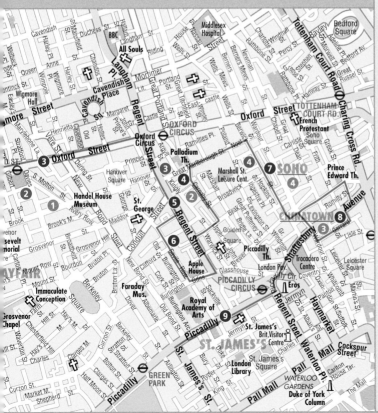

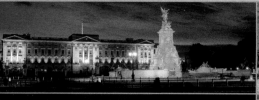

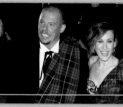

## Sights

### ❶ Wellington Arch

Built in 1830, this triumphal arch occupies a traffic island between the garden of Buckingham Palace and Hyde Park. It is an unmistakable landmark, thanks in large part to its crowning Quadriga – the largest bronze statue in Europe. Until 1992, the arch's tiny rooms housed a police station. Today, they serve as a small museum.

### ❷ The Royal Mews

Originally designed by architect John Nash, the royal stables at Buckingham Palace are now more of a garage. The royal family's golden state coaches are kept here, alongside their horses and their entire fleet of motorized vehicles.

### ❸ Buckingham Palace

London's most famous royal palace is not only the British monarch's official residence, but also the place where foreign heads of state, members of the aristocracy, and other VIPs and dignitaries are ceremonially received. During the summer months, anyone can go inside – although only the staterooms are open to the public (see p. 76).

### ❹ Clarence House

Another John Nash building, Clarence House was the home of the much-loved Queen Mum until her death in 2002. Today, it is the London residence of Prince Charles, his wife Camilla, and Princes William and Harry. Guided tours of the palace operate during the summer, although they only cover the ground floor of the building.

### ❺ St James's Palace

Located on the splendid thoroughfare that is the Mall, this is one of London's oldest palaces. It was originally commissioned by Henry VIII, and continued to provide a home for British monarchs until 1837. Today, the palace complex comprises several buildings that serve both as offices for the royal administrative machine, and as the official residence of the queen's daughter, Princess Anne.

### ❻ Admiralty Arch

Coming from nearby Trafalgar Square, the three arches of Admiralty Arch form a grand entrance to the regal Mall that leads to Buckingham Palace. The arch is surrounded by government buildings. Its middle gate is only opened for ceremonial occasions such as royal processions and state visits.

### ❼ Banqueting House

The Palace of Whitehall served as the official residence of English monarchs from 1530. By 1650, the palace had, with some 1,500 rooms, become the largest building in Europe, but it was largely destroyed by fire in 1698. The Banqueting House is the last surviving part of the original palace. Notable for its Renaissance-style décor – highly unusual in England at the time – and its ceiling painting by Peter Paul Rubens.

### ❽ 10 Downing Street

This rather modest-looking townhouse has been home to British prime ministers since 1732. Judging by its world-famous exterior, the building doesn't seem very big at all – but don't be fooled. The black door opens into a complex that more than measures up to expectations. Originally three buildings, it contains both offices and private accommodation.

### ❾ The Churchill Museum

In 2002, a BBC poll named Winston Churchill the greatest Briton of all time, and it comes as no surprise to find that there is a whole museum devoted to the great statesman. The museum occupies the bunker in which the then prime minister and his cabinet met during World War II. The 21 historic rooms not only document Churchill's life, but also showcase some of the kitsch memorabilia created in his memory.

### ❿ The Palace of Westminster

The royal palace that is the focal point of British government traces its roots back to the 11th century, although the building in its current incarnation dates from the 19th century. It is surely one of London's best-known buildings. The real landmark tourist magnet, however, is the building's clock tower – otherwise known as Big Ben. The clock's almost legendary accuracy is the reason that Londoners still look to it to ring in the new year (see p. 68).

### ⓫ Westminster Abbey

This is a truly splendid Gothic abbey. Over 3,300 people are buried here, among them numerous monarchs, as well as poets, artists, scientists, and statesmen. It has been the traditional scene of English and British coronation ceremonies since William the Conqueror fought his way to the English throne in 1066 (see p. 70).

## Shopping

### ❶ Alexander McQueen

The enfant terrible of the British fashion scene made his name with controversial designs. Today, McQueen's clothes are slightly more conventional. Some of his garments are sold here in his flagship store, although you'll need to make an appointment.
*4–5 Bond Street;*
*Tel 7355 0088; www.*
*alexandermcqueen.com*

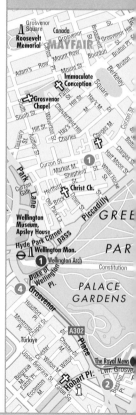

From left: Buckingham Palace provides a popular photo opportunity; the changing of the palace guard; and the international fashion trendsetter Alexander McQueen.

# ROYAL LONDON

Palaces, parks, and empire – this tour guides you through royal London and the government buildings of Whitehall, an area that often plays host to ceremonial appearances by the queen and the regular Changing of the Guard ceremony. (For London dial 020.)

## ② Fortnum & Mason
This most exclusive of grocery stores has been supplying the royal family with fine delicacies for more than 300 years, and no high-society picnic is complete without one of the store's famous hampers.
*181 Piccadilly,*
*Tel 7734 8040,*
*Mon–Sat 10.00–20.00; Sun 12.00–18.00.*
*www.fortnumandmason.com*

## ③ The Bollywood Store
Sparkly slippers, glamorous jewelry, and bright saris compete with Bollywood film posters and DVDs for space in this tiny little shop. It's perfect for an unusual present.
*37 St Martin's Court,*
*Tel 7379 9300,.*
*Mon–Fri 10.00–18.00;*
*Sat 10.00–15.00.*

## ④ Berry Bros & Rudd
With its vaulted cellars, this traditional shop is heaven for wine lovers. They've been selling the world's best vintages here for some 300 years, including – of course – champagne. Priced at nearly £900, a bottle of Roederer Cristal Rosé is the shop's most expensive product, but you can pick up a half-bottle of the house red or white for around a fiver.
*3 St James's Street,*
*Tel 7396 9557; Mon–Fri 10.00–19.00; Sat 10.00–17.00; www.bbr.com*

## Eating and drinking

### ① Ye Grapes
More village inn than metropolitan bar, this Victorian pub provides a cozy refuge in a pretty exclusive area. It's a little bit off the beaten track, but you'll be rewarded with real ale and good English food.
*16 Shepherd Market,*
*Tel 7499 1563,*
*Mon–Sat 11.00–23.00;*
*Sun 12.00–22.30.*

### ② The Goring
Located practically next door to Buckingham Palace, this hotel is a bastion of aristocratic tradition. Its excellent, airy restaurant serves fine English food.
*15 Beeston Place; Grosvenor Gardens; Tel 7396 9000, Mon–Fri and Sun 12.30– 14.30; 18.00–22.00, daily.*
*www.goringhotel.co.uk*

### ③ The Wolseley
One of London's grandest café restaurants, its refined decor is the epitome of good taste. You'll find French brasserie-style food on the menu, although the real highlight is afternoon tea – a very stylish affair. Breakfast is also a popular choice.
*160 Piccadilly; Tel 7499 6996; Mon–Fri 7.00–0.00; Sat 8.00– midnight; Sun 8.00–23.00.*
*www.thewolseley.com*

### ④ Mango Tree
An elegant restaurant, serving the finest Thai cuisine in a most agreeable atmosphere.
*45 Grosvenor Place;*
*Tel 7823 1888;*
*Mon–Wed 12.00–15.00 and 18.00–23.00; Thurs–Sat 12.00–15.00 and 18.00– 23.30; Sun 12.00–22.30.*
*www.mangotree.org.uk*

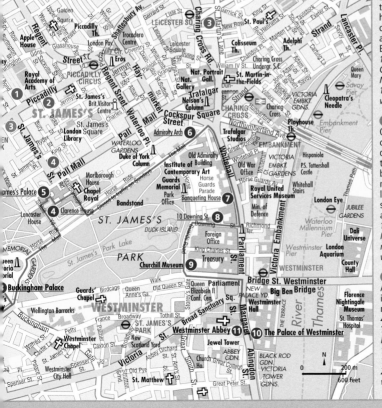

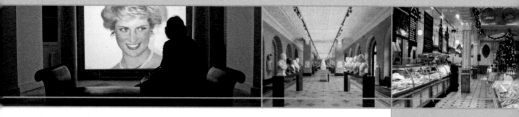

## Sights

**❶ Kensington Palace**
This 17th-century palace is most frequently associated with Princess Diana, who lived here following her divorce from Prince Charles until her death. The palace now hosts an exhibition of some of Diana's dresses, but there's much more to see than this – notably the splendid staterooms and the collection of royal ceremonial costume (see p. 96).

**❷ Princess Diana Memorial Fountain**
This fountain in Diana's memory was opened in the southwest corner of Hyde Park in 2004. It's best described less as a fountain than as a granite canal, whose slight slope allows the water to flow along both sides of its oval shape. It is an artistic water feature designed to symbolize both Diana's openness and her love of children (see p. 98).

**❸ The Serpentine Gallery**
This pretty tea pavilion in Kensington Gardens is one of London's most popular contemporary art galleries. Famous artists from Henry Moore to Andy Warhol and Damien Hirst have all had their work exhibited here. Held in July, the gallery's summer party has become a permanent fixture of the celebrity calendar.

**❹ Albert Memorial**
The Albert Memorial was commissioned by Queen Victoria in 1876 to commemorate her husband Prince Albert. Try to identify the famous figures depicted in the reliefs around the base of the monument – there are 169 in total, drawn from the fields of literature, music, painting, sculpture, and architecture. Shakespeare, Bach, Mozart, Michelangelo, and da Vinci are all to be found on the structure (see p. 80).

**❺ The Science Museum**
The Science Museum brings the complicated world of science to life. The museum is home to over 300,000 exhibits that document the history of science throughout the Western world, and its interactive displays and use of digital technology really allow visitors to experience the latest scientific procedures and equipment at first hand. You can, for example, use on-screen manipulation to add years to your appearance (or strip them away). Alternatively, dive into the three-dimensional world of IMAX cinema.

**❻ Natural History Museum**
The 70 million specimens at the Natural History Museum

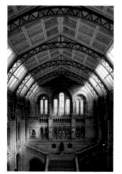

There are more than 70 million exhibits at the Natural History Museum.

fascinate both young and old alike – hardly surprising, given that this is the homeland of Charles Darwin, author and proponent of the theory of evolution. On display in the magnificent building, you'll find geological samples and a collection of stuffed and otherwise preserved specimens that spans every area of biological interest. There's much more to the museum than this, however, and the fascinating themed exhibitions really give you an in-depth insight into the laws and natural processes of nature (see p. 90 and p. 176).

**❼ The Victoria and Albert Museum**
This is not the kind of museum that you can tick off the list with a quick look. With over four million exhibits in some 145 galleries, the V&A literally covers every area of art and design. Its vast collection incorporates items from all over the former British empire, including both modern items and more historic curiosities. Prepare to be amazed. This is a truly astonishing – albeit exhausting – attraction (see p. 88 and p. 174).

**❽ The Brompton Oratory**
The Brompton Oratory's proper name is the Church of the Immaculate Heart of Mary. The building, which boasts the third biggest nave in England, is an exact copy of the Gesù Church in Rome. Built in 1884, the oratory was the first new Catholic church in England since the Reformation. Mass is still celebrated in Latin. Visitors are expected to dress and behave appropriately in the oratory.

## Shopping

**❶ Portobello Market**
Made famous by Hugh Grant and Julia Roberts in *Notting Hill*, Portobello Market is one of London's best. You'll find second-hand clothes, bric-a-brac, books, and groceries.
*Portobello Road,
Mon–Wed and Fri–Sat
8.00–18.30; Thurs 8.00–13.00
(times vary according to
time of year and weather).
www.portobellomarket.org*

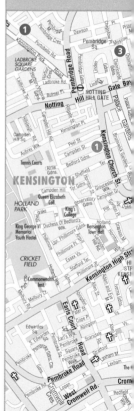

**From left: The memorial to Diana at Kensington Palace; busts at the Victoria and Albert Museum; and a spectacular display at Harrods.**

# THE GREAT MUSEUMS OF KENSINGTON

This walk takes you from Kensington Palace to the great museums in one of London's most exclusive areas. (For London dial 020.)

### ② Harvey Nichols
Knightsbridge would not be Knightsbridge without a suitably exclusive department store, and "Harvey Nicks" more than fits the bill. The rich and famous come here to buy a designer outfit, enjoy culinary delicacies, or pick up a few luxury accessories.
*109–124 Knightsbridge, Tel 7235 5000, Mon–Sat 10.00–20.00; Sun 12.00–18.00.
www.harveynichols.com*

### ③ Emily
A hat is an essential item of any society lady's wardrobe and this boutique caters for the self-respecting lady's every millinery requirement, from Ladies' Day at Ascot racecourse to the queen's garden party.
*Studio 06, Hurlingham Studios, Ranelagh Gardens; Tel 7243 876; Mon–Fri 10.00–19.00; weekends by appointment.
www.emily-london.com*

### ④ Harrods
Europe's biggest department store stocks everything from chocolate bars to antique desks. It is famous not only for its ability to satisfy the most extravagant of its customers' requests, but also for the fact that it successfully turns shopping into a truly exciting experience.
*87–135 Brompton Road; Tel 7730 1234; Mon–Sat 10.00–20.00; Sun 12.00–18.00; www.harrods.com*

## Eating and drinking

### ① The Churchill Arms
A magical and – judging by the Churchill memorabilia – patriotic pub. The pub's Thai food is popular with locals.
*119 Kensington Church Street, Tel 7792 1246, Mon–Fri 11.00–23.00; Sat 11.00–0.00; Sun 12.00–22.30*

### ② Ten Tables
Located within the Rydges Hotel, there are just ten widely spaced tables in this light and airy, slightly Spanish-feeling restaurant. It serves homemade, authentic Modern European cuisine and char grills.
*Rydges Kensington Plaza Hotel, 61 Gloucester Road, Tel 7584 8100, 17.30–22.00, daily.
www.rydges.co.uk*

### ③ Frankie's
One of a small London chain of sleek Italian bar and grill restaurants jointly owned by jockey Frankie Dettori and chef Marco Pierre White.
*3 Yeomans Row, off Brompton Road; Tel 7590 9999; www.frankiesitalianbarandgrill.com*

### ④ Bibendum
Restaurant, oyster bar, and café are all housed in the former Michelin House, and Bibendum does its best to live up to its building's name with a menu of French-inspired dishes.
*Michelin House, 81 Fulham Road; Tel 7581 5817; Mon–Fri 12.00–14.30 and 19.00–23.00; Sat–Sun 12.30–15.00 and 19.00–22.30.
www.bibendum.co.uk*

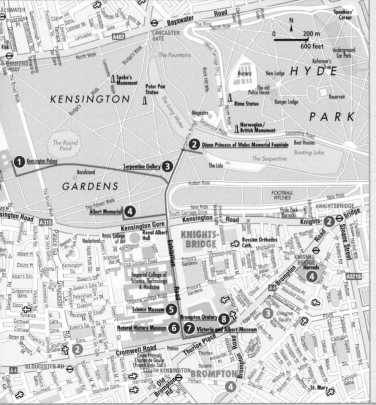

**TOUR OPERATORS**

**City Cruises,** *Cherry Garden Pier, Bermondsey, Tel 77 40 04 00. Sightseeing boats depart from Westminster Pier, Waterloo Pier, Tower Pier, and Greenwich Pier. 17 March–31 Aug from Greenwich approx. every hour*

*from 10.50–18.10 daily; from Westminster approx. twice an hour 10.00–18.00 daily. By night, the London Showboat trip includes a meal, live music, and dancing. April–Oct Wed–Sun; Nov, Dec, and March Thurs–Sat; Jan–Feb Fri–Sat.*

**Flying Fish Tours,** *Tel (0844) 991 5050, www.flyingfishtours.co.uk, Tours depart from Blackfriars Pier and, by prior arrangement, Victoria Embankment. The jet boats travel from Blackfriars Pier to the Thames Barrier and back.*

## Sights

**❶ The Old Royal Naval College**
This fine example of English baroque architecture is yet another building bearing the signature of Christopher Wren. It started life as a hospital for sailors and their relatives, becoming a naval college in the 19th century – a purpose it continued to serve until 1998. It is now occupied by the University of Greenwich.

**❷ Queen's House**
Look between the wings of the Old Royal Naval College to catch sight of this Palladian pavilion. It is one of the last remaining examples of the work of architect Inigo Jones. Originally built for the wife of King James I, it is now a museum.

**❸ The Royal Observatory**
The Greenwich meridian – the longitude line that separates the eastern and western hemispheres – runs right through Greenwich Park. The time ball on the observatory roof is still raised every day, falling to the bottom of its mast at 13.00 Greenwich Mean Time (GMT) in winter and 13.00 BST in summer.

**❹ The National Maritime Museum**
This is one of the leading museums of its kind in the world. Its fascinating collection tells the story of British naval power, and explores the ecology of the oceans.

**❺ The Millennium Dome**
The huge Millennium Dome was originally part of an ambitious project to mark the turn of the millennium. The exhibition inside, billed as a celebration of the third millennium, fell rather flat, however, and the dome was later transformed into the $O_2$ Arena – an entertainment complex (see p. 140).

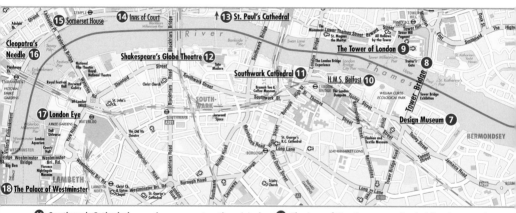

**❶❶ Southwark Cathedral**
Very few truly historic buildings have survived along the south bank of the Thames, but this Anglican church dates back thousands of years. It is one of the area's primary landmarks (see p. 114).

**❶❷ Shakespeare's Globe**
William Shakespeare is England's – and possibly the world's – greatest poet. The playhouse he built with his own drama company was destroyed by fire some 300 years ago, but a replica was finally built on almost exactly the same spot as the original in 1997 (see p. 112).

**❶❸ St Paul's Cathedral**
The cathedral is a symbol of British resilience in the face of adversity. Built after the Great Fire of 1666, this baroque church was Christopher's Wren greatest masterpiece – the building that really cemented its architect's place in history. St Paul's magnificent dome towers 108 m (354 feet) above the city, a fact that for a long time made it London's tallest building (see p. 42).

**❶❹ The Inns of Court**
The Inns of Court are the four societies of English barristers and their offices. It's a world far removed from the busy city that surrounds it, thanks not only to the exclusivity of its members' profession but also to the idyllic setting of the historic complex of buildings itself – complete with labyrinthine passageways and green spaces. It's a real oasis on the edge of the City.

**❶❺ Somerset House**
Somerset House lies right on the bank of the river. Its neo-classical façade conceals an important cultural and entertainment complex, with art galleries, concerts, and other events. The building was originally the official residence of the Duke of Somerset, and served various administrative functions for over 200 years.

**❶❻ Cleopatra's Needle**
Rising some 21 m (69 feet) above the Thames, this 3,500-year-old Egyptian obelisk is hard to miss. In reality it has nothing to do with Queen Cleopatra herself, but was

**The Thames, depicted here at the Millennium Bridge, has been a catalyst of London's development since the city's foundation.**

# THAMES BOAT CRUISE

This water-borne route follows the river between Greenwich Pier and Westminster Pier in either direction. It passes all the most famous London landmarks, and there are additional stops at Tower Pier and Waterloo Pier. (For London dial 020.)

**6 Canary Wharf**
London's tallest buildings are a gleaming example of post-modernist architecture and a landmark symbol of the global metropolis's financial hub. Canary Wharf was built on the Isle of Dogs as part of the regeneration of the Docklands area (see p. 136).

**7 The Design Museum**
This little museum was once a banana warehouse. Its current modernist appearance

provides a striking contrast to the grandiose exterior of nearby Tower Bridge. The changing temporary exhibitions are well worth a visit.

**8 Tower Bridge**
By far London's most beautiful bridge, this masterpiece of Victorian engineering is even more of an attraction when you pass underneath it by river. When the bridge opens it is quite an event, and worth waiting to see (see p. 28).

**9 The Tower of London**
The magnifcent crown jewels and a long list of famous historical prisoners have made the Tower of London one of the most popular tourist attractions on the banks of the Thames. Comprising far more than just the original central bastion known as the White Tower, the complex bears witness to the entire history of British rule throughout the centuries (see p. 30).

**10 HMS *Belfast***
HMS *Belfast* was built at the Harland & Wolff dockyards in Belfast in 1938. Now a museum ship, its operational history includes a role in the D-Day landings off the coast of Normandy during World War II. It is a proud symbol of England's former naval power. Would-be sailors of all ages will take great pleasure in exploring both the cruiser's history and its battleship equipment.

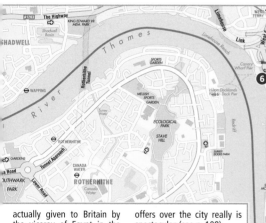

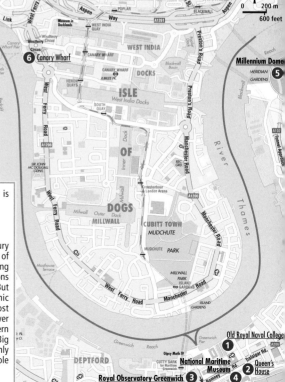

actually given to Britain by the viceroy of Egypt in the 19th century to commemorate Nelson's victory over the Napoleonic armies at the Battle of the Nile.

**17 The London Eye**
Located on the South Bank, the London Eye is, at a height of 65 m (443 feet), the world's biggest Ferris wheel. Like the Millennium Dome, it was originally erected to celebrate the start of the new millennium. It is now one of London's biggest tourist magnets, and the view it

offers over the city really is spectacular (see p. 108).

**18 The Palace of Westminster**
This imposing 19th-century palace is the focal point of British government, housing both the House of Commons and the House of Lords. But the extensive neo-Gothic building is probably most famous for the clock tower located on its north-eastern face. Popularly known as Big Ben, it is a landmark not only for London, but for the whole of England.

From Westminster Bridge, you can see the statue of the warrior queen Boudicca, the leafy Victoria Embankment along the north side of the Thames, the unmistakable big wheel of the London Eye, and, a little further down the river, Tate Modern.

## KEY

| | |
|---|---|
| | Primary route (expressway) |
| | A road (arterial road) |
| | Minor road |
| | Side road (local road) |
| | Footpath |
| | Pedestrian zone |
| | Railway (railroad) |
| | Industrial railway (railroad) |
| | Regional/suburban railway (railroad) |
| | Underground (subway)/ under construction/planned |
| | Ferry |
| | Congestion charge zone |

196 198 200 202
194
204 206 208 210

# CITY ATLAS

The maps in the City Atlas section give detailed practical information to help make your stay more enjoyable. Clear symbols indicate the position of buildings and monuments of note, facilities and services, public buildings, the transport network, and built-up areas and green spaces (see the key to the maps below).

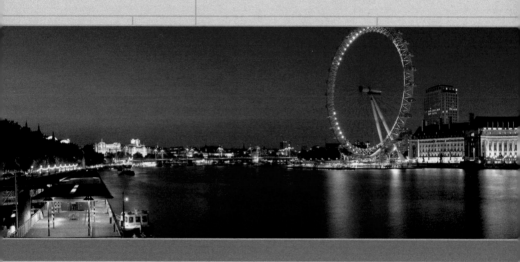

| | | | |
|---|---|---|---|
| | Densely built-up area; Thinly built-up area | A40 | Primary route (expressway) number | ⊕ | Hospital |
| | Public building | A404 | A road (arterial road) number | ♪ | Radio/television tower |
| | Building of note; Industrial building | ♪ | Embassy | ♱ | Church |
| | Green space | ➤ | One-way street | ✡ | Synagogue |
| | Wooded area | ✈ | Airport | ☾ | Mosque |
| ⁺₊⁺ ʟʟʟ | Cemetery; Jewish cemetery | 🏟 | Stadium | ⎗ | Column/ monument |
| ⬒ | Principal train station | 🏴 | Exhibition hall | ⬆ | Tower |
| ⊑⊒ | National Rail | P+R | Park and ride | ⬚ | Theater |
| ⊖ | London Underground | PP | Car park; Multi-story car park | M̂ | Museum |
| ⊖ | London Transport | 🚎 | Bus station | 📖 | Library |
| | | ⓘ | Information | ✳ | Viewpoint |
| | | ✉ | Post office | ⚓ | Docks |

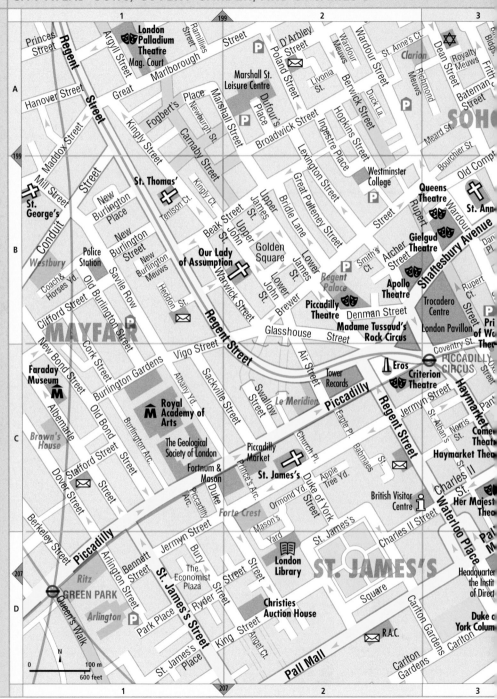

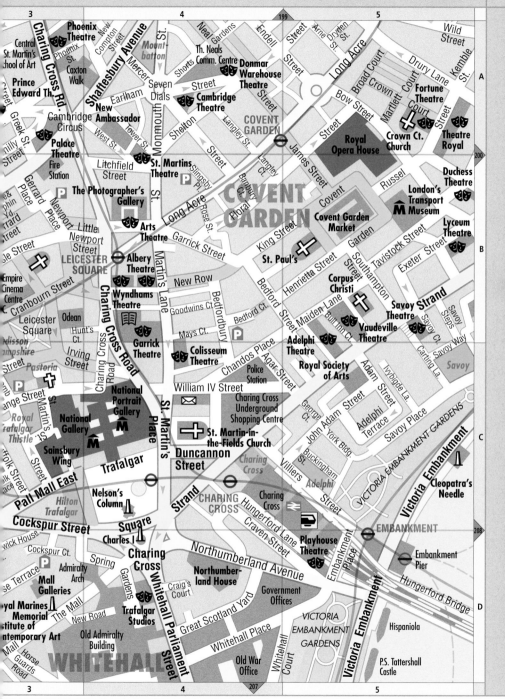

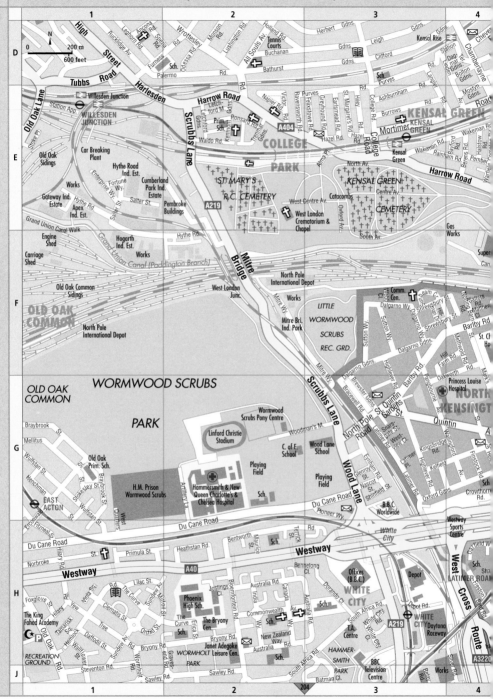

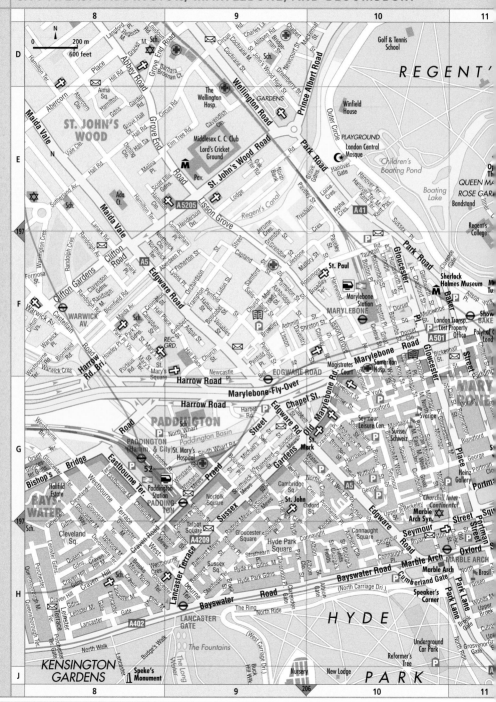

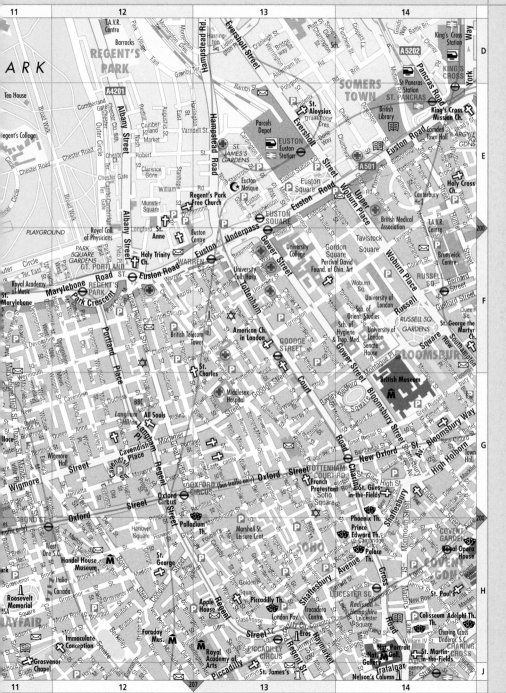

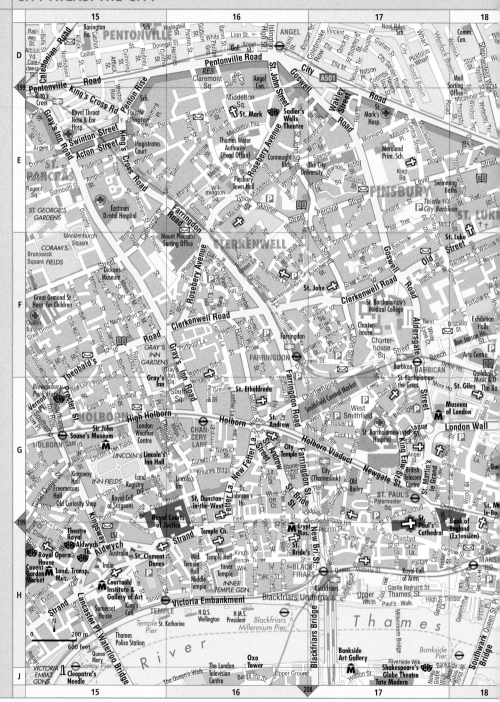

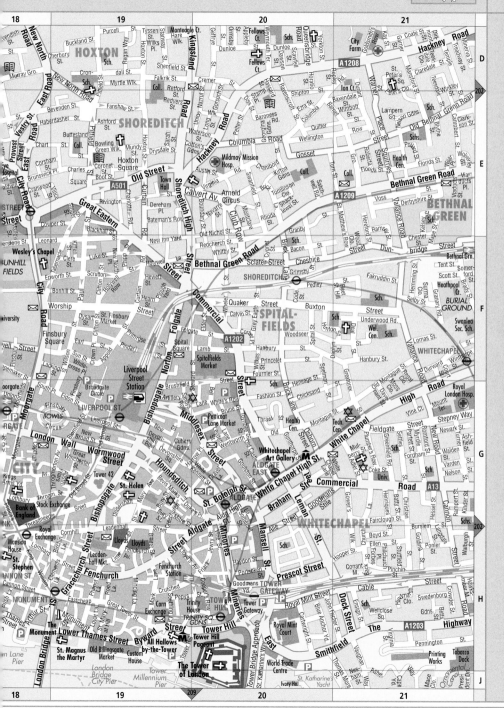

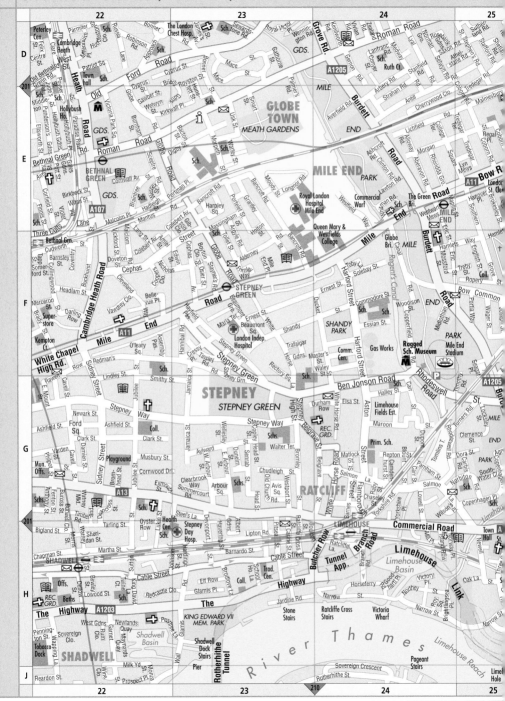

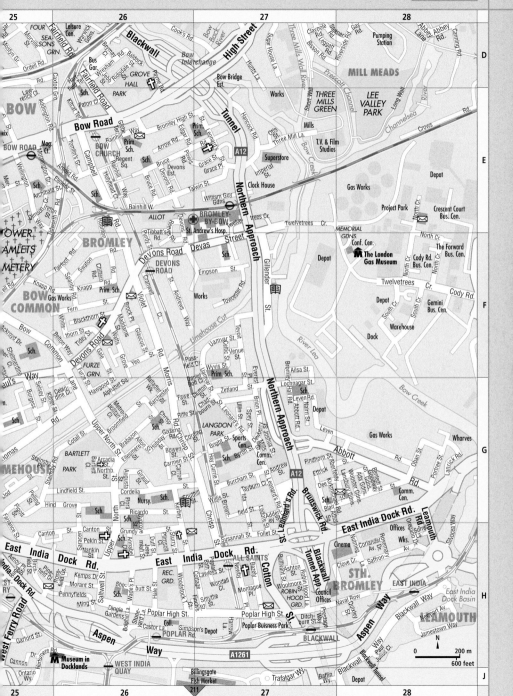

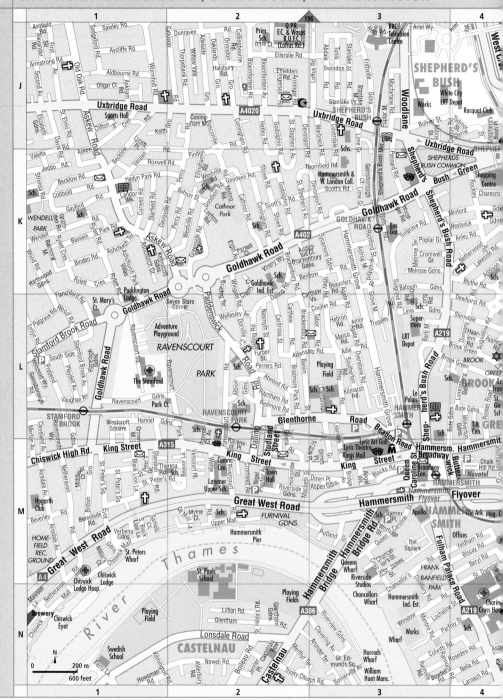

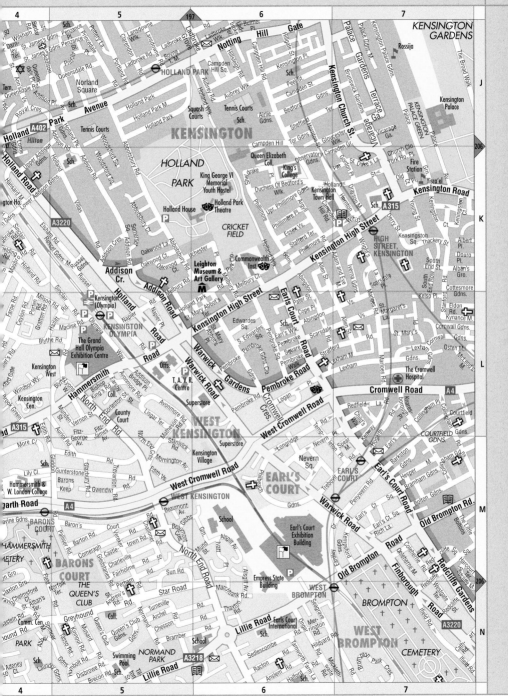

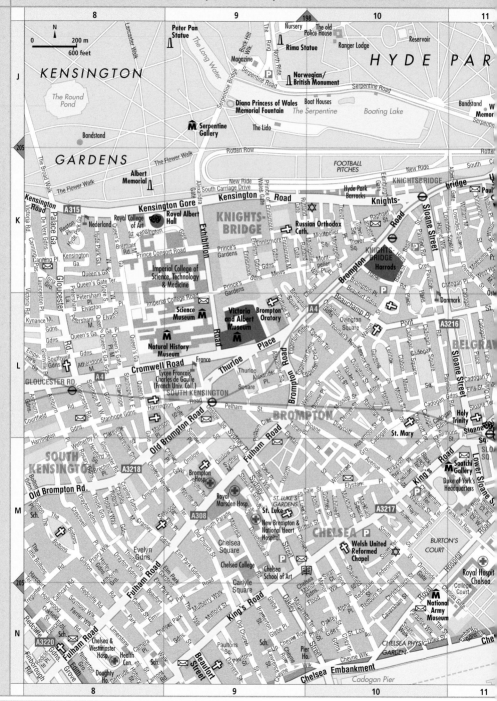

N

0    200 m
600 feet

**KENSINGTON**

The Round
Pond

Peter Pan
Statue

Nursery

198

Buck Hill Wk.

The Ring

North Ride

The old
Police House

Ranger Lodge

Reservoir

Rima Statue

**HYDE PARK**

Magazine

Norwegian/
British Monument

Serpentine Bridge

Serpentine Road

Serpentine Road

Diana Princess of Wales
Memorial Fountain

The Serpentine

Boat Houses

Boating Lake

Bandstand

W
Memor

The Lido

Serpentin

Serpentine
Gallery

Bandstand

**GARDENS**

The Flower Walk

Rotten Row

FOOTBALL
PITCHES

New Ride

Rotter

The Broad Walk

Albert
Memorial

The Flower Walk

Alexandra Gate

South Carriage Drive

New Ride
Wales Gate

Prince of Wales Gate

Hyde Park
Barracks

New Ride

KNIGHTSBRIDGE

Edinburgh Gate

South Ca

bridge

Paul'

U

Kensington
Road

A315

Kensington Gore

Royal College
of Art

Royal Albert
Hall

**KNIGHTS-
BRIDGE**

Kensington    Road

Knights-

Knights-

Russian Orthodox
Cath.

Sloane Street

Nederland

Queen's Ga.

Prince Consort Road

Exhibition

Prince's
Gardens

Ennismore Gdns.

Montpelier

Trevor
Sq.

Raphael

Road

**KNIGHTS-
BRIDGE**

Harrods

Prince's
Gardens

Imperial College
of Science, Technology
& Medicine

Imperial College Road

Mews

Montpelier
Pl.

Brompton

Beauchamp Pl.

Dannmark

A4

Science
Museum

Victoria
and Albert
Museum

Brompton
Oratory

Ovington

A3216

**BELGRAV**

Natural History
Museum

Brompton

Place

Ovington
Square

Pont

Cadogan
Square

Sloane Street

Cromwell Road

Lycee Francais
Charles de Gaulle
(French Univ. Coll.)

Thurloe

Thurloe
Square

Alexander Sq.

Holy
Trinity

GLOUCESTER RD

A4

SOUTH KENSINGTON
Road

Pelham    St.

**BROMPTON**

St. Mary

Sloane
Sq.

SLOA
SQ.

Harrington

Pelham

Sydney St.

King's

Saatchi
Gallery

**SOUTH
KENSINGTON**

A3218

Brompton
Hosp.

Onslow

Fulham    Road

Duke of York's
Headquarters

Old Brompton Rd.

Royal
Marsden Hosp.

St. Luke

ST. LUKE'S
GARDENS

A3217

**CHELSEA**

BURTON'S
COURT

New Brompton &
National Heart
Hospital

A308

Evelyn
Gdns.

Chelsea
Square

Chelsea College

Welsh United
Reformed
Chapel

Royal Hospital
Chelsea

The Boltons

Chelsea
School of Art

Carlyle
Square

College
Court

**National
Army
Museum**

Fulham Road

Fulham Road

King's    Road

CHELSEA PHYSIC
GARDEN

A3220

Chelsea &
Westminster
Hosp.

Health
Cen.

Pier
Ho.

Cheyne Wlk.

Chelsea Embankment

Che

Beaufort
Street

Paultons
Sq.

Cadogan Pier

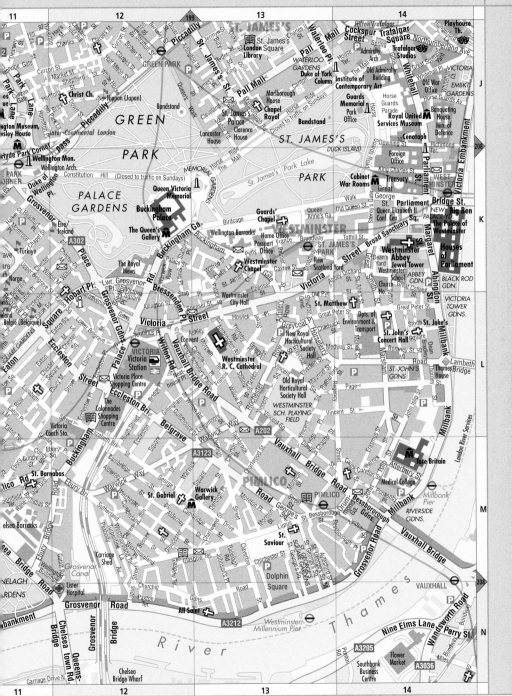

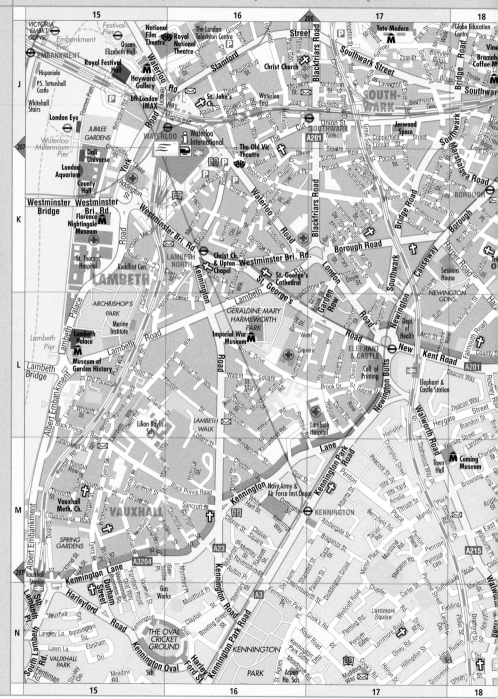

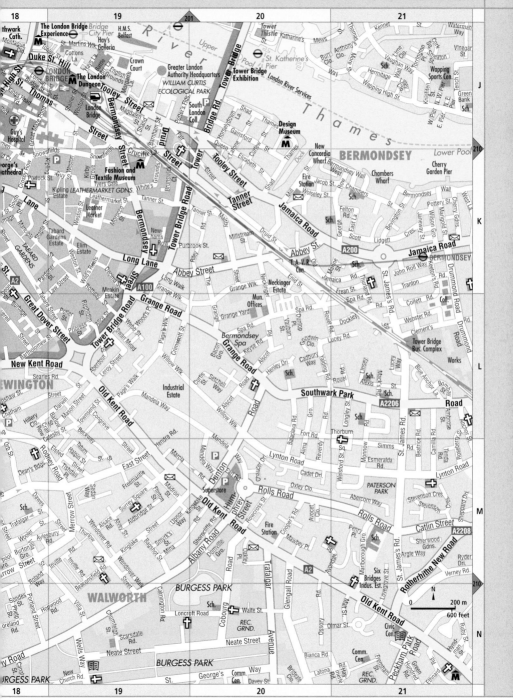

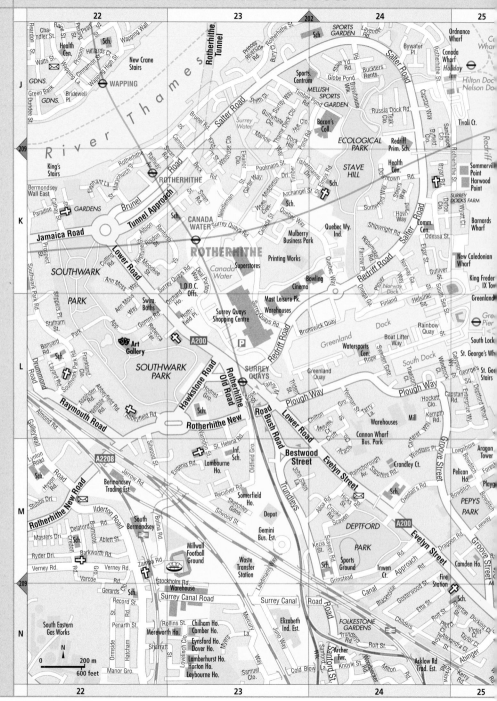

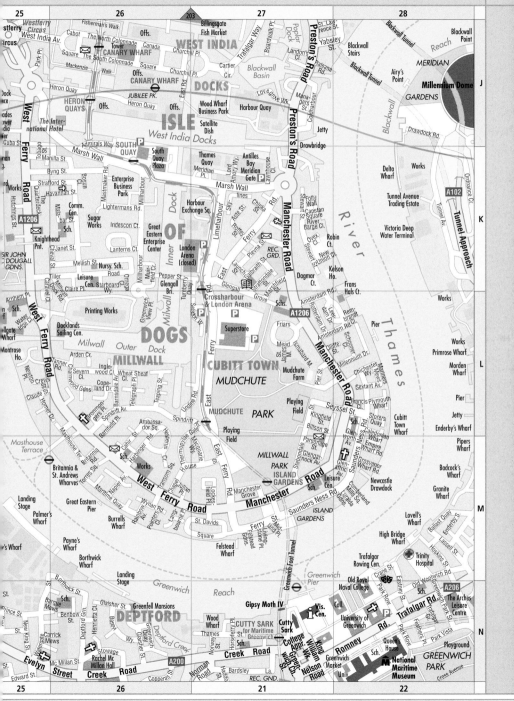

| Street | Page | Grid |
|---|---|---|
| **A**bbey Gardens | 198 | D8 |
| Abbey Orchard Street | 207 | K14 |
| Abbey Street | 209 | K20 |
| Abercorn Close | 198 | E8 |
| Abercorn Place | 198 | D8 |
| Abercorn Way | 209 | M21 |
| Aberdeen Place | 198 | F9 |
| Aberdour Street | 209 | L19 |
| Abingdon Street | 207 | K14 |
| Acton Street | 200 | E15 |
| Adam Street | 200 | H15 |
| Adam's Row | 199 | H11 |
| Addington Street | 208 | K15 |
| Adeline Place | 199 | G14 |
| Adler Street | 201 | G21 |
| Adpar Street | 198 | F9 |
| Affleck Street | 200 | D15 |
| Agdon Street | 200 | E17 |
| Air Street | 199 | H13 |
| Alaska Street | 208 | J16 |
| Albany Road | 209 | M20 |
| Albany Street | 199 | E12 |
| Albemarle Street | 199 | J12 |
| Albert Embankment | 208 | L15 |
| Albert Gate | 206 | K11 |
| Alberta Street | 208 | M17 |
| Albion Close | 198 | H10 |
| Albion Gate | 198 | H10 |
| Albion Place | 200 | F17 |
| Albion Street | 198 | H10 |
| Albion Yard | 200 | D15 |
| Aldbridge Street | 209 | M19 |
| Aldenham Street | 199 | D13 |
| Aldermanbury Square | 200 | G18 |
| Alderney Street | 207 | M12 |
| Aldersgate Street | 200 | G17 |
| Aldford Street | 199 | J11 |
| Aldgate | 201 | G20 |
| Aldgate High Street | 201 | G20 |
| Aldwych | 200 | H15 |
| Alexander Place | 206 | L9 |
| Alexander Square | 206 | L9 |
| Alexandra Gate | 206 | K9 |
| Alexis Street | 209 | L21 |
| Alfred Place | 199 | F13 |
| Alice Street | 209 | L19 |
| Alie Street | 201 | G20 |
| Allington Street | 207 | L12 |
| Allitsen Road | 198 | D9 |
| Allsop Place | 198 | F11 |
| Alma Grove | 209 | L20 |
| Alma Square | 198 | E8 |
| Alpha Crescent | 198 | E10 |
| Alpha Place | 206 | N10 |
| Alsace Road | 209 | M19 |
| Alscot Road | 209 | L20 |
| Alvey Street | 209 | M19 |
| Ambergate Street | 208 | M17 |
| Ambrosden Avenue | 207 | L13 |
| Ambrose Street | 209 | L21 |
| Amelia Street | 208 | M17 |
| Ampton Street | 200 | E15 |
| Amwell Street | 200 | E16 |
| Anchor Street | 209 | L21 |
| Angel Mews | 200 | D16 |
| Angel Street | 200 | G17 |
| Angle Street | 208 | M18 |
| Anthony's Close | 209 | J21 |
| Appold Street | 201 | F19 |
| Aquinas Street | 208 | J16 |
| Arch Street | 208 | L17 |
| Archery Close | 198 | H10 |
| Argle Way | 209 | M21 |
| Argyle Street | 199 | E14 |
| Argyll Street | 199 | G12 |
| Arlington Street | 207 | J13 |
| Arnold Circus | 201 | E20 |
| Arnside Street | 208 | N18 |
| Arthur Street | 201 | H18 |
| Artillery Lane | 201 | G20 |
| Artillery Row | 207 | L13 |
| Arundel Street | 200 | H15 |
| Ashbridge Street | 198 | F9 |
| Ashburn Gardens | 206 | L8 |
| Ashburn Place | 206 | L8 |
| Ashby Street | 200 | E17 |
| Asher Way | 201 | J21 |
| Ashford Street | 201 | E19 |
| Ashley Place | 207 | L13 |
| Ashmill Street | 198 | F9 |
| Astell Street | 206 | M10 |
| Atherstone Mews | 206 | L8 |
| Atterbury Street | 207 | M14 |
| Aubrey Place | 198 | D8 |
| Auckland Street | 208 | M15 |
| Augustus Street | 199 | E12 |
| Aulton Place | 208 | M16 |
| Austin Friars | 201 | G19 |
| Austral Street | 208 | L16 |
| Aveline Street | 208 | M16 |
| Avery Row | 199 | H12 |
| Avocet Close | 209 | M20 |
| Avon Place | 208 | K18 |
| Avondale Square | 209 | M21 |
| Aybrook Street | 199 | G11 |
| Aylesbury Road | 209 | M19 |
| Aylesbury Street | 200 | F17 |
| Aylesford Street | 207 | M13 |
| Ayres Street | 208 | J18 |
| **B**ack Church Lane | 201 | G21 |
| Back Hill | 200 | F16 |
| Bacon Grove | 209 | L20 |
| Bacon Street | 201 | F20 |
| Bainbridge Street | 199 | G14 |
| Baker Street | 198 | F11 |
| Baker's Mews | 198 | G11 |
| Baker's Row | 200 | F16 |
| Balaclava Road | 209 | L20 |
| Balcombe Street | 198 | F10 |
| Balderton Street | 199 | H11 |
| Baldwin Street | 201 | E18 |
| Baldwins Gardens | 200 | F16 |
| Balfe Street | 200 | D15 |
| Balfour Street | 209 | L18 |
| Baltic Street | 200 | F17 |
| Bank End | 208 | J18 |
| Bankside | 200 | H17 |
| Banner Street | 200 | F18 |
| Barbara Brosnan Court | 198 | D9 |
| Barge House Street | 200 | J16 |
| Barlow Street | 209 | L19 |
| Barnby Street | 199 | E13 |
| Barnet Grove | 201 | E21 |
| Barnham Street | 209 | J19 |
| Baron Street | 200 | D16 |
| Baron's Place | 208 | K16 |
| Baroness Road | 201 | E20 |
| Barrett Street | 199 | G11 |
| Barter Street | 199 | G14 |
| Bartholomew Close | 200 | G17 |
| Bartholomew Street | 209 | L18 |
| Basil Street | 206 | K10 |
| Basinghall Avenue | 201 | G18 |
| Basinghall Street | 201 | G18 |
| Bastwick Street | 200 | F17 |
| Bateman Street | 199 | H13 |
| Bateman's Row | 201 | E19 |
| Bath Street | 200 | E18 |
| Bath Terrace | 208 | L18 |
| Bathurst Mews | 198 | H9 |
| Bathurst Street | 198 | H9 |
| Battle Bridge | 199 | D14 |
| Battle Bridge Lane | 209 | J19 |
| Batty Street | 201 | G21 |
| Baxendale Street | 201 | E21 |
| Bayley Street | 199 | G13 |
| Baylis Road | 208 | K16 |
| Beaconsfield Road | 209 | M19 |
| Beak Street | 199 | H13 |
| Bear Gardens | 200 | J18 |
| Bear Lane | 208 | J17 |
| Beatrice Road | 209 | L21 |
| Beauchamp Place | 206 | L10 |
| Beaufort Gardens | 206 | L10 |
| Beaufort Street | 206 | N9 |
| Beaumont Place | 199 | F13 |
| Beaumont Street | 199 | F11 |
| Beckway Street | 209 | M19 |
| Bedale Street | 209 | J18 |
| Bedford Avenue | 199 | G14 |
| Bedford Place | 199 | F14 |
| Bedford Row | 200 | F15 |
| Bedford Square | 199 | G14 |
| Bedford Street | 199 | H14 |
| Beech Street | 200 | F18 |
| Beeston Place | 207 | L12 |
| Belgrave Mews North | 206 | K11 |
| Belgrave Mews South | 207 | K11 |
| Belgrave Mews West | 206 | K11 |
| Belgrave Place | 207 | L11 |
| Belgrave Road | 207 | M13 |
| Belgrave Square | 207 | K11 |
| Bell Lane | 201 | G20 |
| Bell Street | 198 | F9 |
| Bell Wharf Lane | 200 | H18 |
| Bell Yard | 200 | G16 |
| Belvedere Road | 208 | J15 |
| Benjamin Street | 200 | F17 |
| Bentinck Street | 199 | G11 |
| Berkeley Square | 199 | H12 |
| Berkeley Street | 207 | J12 |
| Bermondsey Street | 209 | J19 |
| Bermondsey Wall East | 209 | K21 |
| Bermondsey Wall West | 209 | K21 |
| Bernard Street | 199 | F14 |
| Berners Mews | 199 | G13 |
| Berners Street | 199 | G13 |
| Berry Street | 200 | F17 |
| Berryfield Road | 208 | M17 |
| Berwick Street | 199 | H13 |
| Bessborough Gardens | 207 | M14 |
| Bessborough Place | 207 | M14 |
| Bessborough Street | 207 | M13 |
| Bethnal Green Road | 201 | E21 |
| Betterton Street | 199 | G14 |
| Betts Street | 201 | H21 |
| Bevenden Street | 201 | E19 |
| Bevington Street | 209 | K21 |
| Bevis Marks | 201 | G19 |
| Bianca Road | 209 | N20 |
| Bickenhall Street | 198 | F10 |
| Bidborough Street | 199 | E14 |
| Billiter Street | 201 | H19 |
| Binney Street | 199 | H11 |
| Birchin Lane | 201 | H19 |
| Birdcage Walk | 207 | K13 |
| Birkenhead Street | 200 | E15 |
| Bishop's Bridge Road | 198 | G8 |
| Bishop's Terrace | 208 | L16 |
| Bishopsgate | 201 | G19 |
| Bittern Street | 208 | K17 |
| Black Prince Road | 208 | L15 |
| Blackfriars Bridge | 200 | H17 |
| Blackfriars Lane | 200 | H17 |
| Blackfriars Road | 208 | J17 |
| Blackfriars Underpass | 200 | H16 |
| Blackhall Street | 201 | E19 |
| Blacklands Terrace | 206 | M10 |
| Blackwood Street | 209 | M18 |
| Blandford Street | 198 | G11 |
| Bletchley Street | 200 | D18 |
| Blomfield Road | 198 | F8 |
| Blomfield Street | 201 | G19 |
| Blomfield Terrace | 207 | M11 |
| Bloomsbury Place | 199 | G14 |
| Bloomsbury Square | 199 | G14 |
| Bloomsbury Street | 199 | G14 |
| Bloomsbury Way | 199 | G14 |
| Blue Anchor Lane | 209 | L21 |
| Blue Anchor Yard | 201 | H20 |
| Blythe Street | 201 | E21 |
| Bolsover Street | 199 | F12 |
| Bolton Place | 206 | M8 |
| Bolton Street | 207 | J12 |
| Bombay Street | 209 | L21 |
| Bondway | 207 | N14 |
| Bonhill Street | 201 | F19 |
| Bonnington Square | 209 | N15 |
| Boot Street | 201 | E19 |
| Borough High Street | 209 | J18 |
| Borough Road | 208 | K17 |
| Boscobel Street | 198 | F9 |
| Boston Place | 198 | F10 |
| Boswell Street | 200 | F15 |
| Boundary Road | 208 | N18 |
| Boundary Street | 201 | E20 |
| Bourdon Street | 199 | H12 |
| Bourne Street | 207 | M11 |
| Bouverie Place | 198 | G9 |
| Bouverie Street | 200 | H16 |
| Bow Lane | 200 | H18 |
| Bow Street | 200 | H15 |
| Bowling Green Lane | 200 | F16 |
| Bowling Green Street | 208 | N16 |
| Bowling Green Way | 201 | E19 |
| Boyd Street | 201 | H21 |
| Boyfield Street | 208 | K17 |
| Boyson Road | 208 | N18 |
| Brackley Street | 200 | F18 |
| Brad Street | 208 | J16 |
| Bradenham Close | 209 | N18 |
| Braganza Street | 208 | M17 |

| | | | | | | | |
|---|---|---|---|---|---|---|---|
| Braham Street | 201 | G20 | Budge's Walk | 198 | H8 | Carnaby Street | 199 | H13 | Cherbury Street | 201 | D19 |

Braham Street 201 *G20*  
Bramerton Street 206 *N9*  
Brandon Mews 201 *G18*  
Brandon Street 208 *L18*  
Bray Place 206 *M10*  
Bread Street 200 *H18*  
Bream's Buildings 200 *G16*  
Brechin Place 206 *M8*  
Bremner Road 206 *K8*  
Brendon Street 198 *G10*  
Bressenden Place 207 *L12*  
Brewer Street 199 *H13*  
Brick Lane 201 *E20*  
Brick Street 207 *J12*  
Brideale Close 209 *N20*  
Bridge Place 207 *L12*  
Bridge Street 207 *K14*  
Bridgeman Street 198 *D9*  
Bridgeway Street 199 *D13*  
Bridle Lane 199 *H13*  
Brill Place 199 *D14*  
Briset Street 200 *F17*  
Britannia Way 201 *E18*  
Britten Street 206 *M10*  
Britton Street 200 *F17*  
Broad Court 200 *H15*  
Broad Sanctuary 207 *K14*  
Broad Walk 199 *E11*  
Broadbent Street 199 *H12*  
Broadgate Circle 201 *G19*  
Broadley Street 198 *F9*  
Broadley Terrace 198 *F10*  
Broadstone Place 198 *G11*  
Broadway 207 *K13*  
Broadwick Street 199 *H13*  
Brockham Street 208 *K18*  
Brompton Place 206 *K10*  
Brompton Road 206 *L9*  
Brompton Square 206 *L9*  
Bronti Close 208 *M18*  
Brook Drive 208 *L16*  
Brook Gate 198 *H11*  
Brook Street 199 *H12*  
Brook Street 198 *H9*  
Brook's Mews 199 *H12*  
Brooke Street 200 *G16*  
Brooke's Court 200 *G16*  
Brooks Mews North 198 *H8*  
Brown Hart Gardens 199 *H11*  
Brown Street 198 *G10*  
Browning Street 208 *M18*  
Brownlow Mews 200 *F15*  
Brune Street 201 *G20*  
Brunswick Court 209 *K19*  
Brunswick Place 201 *E18*  
Brunswick Square 200 *F15*  
Brushfield Street 201 *G20*  
Bruton Lane 199 *H12*  
Bruton Place 199 *H12*  
Bruton Street 199 *H12*  
Bryanston Mews East 198 *G10*  
Bryanston Mews West 198 *G10*  
Bryanston Square 198 *G10*  
Bryanston Street 198 *H10*  
Buck Hill Way 198 *J9*  
Buckingham Gate 207 *K12*  
Buckingham Palace Road 207 *L12*  
Buckingham Street 199 *J14*  
Buckland Street 201 *D19*  
Bucknall Street 199 *G14*  

Budge's Walk 198 *H8*  
Bulstrode Place 199 *G11*  
Bulstrode Street 199 *G11*  
Bunhill Row 201 *F18*  
Burbage Street 209 *L18*  
Burlington Arcade 199 *H13*  
Burlington Gardens 199 *H13*  
Burr Close 209 *J20*  
Burslem Street 201 *G21*  
Burton Grove 209 *M18*  
Burton Street 199 *E14*  
Bury Place 199 *G14*  
Bury Street 201 *G19*  
Bury Street 207 *J13*  
Bury Way 206 *M9*  
Bush Lane 201 *H18*  
Bute Street 206 *L9*  
Buttesland Street 201 *E19*  
Buxton Street 201 *F21*  
Byward Street 201 *H19*  

Cabbell Street 198 *G9*  
Cable Street 201 *H21*  
Cadbury Way 209 *L20*  
Cadet Drive 209 *M20*  
Cadiz Street 208 *M18*  
Cadogan Gardens 206 *L10*  
Cadogan Lane 206 *L11*  
Cadogan Place 206 *K11*  
Cadogan Square 206 *L10*  
Cadogan Street 206 *L10*  
Cale Street 206 *M9*  
Caledonia Street 200 *D15*  
Callow Street 206 *N8*  
Calmington Road 209 *N19*  
Calshot Street 200 *D15*  
Calthorpe Street 200 *E15*  
Calvert Avenue 201 *E20*  
Calvin Street 201 *F20*  
Cambr. Terrace 199 *E12*  
Cambridge Circle 199 *H14*  
Cambridge Gate 199 *E12*  
Cambridge Square 198 *G9*  
Cambridge Street 207 *M12*  
Camera Place 206 *N8*  
Camilla Road 209 *L21*  
Campbell Street 198 *F8*  
Canada Place 211 *J26*  
Canal Street 209 *N18*  
Canning Passage 206 *K8*  
Canning Place 206 *K8*  
Cannon Street 200 *H18*  
Cannon Street Road 201 *H21*  
Canrobert Street 201 *E21*  
Cape Yard 201 *J21*  
Capland Street 198 *F9*  
Capper Street 199 *F13*  
Carburton Street 199 *F12*  
Cardigan Street 208 *M16*  
Cardington Street 199 *E13*  
Carey Street 200 *G15*  
Carlisle Lane 208 *K15*  
Carlisle Place 207 *L13*  
Carlisle Street 199 *G13*  
Carlos Place 199 *H11*  
Carlton House Terrace 207 *J13*  
Carlyle Square 206 *N9*  
Carmelite Street 200 *H16*  

Carnaby Street 199 *H13*  
Caroline Terrace 207 *L11*  
Carter Lane 200 *H17*  
Carter Street 208 *N17*  
Carting Lane 200 *H15*  
Cartwright Gardens 199 *E14*  
Cartwright Street 201 *H20*  
Castle Baynard Street 200 *H17*  
Castle Lane 207 *K13*  
Catesby Street 209 *L19*  
Cathcart Road 206 *N8*  
Cathedral Street 209 *J18*  
Catlin Street 209 *M21*  
Cato Street 198 *G10*  
Causton Street 207 *M14*  
Cavendish Close 198 *E9*  
Cavendish Place 199 *G12*  
Cavendish Square 199 *G12*  
Cavendish Street 201 *D18*  
Cavendish Street 199 *F13*  
Caversham Street 206 *N10*  
Caxton Street 207 *K13*  
Cayton Street 201 *E18*  
Centaur Street 208 *K16*  
Central Street 200 *E17*  
Central Street 199 *G14*  
Chad's Street 199 *E14*  
Chadwick Street 207 *L13*  
Chagford Street 198 *F10*  
Chalbert Street 198 *D9*  
Chambers Street 209 *K21*  
Chambord Street 201 *E20*  
Chancel Street 208 *J17*  
Chancery Lane 200 *G16*  
Chandos Place 199 *H14*  
Chandos Street 199 *G12*  
Chapel Street 198 *G10*  
Chapel Street 207 *K11*  
Chaplin Close 208 *K16*  
Chapter Road 208 *N17*  
Chapter Street 207 *L13*  
Charing Cross Road 199 *H14*  
Charles II Street 207 *J13*  
Charles Lane 198 *D9*  
Charles Square 201 *E19*  
Charles Street 207 *J12*  
Charleston Street 208 *M18*  
Charlotte Road 201 *E19*  
Charlotte Street 199 *F13*  
Charlwood Street 207 *M13*  
Charrington Street 199 *D13*  
Chart Street 201 *E19*  
Charterhouse Square 200 *F17*  
Charterhouse Street 200 *F17*  
Chatham Street 209 *L18*  
Chaucer Drive 209 *M20*  
Cheapside 200 *G18*  
Chelsea Bridge 207 *N12*  
Chelsea Bridge Road 207 *M11*  
Chelsea Embankment 206 *N10*  
Chelsea Gate 206 *N11*  
Chelsea Manor Gardens 206 *N10*  
Chelsea Manor Street 206 *M10*  
Chelsea Park Gardens 206 *N9*  
Chelsea Square 206 *M9*  
Cheltenham Terrace 206 *M10*  
Cheney Road 200 *D14*  
Chenies Mews 199 *F13*  
Chenies Street 199 *F13*  
Chequer Street 200 *F18*  

Cherbury Street 201 *D19*  
Cherry Gardens 209 *K21*  
Chesham Place 207 *L11*  
Chesham Street 206 *L11*  
Cheshire Street 201 *F21*  
Chester Close North 199 *E12*  
Chester Court 199 *E12*  
Chester Gate 199 *E12*  
Chester Mews 207 *K12*  
Chester Road 199 *E11*  
Chester Row 207 *L11*  
Chester Square 207 *L12*  
Chester Street 201 *F21*  
Chester Street 207 *K11*  
Chester Terrace 199 *E12*  
Chester Way 208 *M16*  
Chesterfield Hill 207 *J12*  
Cheval Place 206 *K10*  
Cheyne Gardens 206 *N10*  
Cheyne Row 206 *N9*  
Cheyne Walk 206 *N9*  
Chicheley Street 208 *K15*  
Chichester Street 207 *M13*  
Chicksand Street 201 *G20*  
Chiltern Street 198 *F11*  
Chilworth Mews 198 *G8*  
Chiswell Street 201 *F18*  
Christchurch Street 206 *M10*  
Christian Street 201 *H21*  
Chumleigh Street 209 *N19*  
Church Street 198 *F9*  
Church Yard Row 208 *L17*  
Churchill Gardens Road 207 *N13*  
Churchway 199 *E14*  
Churton Street 207 *M13*  
Circus Road 198 *E9*  
City Garden Row 200 *D17*  
City Road 200 *D17*  
Clabon Mews 206 *L10*  
Claredale Street 201 *D21*  
Claremont Close 200 *D16*  
Claremont Square 200 *D16*  
Clarence Gardens 199 *E12*  
Clarence Gate 198 *F11*  
Clarendon Gardens 198 *F8*  
Clarendon Gate 198 *H9*  
Clarendon Place 198 *H9*  
Clarendon Street 207 *M12*  
Clareville Grove 206 *M8*  
Clareville Street 206 *L8*  
Clarges Mews 207 *J12*  
Clarges Street 207 *J12*  
Claverton Street 207 *M13*  
Clay Street 198 *G11*  
Clayton Street 208 *N16*  
Cleaver Square 208 *M16*  
Cleaver Street 208 *M16*  
Clement's Inn 200 *H15*  
Clement's Road 209 *L21*  
Clements Lane 201 *H19*  
Clere Street 201 *F19*  
Clerkenwell Close 200 *F16*  
Clerkenwell Green 200 *F16*  
Clerkenwell Road 200 *F16*  
Cleveland Gardens 198 *H8*  
Cleveland Row 207 *J13*  
Cleveland Square 198 *H8*  
Cleveland Street 199 *F12*  
Cleveland Terrace 198 *G8*  
Clifford Street 199 *H12*

| Street | Page | Grid |
|---|---|---|
| Eldon Street | 201 | G19 |
| Elgin Mews South | 198 | E7 |
| Elia Mews | 200 | D17 |
| Elia Street | 200 | D17 |
| Elim Estate | 209 | K19 |
| Elizabeth Bridge | 207 | L12 |
| Elizabeth Street | 207 | L11 |
| Ellen Street | 201 | H21 |
| Elliott's Row | 208 | L17 |
| Ellis Street | 206 | L11 |
| Elm Park Gardens | 206 | M9 |
| Elm Park Lane | 206 | N9 |
| Elm Park Road | 206 | N9 |
| Elm Place | 206 | M9 |
| Elm Tree Road | 198 | E9 |
| Elms Mews | 198 | H8 |
| Elsted Street | 209 | M19 |
| Elvaston Mews | 206 | L8 |
| Elvaston Place | 206 | L8 |
| Elverton Street | 207 | L13 |
| Ely Place | 200 | G16 |
| Elystan Place | 206 | M10 |
| Elystan Street | 206 | M10 |
| Embankment Gardens | 206 | N11 |
| Emerald Street | 200 | F15 |
| Emery Hill Street | 207 | L13 |
| Emperor's Gate | 206 | L8 |
| Endell Street | 199 | G14 |
| Endsleigh Gardens | 199 | E13 |
| Endsleigh Street | 199 | E14 |
| English Grounds | 209 | J19 |
| Enid Street | 209 | K20 |
| EnnisMews Gardens | 206 | K9 |
| Ennismore Gardens | 206 | K9 |
| Ennismore Gardens Mews | 206 | K9 |
| Ennismore Mews | 206 | K9 |
| Ensign Street | 201 | H21 |
| Epworth Street | 201 | F19 |
| Erasmus Street | 207 | M14 |
| Errol Street | 200 | F18 |
| Esmeralda Road | 209 | M21 |
| Ethnard Road | 209 | N21 |
| Euston Road | 199 | E13 |
| Euston Square | 199 | E13 |
| Euston Station Col. | 199 | E13 |
| Euston Street | 199 | E13 |
| Euston Underpass | 199 | F13 |
| Evelyn Gardens | 206 | M8 |
| Eversholt Street | 199 | D13 |
| Ewer Street | 208 | J17 |
| Exeter Street | 200 | H15 |
| Exhibition Road | 206 | K9 |
| Exmouth Market | 200 | E16 |
| Eyre Street Hill | 200 | F16 |
| Ezra Street | 201 | E20 |
| Fair Street | 209 | K20 |
| Fairclough Street | 201 | G21 |
| Fakruddin Street | 201 | F21 |
| Falkrik Street | 201 | D19 |
| Falmouth Road | 209 | K18 |
| Fann Street | 200 | F17 |
| Fanshaw Street | 201 | E19 |
| Farm Street | 199 | H12 |
| Farnham Royal | 208 | N15 |
| Farrier Way | 206 | N8 |
| Farringdon Lane | 200 | F16 |
| Farringdon Road | 200 | E16 |
| Farringdon Street | 200 | G16 |
| Fashion Street | 201 | G20 |
| Faunce Street | 208 | M17 |
| Fawcett Street | 206 | N8 |
| Featherstone Street | 201 | F18 |
| Felton Road | 209 | K21 |
| Fenchurch Avenue | 201 | H19 |
| Fenchurch Street | 201 | H19 |
| Fetter Lane | 200 | G16 |
| Fieldgate Street | 201 | G21 |
| Fielding Street | 208 | N18 |
| Finsbury Avenue | 201 | G19 |
| Finsbury Circus | 201 | G19 |
| Finsbury Square | 201 | F19 |
| First Street | 206 | L10 |
| Fisherton Street | 198 | F9 |
| Fitzalan Street | 208 | L16 |
| Fitzhardinge Street | 198 | G11 |
| Fitzroy Square | 199 | F12 |
| Fitzroy Street | 199 | F13 |
| Flaxman Terrace | 199 | E14 |
| Fleet Lane | 200 | G17 |
| Fleet Street | 200 | G16 |
| Fleet Street Hill | 201 | F21 |
| Fleming Road | 208 | N17 |
| Flinton Street | 209 | M19 |
| Flood Street | 206 | N10 |
| Flood Way | 206 | N10 |
| Floral Street | 199 | H14 |
| Florida Street | 201 | E21 |
| Foley Street | 199 | G13 |
| Folgate Street | 201 | F20 |
| Forbes Street | 201 | H21 |
| Fordham Street | 201 | G21 |
| Fore Street | 200 | G18 |
| Forset Street | 198 | G10 |
| Forsyth Gardens | 208 | N17 |
| Fort Road | 209 | L20 |
| Fortune Street | 200 | F18 |
| Foster Lane | 200 | G17 |
| Foubert's Place | 199 | H13 |
| Foulis Terrace | 206 | M9 |
| Fournier Street | 201 | F20 |
| Frampton Street | 198 | F9 |
| Francis Street | 207 | L13 |
| Franklin's Row | 206 | M11 |
| Frazier Street | 208 | K16 |
| Frean Street | 209 | K21 |
| Frederick Street | 200 | E15 |
| Freemantle Street | 209 | M19 |
| Frensham Street | 209 | N21 |
| Friday Street | 200 | H17 |
| Frith Street | 199 | H13 |
| Fulham Road | 206 | L9 |
| Fulwood Place | 200 | G15 |
| Furnival Street | 200 | G16 |
| Gainsford Street | 209 | J20 |
| Gambia Street | 208 | J17 |
| Garden Road | 198 | E8 |
| Garden Row | 208 | L17 |
| Gardners Lane | 200 | H17 |
| Garlick Hill | 200 | H18 |
| Garner Street | 201 | D21 |
| Garrett Street | 200 | F18 |
| Garrick Street | 199 | H14 |
| Gasholder Place | 208 | M15 |
| Gate Street | 200 | G15 |
| Gateway | 208 | N18 |
| Gatliff Road | 207 | M12 |
| Gaywood Street | 208 | L17 |
| Gaza Street | 208 | M17 |
| Gee Street | 200 | F17 |
| Geffrye Street | 201 | D20 |
| George Row | 209 | K21 |
| George Street | 198 | G10 |
| Georgina Gardens | 201 | E20 |
| Geraldine Street | 208 | L16 |
| Gerrard Street | 199 | H14 |
| Gerridge Street | 208 | K16 |
| Gertrude Street | 206 | N8 |
| Gibson Road | 208 | L15 |
| Gilbert Place | 199 | G14 |
| Gilbert Road | 208 | L16 |
| Gilbert Street | 199 | H11 |
| Gillingham Street | 207 | L12 |
| Gilston Road | 206 | M8 |
| Giltspur Street | 200 | G17 |
| Gladsstone Street | 208 | K17 |
| Glasgow Terrace | 207 | M12 |
| Glasshill Street | 208 | K17 |
| Glasshouse Street | 199 | H13 |
| Glasshouse Walk | 208 | M15 |
| Glebe Place | 206 | N9 |
| Glengall Road | 209 | N20 |
| Glentworth Street | 198 | F10 |
| Gloucester Gardens | 198 | G8 |
| Gloucester Mews | 198 | H8 |
| Gloucester Mews Way | 198 | G8 |
| Gloucester Place | 198 | F10 |
| Gloucester Place Mews | 198 | G10 |
| Gloucester Road | 206 | L8 |
| Gloucester Square | 198 | H9 |
| Gloucester Street | 207 | M13 |
| Gloucester Way | 200 | E16 |
| Glyn Street | 208 | M15 |
| Godfrey Street | 206 | M10 |
| Goding Street | 208 | M15 |
| Godliman Street | 200 | H17 |
| Godson Street | 200 | D16 |
| Godwin Close | 200 | D18 |
| Golden Lane | 200 | F18 |
| Golden Square | 199 | H13 |
| Golding Street | 201 | H21 |
| Goodge Street | 199 | G13 |
| Goodmans Stile | 201 | G20 |
| Goodmans Yard | 201 | H20 |
| Goodwin Close | 209 | L20 |
| Gordon Square | 199 | F14 |
| Gordon Street | 199 | E13 |
| Gore South | 206 | K8 |
| Gorsuch Street | 201 | E20 |
| Gosfield Street | 199 | G12 |
| Gosset Street | 201 | E21 |
| Goswell Road | 200 | E17 |
| Gough Street | 200 | F15 |
| Goulston Street | 201 | G20 |
| Gower Place | 199 | F13 |
| Gower Street | 199 | F13 |
| Gower's Way | 201 | G21 |
| Gracechurch Street | 201 | H19 |
| Graces Mews | 198 | D8 |
| Grafton Mews | 199 | F13 |
| Grafton Way | 199 | F13 |
| Graham Street | 200 | D17 |
| Graham Terrace | 207 | M11 |
| Granary Road | 201 | F21 |
| Granby Street | 201 | E20 |
| Granby Terrace | 199 | D12 |
| Grange Court | 200 | G15 |
| Grange Road | 209 | L19 |
| Grange Way | 209 | K19 |
| Grange Yard | 209 | L20 |
| Granville Square | 200 | E15 |
| Gravel Lane | 201 | G20 |
| Gray Street | 208 | K16 |
| Gray's Inn Road | 200 | E15 |
| Gray's Inn Square | 200 | F16 |
| Great Central Street | 198 | F10 |
| Great Chapel Street | 199 | G13 |
| Great College Street | 207 | K14 |
| Great Cumberland Place | 198 | H10 |
| Great Dover Street | 208 | K18 |
| Great Eastern Street | 201 | F19 |
| Great George Street | 207 | K14 |
| Great Guildford Street | 208 | J17 |
| Great James Street | 200 | F15 |
| Great Marlborough Street | 199 | G13 |
| Great Maze Pond | 209 | J18 |
| Great Ormond Street | 200 | F15 |
| Great Percy Street | 200 | E15 |
| Great Peter Street | 207 | L14 |
| Great Portland Street | 199 | F12 |
| Great Pulteney Street | 199 | H13 |
| Great Queen Street | 200 | G15 |
| Great Russell Street | 199 | G14 |
| Great Scotland Yard | 207 | J14 |
| Great Smith Street | 207 | L14 |
| Great Suffolk Street | 208 | J17 |
| Great Sutton Street | 200 | F17 |
| Great Titchfield Street | 199 | F12 |
| Great Tower Street | 201 | H19 |
| Great Winchester Street | 201 | G19 |
| Greatorex Street | 201 | G21 |
| Greek Street | 199 | H14 |
| Green Street | 198 | H11 |
| Greenberry Street | 198 | D9 |
| Greencoat Place | 207 | L13 |
| Greenfield Road | 201 | G21 |
| Greenham Close | 208 | K16 |
| Greet Street | 208 | J16 |
| Grendon Street | 198 | F9 |
| Grenville Place | 206 | L8 |
| Grenville Street | 200 | F15 |
| Gresham Street | 200 | G18 |
| Gresse Street | 199 | G13 |
| Greville Street | 200 | G16 |
| Grey Eagle Street | 201 | F20 |
| Greycoat Place | 207 | L13 |
| Greycoat Street | 207 | L13 |
| Grimsby Street | 201 | F20 |
| Grosvenor Bridge | 207 | N12 |
| Grosvenor Crescent | 207 | K11 |
| Grosvenor Gardens | 207 | L12 |
| Grosvenor Gate | 198 | H11 |
| Grosvenor Hill | 199 | H12 |
| Grosvenor Place | 207 | K12 |
| Grosvenor Road | 207 | M14 |
| Grosvenor Square | 199 | H11 |
| Grosvenor Street | 199 | H12 |
| Grosvenor Terrace | 208 | N18 |
| Grove Castle Street | 199 | G12 |
| Grove End Road | 198 | D8 |
| Grove Gardens | 198 | E10 |

| | | | | | | | | |
|---|---|---|---|---|---|---|---|---|
| Lambeth Way | 208 | L15 | Lizard Street | 200 | E18 | Maiden Lane | 199 | H14 |
| Lamont Road | 206 | N8 | Lloyd Baker Street | 200 | E16 | Maidstone Buildings | 208 | J18 |
| Lampern Square | 201 | E21 | Lloyd Street | 200 | E16 | Malborough Place | 198 | D8 |
| Lanark Place | 198 | F8 | Lloyd's Avenue | 201 | H19 | Malden Lane | 208 | J18 |
| Lancaster Gate | 198 | H8 | Lodge Road | 198 | E9 | Malet Street | 199 | F14 |
| Lancaster Place | 200 | H15 | Lodson Street | 208 | K16 | Mallord Street | 206 | N9 |
| Lancaster Street | 208 | K17 | Lollard Street | 208 | L15 | Mallory Street | 198 | F10 |
| Lancaster Terrace | 198 | H9 | Lombard Street | 208 | J17 | Mallow Street | 201 | E18 |
| Lancaster Walk | 198 | J8 | Lomas Street | 201 | F21 | Malt Street | 209 | N21 |
| Lancelot Place | 206 | K10 | Lombard Lane | 200 | H16 | Maltby Street | 209 | K20 |
| Lancester Mews | 198 | H8 | Lombard Street | 201 | H19 | Manchester Square | 199 | G11 |
| Langdale Close | 208 | N17 | Loncroft Road | 209 | N20 | Manchester Street | 198 | G11 |
| Langdale Street | 201 | H21 | London Bridge | 201 | J18 | Manciple Street | 209 | K18 |
| Langford Place | 198 | D8 | London Bridge Street | 209 | J18 | Mandela Way | 209 | L19 |
| Langham Place | 199 | G12 | London Road | 208 | L17 | Mandeville Place | 199 | G11 |
| Langham Street | 199 | G12 | London Street | 198 | G8 | Manor Place | 208 | M17 |
| Langley Lane | 208 | N15 | London Wall | 200 | G18 | Manresa Road | 206 | M9 |
| Langley Street | 199 | H14 | Long Acre | 199 | H14 | Mansell Street | 201 | H20 |
| Lant Street | 208 | K18 | Long Lane | 200 | G17 | Mansfield Street | 199 | G12 |
| Larcom Street | 208 | M18 | Long Lane | 209 | K18 | Mansford Street | 201 | D21 |
| Latona Road | 209 | N21 | Long Street | 201 | E20 | Manson Place | 206 | L8 |
| Launceston Place | 206 | L8 | Long Walk | 209 | K19 | Mape Street | 201 | E21 |
| Lavington Street | 208 | J17 | Longford Street | 199 | F12 | Maple Street | 199 | F13 |
| Law Street | 209 | K19 | Longley Street | 201 | L21 | Marble Arch | 198 | H10 |
| Lawn Lane | 208 | N15 | Longmoore Street | 207 | L13 | Marchmont Street | 199 | F14 |
| Lawrence Street | 206 | N9 | Lorne Crescent | 198 | E10 | Marcia Road | 209 | M19 |
| Laystall Street | 200 | F16 | Lorrimore Road | 208 | N17 | Margaret Street | 199 | G12 |
| Leadenhall Street | 201 | H19 | Lorrimore Square | 208 | N17 | Margaret Street | 207 | K14 |
| Leake Street | 208 | K15 | Lothbury | 201 | G18 | Margaretta Terrace | 206 | N10 |
| Leather Lane | 200 | F16 | Loughborough Street | 208 | M15 | Margery Street | 200 | E16 |
| Leathermarket Street | 209 | K19 | Lovat Lane | 201 | H19 | Marigold Street | 209 | K21 |
| Lees Place | 198 | H11 | Love Lane | 200 | G18 | Marine Street | 209 | K21 |
| Leicester Square | 199 | H14 | Lovegrove Street | 209 | M21 | Mark Lane | 201 | H19 |
| Leicester Street | 199 | H14 | Lovers' Way | 206 | J11 | Market Mews | 207 | J12 |
| Leigh Hunt Street | 208 | K17 | Lower Belgrave Street | 207 | L12 | Markham Square | 206 | M10 |
| Leinster Gardens | 198 | H8 | Lower Grosvenor | | | Markham Street | 206 | M10 |
| Leinster Mews | 198 | H8 | Place | 207 | K12 | Marlborough Grove | 209 | M21 |
| Leinster Terrace | 198 | H8 | Lower Marsh | 208 | K16 | Marlborough Road | 207 | J13 |
| Leman Street | 201 | G20 | Lower Sloane Street | 206 | M11 | Marshall Street | 199 | H13 |
| Lennox Gardens | 206 | L10 | Lower Thames Street | 201 | H19 | Marshalsea Road | 208 | K18 |
| Lennox Gardens | | | Lowndes Place | 207 | L11 | Marsham Street | 207 | L14 |
| Mews | 206 | L10 | Lowndes Square | 206 | K11 | Marsland Road | 208 | M17 |
| Leonard Street | 201 | F19 | Lowndes Street | 206 | K11 | Marylebone High | | |
| Leroy Street | 209 | L19 | Lucan Place | 206 | L9 | Street | 199 | F11 |
| Lever Street | 200 | E18 | Lucey Road | 209 | L21 | Marylebone Lane | 199 | G11 |
| Lexington Street | 199 | H13 | Lucey Way | 209 | L21 | Marylebone Road | 198 | F10 |
| Leyden Street | 201 | G20 | Ludgate Circus | 200 | G17 | Marylebone Street | 199 | G11 |
| Library Street | 208 | K17 | Ludgate Hill | 200 | G17 | Marylebone Way | 206 | K10 |
| Lidlington Place | 199 | D13 | Luke Street | 201 | F19 | Marylebone-Fly-Over | 198 | G9 |
| Lilestone Street | 198 | F10 | Lupus Street | 207 | M12 | Marylee Way | 208 | M15 |
| Lilley Close | 209 | J21 | Luton Street | 198 | F9 | Mason Street | 209 | L19 |
| Lime Close | 209 | J21 | Luxborough Street | 198 | F11 | Mason's Place | 200 | E17 |
| Lime Street | 201 | H19 | Lyall Street | 207 | L11 | Maunsel Street | 207 | L13 |
| Limeburnerl Lane | 200 | G17 | Lynton Road | 209 | M20 | Mawbey Street | 209 | M20 |
| Limerstone Street | 206 | N8 | Lyons Place | 198 | F9 | Meadcroft Road | 208 | N16 |
| Lincoln's Inn Fields | 200 | G15 | Lytham Street | 209 | M18 | Meadow Road | 208 | N15 |
| Lindsay Square | 207 | M14 | | | | Meadow Row | 208 | L17 |
| Lindsey Street | 200 | F17 | | | | Meakin Estate | 209 | K19 |
| Linhope Street | 198 | F10 | | | | Mecklenburgh Square | 200 | F15 |
| Linsey Street | 209 | L21 | | | | Medway Street | 207 | L14 |
| Lisle Street | 199 | H14 | | | | Melcombe Street | 198 | F10 |
| Lisson Grove | 198 | E9 | **M**acclesfield Road | 200 | E17 | Melina Place | 198 | E8 |
| Lisson Street | 198 | F9 | Mace Close | 201 | J21 | Melton Street | 199 | E13 |
| Little Britain | 200 | G17 | Mack's Road | 209 | L21 | Mepham Street | 208 | J16 |
| Little Dorrit Court | 208 | K18 | Macklin Street | 200 | G15 | Mercer Street | 199 | H14 |
| Little New Street | 200 | G16 | Macleod Street | 208 | M18 | Merlin Street | 200 | E16 |
| Little Portland Street | 199 | G12 | Maddock Way | 208 | N17 | Mermaid Court | 209 | K18 |
| Little Somerset Street | 201 | G20 | Maddox Street | 199 | H12 | Merrick Square | 208 | K18 |
| Little Trinity Lane | 200 | H18 | Madron Street | 209 | M19 | Merrow Street | 209 | M18 |
| Liverpool Grove | 209 | M18 | Magdalen Street | 209 | J19 | Methley Street | 208 | M16 |
| Liverpool Street | 201 | G19 | Maida Avenue | 198 | F8 | Mews Street | 209 | J21 |

| | | | | | |
|---|---|---|---|---|---|
| Micawber Street | 200 | E18 |
| Middelton Square | 200 | E16 |
| Middle Temple Lane | 200 | H16 |
| Middlesex Street | 201 | G20 |
| Midland Road | 199 | E14 |
| Milborne Grove | 206 | M8 |
| Milcote Street | 208 | K17 |
| Miles Street | 207 | N14 |
| Milford Lane | 200 | H16 |
| Milk Street | 200 | G18 |
| Mill Street | 209 | K20 |
| Millbank | 207 | L14 |
| Millennium Bridge | 200 | H17 |
| Millman Street | 200 | F15 |
| Millstream Street | 209 | K20 |
| Milner Street | 206 | L10 |
| Milton Street | 201 | F18 |
| Milverton Street | 208 | M16 |
| Mina Road | 209 | M19 |
| Mincing Lane | 201 | H19 |
| Minera Mews | 207 | L11 |
| Minerva Street | 201 | D21 |
| Minories | 201 | H20 |
| Mitchell Street | 200 | E18 |
| Mitre Court | 200 | H16 |
| Mitre Road | 208 | K16 |
| Mitre Street | 201 | G19 |
| Molyneux Street | 198 | G10 |
| Monck Street | 207 | L14 |
| Monkton Street | 208 | L16 |
| Monmouth Street | 199 | H14 |
| Monnow Road | 209 | L21 |
| Montagu Mews North | 198 | G10 |
| Montagu Mews West | 198 | G10 |
| Montagu Place | 198 | G10 |
| Montagu Square | 198 | G10 |
| Montagu Street | 198 | G10 |
| Montague Close | 209 | J18 |
| Montague Place | 199 | F14 |
| Montague Street | 199 | G14 |
| Montague Street | 200 | G17 |
| Montclare Street | 201 | E20 |
| Montford Place | 208 | M16 |
| Montpelier Place | 206 | K10 |
| Montpelier Square | 206 | K10 |
| Montpelier Street | 206 | K10 |
| Montpelier Way | 206 | K10 |
| Montrose Place | 207 | K11 |
| Monument Street | 201 | H19 |
| Moor Lane | 201 | G18 |
| Moore Street | 206 | L10 |
| Moorfields | 201 | G18 |
| Moorgate | 201 | G18 |
| Mora Street | 200 | E18 |
| Morecamble Street | 208 | M18 |
| Moreland Street | 200 | E17 |
| Moreton Place | 207 | M13 |
| Moreton Street | 207 | M13 |
| Morgan's Lane | 209 | J19 |
| Morley Street | 208 | K16 |
| Mornington Crescent | 199 | D12 |
| Morocco Street | 209 | K19 |
| Morpeth Terrace | 207 | L13 |
| Mortimer Street | 199 | G13 |
| Morwell Street | 199 | G14 |
| Moss Close | 201 | G21 |
| Mossop Street | 206 | L10 |
| Motcomb Street | 206 | K11 |
| Mount Pleasant | 200 | F16 |
| Mount Row | 199 | H12 |
| Mount Street | 199 | H11 |

# INDEX OF STREETS

| | | | | | | | |
|---|---|---|---|---|---|---|---|
| **U**fford Street | 208 | *K16* | **W**adding Street | 209 | *M18* | Westminster Bridge | 208 | *K15* |

## U

Ufford Street 208 *K16*
Underpass 207 *K11*
Undershaft 201 *G19*
Underwood Road 201 *F21*
Underwood Street 200 *E18*
Union Street 208 *J17*
Union Way 201 *E20*
University Street 199 *F13*
Upbrook Mews 198 *H8*
Upnor Way 209 *M19*
Upper Belgrave Street 207 *K11*
Upper Berkeley Street 198 *G10*
Upper Brook Street 198 *H11*
Upper Cheyne Row 206 *N9*
Upper Grosvenor Street 198 *H11*
Upper Ground 208 *J16*
Upper Harley Street 199 *F11*
Upper John Street 199 *H13*
Upper Marsh 208 *K15*
Upper Montagu Street 198 *F10*
Upper Thames Street 200 *H17*
Upper Wimpole Street 199 *F11*
Upper Woburn Place 199 *E14*
Urlwin Street 208 *N18*

## V

Vale Close 198 *E8*
Valentine Place 208 *K16*
Vallance Road 201 *E21*
Varden Street 201 *G21*
Varndell Street 199 *E13*
Vauban Street 209 *L20*
Vaughan Way 201 *H21*
Vauxhall Bridge 207 *M14*
Vauxhall Bridge Road 207 *L13*
Vauxhall Grove 208 *N15*
Vauxhall Street 208 *M15*
Vauxhall Way 208 *M15*
Venables Street 198 *F9*
Vere Street 199 *G12*
Vernon Place 200 *G15*
Vestry Street 201 *E18*
Viaducts Place 201 *E21*
Viaducts Street 201 *E21*
Victoria Embankment 200 *H16*
Victoria Road 206 *K8*
Victoria Square 207 *L12*
Victoria Street 207 *K14*
Victory Place 208 *L18*
Villa Street 209 *M18*
Villiers Street 199 *J14*
Vince Street 201 *E19*
Vincent Square 207 *L13*
Vincent Street 207 *L14*
Vincent Terrace 200 *D17*
Vine Court 201 *G21*
Vine Street 201 *H20*
Vinegar Street 209 *J21*
Vintners Place 200 *H18*
Violet Hill 198 *D8*
Virginia Road 201 *E20*
Virginia Street 201 *H21*
Voss Street 201 *E21*

## W

Wadding Street 209 *M18*
Waite Street 209 *N20*
Wakefield Street 199 *E14*
Wakley Street 200 *E17*
Walbrook 201 *H18*
Walcot Square 208 *L16*
Walden Street 201 *G21*
Walnut Tree Way 208 *L16*
Walpole Street 206 *M10*
Walton Street 206 *L10*
Walworth Place 208 *M18*
Walworth Road 208 *L17*
Wandsworth Road 207 *N14*
Wansey Street 208 *L18*
Wapping High Street 209 *J21*
Wardour Street 199 *G13*
Warner Place 201 *E21*
Warner Street 200 *F16*
Warren Street 199 *F12*
Warrington Crescent 198 *F8*
Warwick Crescent 198 *F8*
Warwick Lane 200 *G17*
Warwick Place 198 *F8*
Warwick Row 207 *K12*
Warwick Square 207 *M13*
Warwick Street 199 *H13*
Warwick Way 207 *L13*
Water Gardens 198 *G10*
Waterloo Bridge 200 *H15*
Waterloo Place 207 *J13*
Waterloo Road 208 *J15*
Waterman Way 209 *J21*
Waterson Street 201 *E20*
Watling Street 200 *H18*
Waverley Place 198 *D9*
Waverton Street 207 *J12*
Wear Place 201 *E21*
Webb Street 209 *L19*
Webber Row 208 *K16*
Webber Street 208 *K16*
Webster Road 209 *L21*
Welbeck Street 199 *G12*
Wellclose Square 201 *H21*
Weller Street 208 *K18*
Wellesley Terrace 200 *E18*
Wellington Buildings 207 *M11*
Wellington Road 198 *E9*
Wellington Row 201 *E21*
Wells Mews 199 *G13*
Wells Street 199 *G13*
Wells Way 209 *N19*
Welsford Street 209 *M21*
Wendower Road 209 *M19*
Wendower Walk 209 *M19*
Wenlock Road 200 *D18*
Wenlock Street 201 *D18*
Wentworth Street 201 *G20*
Werrington Street 199 *D13*
West Halkin Street 206 *K11*
West Pier 209 *J21*
West Smithfield 200 *G17*
West Square 208 *L16*
West Street 199 *H14*
Westbourne Bridge 198 *G8*
Westbourne Crescent 198 *H9*
Westbourne Grove 197 *H7*
Westbourne Terrace 198 *G8*
Westbourne Terrace Road 198 *F8*
Westcott Road 208 *N17*
Westland Place 201 *E18*

Westminster Bridge 208 *K15*
Westminster Bridge Road 208 *K15*
Westminster Business Square 208 *N15*
Westmoreland Place 207 *M12*
Westmoreland Road 209 *N18*
Westmoreland Street 199 *G11*
Westmoreland Terrace 207 *M12*
Weston Rise 200 *E15*
Weston Street 209 *J19*
Wetherby Place 206 *M8*
Weymouth Mews 199 *G12*
Weymouth Street 199 *F12*
Weymouth Terrace 201 *D20*
Wharf Road 200 *D17*
Wharfdale Road 200 *D15*
Wharton Street 200 *E16*
Wheler Street 201 *F20*
Whetstone Park 200 *G15*
Whidborne Street 199 *E14*
Whiskin Street 200 *E16*
Whitby Street 201 *F20*
Whitcomb Street 199 *H14*
White Chapel High Road 201 *G21*
White Chapel High Street 201 *G20*
White Chapel Lane 201 *G20*
White Hart Street 208 *M16*
White Horse Street 207 *J12*
White Kennett Street 201 *G20*
White Lion Hill 200 *H17*
White Lion Street 200 *D16*
White Lyon Court 200 *F17*
White's Grounds 209 *K19*
White's Row 201 *G20*
Whitecross Place 201 *F19*
Whitecross Street 200 *F18*
Whitefriars Street 200 *H16*
Whitehall 207 *J14*
Whitehall Court 207 *J14*
Whitehall Place 207 *J14*
Whitehead's Grove 206 *M10*
Whitfield Street 199 *F13*
Whitgift Street 208 *L15*
Wickham Street 208 *M15*
Wigmore Place 199 *G12*
Wigmore Street 199 *G11*
Wild Street 200 *G15*
Wild's Rents 209 *K19*
Wilfred Street 207 *K13*
Wilkes Street 201 *F20*
Wilks Place 201 *D19*
William IV Street 199 *H14*
William Mews 206 *K11*
William Road 199 *E12*
Willow Place 207 *L13*
Willow Way 209 *L19*
Wilmington Square 200 *E16*
Wilson Grove 209 *K21*
Wilson Street 201 *F19*
Wilton Crescent 206 *K11*
Wilton Mews 207 *K12*
Wilton Place 206 *K11*
Wilton Road 207 *L12*
Wilton Street 207 *K12*
Wimbolt Street 201 *E21*
Wimpole Mews 199 *G12*
Wimpole Street 199 *G12*

Winchester Street 207 *M12*
Winchester Way 209 *J18*
Wincott Street 208 *L16*
Windmill Street 199 *G13*
Windmill Walk 208 *J16*
Windsor Terrace 200 *E18*
Wine Office Court 200 *G16*
Winkley Street 201 *D21*
Winsland Mews 198 *G9*
Winsland Street 198 *G9*
Winsley Street 199 *G13*
Winthorpe Street 201 *F21*
Withers Place 200 *F18*
Woburn Place 199 *F14*
Woburn Square 199 *F14*
Wolseley Street 209 *K20*
Wolverley Street 201 *E21*
Wood Close 201 *F21*
Wood Street 200 *G18*
Wood's Place 209 *L19*
Woodbridge Street 200 *F16*
Woods Mews 198 *H11*
Woodseer Street 201 *F21*
Woodstock Street 199 *H12*
Wooler Street 209 *M18*
Wootton Street 208 *J16*
Worgan Street 208 *M15*
Wormwood Street 201 *G19*
Worship Street 201 *F19*
Wren Street 200 *F15*
Wyclif Street 200 *E17*
Wyndham Street 198 *F10*
Wynyatt Street 200 *E17*

## Y

Yalding Road 209 *L20*
Yardley Street 200 *E16*
Yeoman's Row 206 *L10*
York Bridge 199 *F11*
York Gate 199 *F11*
York Road 208 *J15*
York Street 198 *G10*
York Terrace East 199 *F11*
York Terrace West 198 *F11*
Yorkton Street 201 *D20*

## Z

Zoar Street 208 *J17*

# INDEX OF KEY PEOPLE AND PLACES, WITH WEBSITES

| KEYWORD | CITY ATLAS PAGE | MAP REF. | PAGE | WEBSITE |
|---------|-----------------|----------|------|---------|
| Green Park | 207 | J/K12 | | www.royalparks.org.uk/parks/green_park |
| Greenwich | | | 138 | www.greenwich.gov.uk |
| Greenwich Park | 211 | N22 | 138 | www.royalparks.org.uk/ |
| | | | | parks/greenwich_park |
| Grosholtz, Marie | | | 125 | |
| Guildford Four | | | 47 | |
| Guildhall | 200 | G18 | 38 | www.cityoflondon.gov.uk |
| **H**ampton Court Palace | | | 146 | www.hrp.org.uk/hamptoncourtpalace |
| Handel, George Frideric | | | 17, 73, 123 | |
| Handel House Museum | 199 | H12 | | www.handelhouse.org |
| Harrod, Charles Henry | | | 87 | |
| Harrods | 206 | K10 | 86, 98 | www.harrods.com |
| Harry, Prince | | | 149 | |
| Haymarket Theatre | 195 | C3 | | www.trh.co.uk |
| Hayward Gallery | 208 | J15 | 106 | www.haywardgallery.org.uk |
| Henry II | | | 12 | |
| Henry III | | | 72, 122 | |
| Henry VII | | | 12, 72 | |
| Henry VIII | | | 14, 70, 124, 147 | |
| Hermitage Rooms | | | 55 | www.hermitagerooms.org.uk |
| Hesketh, Sir Thomas | | | 72 | |
| HMS *Belfast* | 209 | J19 | | http://hmsbelfast.iwm.org.uk |
| Houses of Parliament | 207 | K14 | 13, 51 | www.parliament.uk |
| | | | 68 | |
| HSBC Tower | | | 136 | www.cwcontractors.com/ |
| | | | | projects8Canada.asp |
| Hyde Park | 206 | J10/11 | 80, 83 | www.royalparks.org.uk |
| **I**sle of Dogs | 211 | | 131 | www.gardenvisit.com |
| **J**ames I | | | 15 | |
| James II | | | 15, 35 | |
| Jewel Tower | 207 | K14 | 69 | www.english-heritage.org.uk |
| John, King | | | 12 | |
| **K**ensington Gardens | 206 | J/K8 | 83, 96, 99 | www.royalparks.org.uk |
| Kensington High Street | 205 | L5-K7 | 83 | www.streetsensation.co.uk/ |
| | | | | kensing/ken_intro.htm |
| Kensington Palace | 205 | J7 | 83, 96, 99 | www.hrp.org.uk/KensingtonPalace |
| Kenwood House | | | 17 | www.english-heritage.org.uk |
| King's Library | | | 122 | www.britishmuseum.org |
| Knightsbridge | 206 | K10/11 | 87 | www.westminster.gov.uk |
| **L**ambeth Bridge | 207, 208 | L14/15 | 107 | www.touruk.co.uk |
| Lambeth Palace | 208 | L15 | | www.archbishopofcanterbury.org/108 |
| Leadenhall Market | 201 | H19 | 6, 32 | www.leadenhallmarket.co.uk |
| Livingstone, Ken | | | 22 | |
| Lloyd, Edward | | | 31 | |
| Lloyd's of London | 201 | H19 | 23, 32 | www.lloyds.com |
| Londinium | | | 10 | britannia.com/history/londonhistory |
| London Aquarium | 208 | K15 | | www.londonaquarium.co.uk |
| London Bridge | 201 | H/J18 | 15, 17, 19, 29 | www.oldlondonbridge.com |
| London County Council | | | 18 | www.london.gov.uk |

| KEYWORD | CITY ATLAS PAGE | MAP REF. | PAGE | WEBSITE |
|---|---|---|---|---|
| Tower Bridge | 209 | J20 | 28, 107 | www.towerbridge.org.uk |
| Tower of London | 201 | H/J20 | 13, 30 | http://hrp.org.uk |
| Trafalgar Square | 195 | C4 | 4, 60 | www.london.gov.uk/trafalgarsquare |
| Trocadero Centre | 199 | H13 | 65 | www.londontrocadero.com |
| Tudor dynasty | | | 12, 14ff. | |
| Turner, William | | | 74 | |
| **U**niversity of London | 199 | F14 | | www.lon.ac.uk |
| **V**ictoria, Queen | | | 18, 19, 30, 77, 93 | |
| Victoria and Albert Museum | 206 | L9 | 88, 174 | www.vam.ac.uk |
| Victoria Station | 207 | L12 | | www.networkrail.co.uk/aspx/947.aspx |
| Vikings | | | 11 | www.museumoflondon.org.uk |
| **W**alworth | 209 | N19 | 12 | www.southwark.gov.uk |
| Wanamaker, Sam | | | 113 | |
| Waterloo Bridge | 200 | H/J15 | | www.peterlind.co.uk/ladies_bridge.htm |
| Waterloo Chamber | | | 150 | www.windsorfestival.com |
| Waterloo International | 208 | J/K16 | | www.networkrail.co.uk/aspx/959.aspx |
| Wellington Monument | 207 | K11 | | www.english-heritage.org.uk |
| Wellington Museum, Apsley House | 207 | J11 | | www.english-heritage.org.uk |
| Westbourne Grove | 197 | G/H7 | 100 | www.westbourne-grove.com |
| West End | | | 16, 51 65 | www.westendlive.co.uk |
| Westminster Abbey | 207 | K14 | 11ff, 21, 69 ff. | www.westminster-abbey.org |
| Westminster Bridge | 208 | K15 | 16, 44 | www.touruk.co.uk |
| Westminster City Hall | 207 | L13 | | www.westminster.gov.uk |
| Westminster Hall | | | 13, 69 | www.parliament.uk |
| Westminster, Palace of (Houses of Parliament) | 207 | K14 | 2, 13, 51, 68, 108 | www.parliament.uk |
| Westminster R. C. Cathedral | 207 | L13 | | www.westminstercathedral.org.uk |
| Westwood, Vivienne | | | 94 | |
| White Tower (Tower of London) | 201 | H/J20 | 12, 31 | www.camelotintl.com |
| Wilde, Oscar | | | 47 | |
| William, Prince | | | 99, 149 | |
| William the Conqueror | | | 12, 30, 71, 151 | |
| William II | | | 122 | |
| William III of Orange | | | 14, 15 | |
| Windsor Castle | | | 150 | www.windsor.gov.uk |
| Wren, Christopher | | | 17, 43, 49, 146 | |

MONACO BOOKS is an imprint of Verlag Wolfgang Kunth

© Verlag Wolfgang Kunth GmbH & Co.KG, Munich, 2009
Concept: Wolfgang Kunth
Editing and design: Verlag Wolfgang Kunth GmbH&Co.KG
English translation: JMS Books LLP (translation Nicola Coates, editor Jenni Davis, design cbdesign)

For distribution please contact:

Monaco Books
c/o Verlag Wolfgang Kunth, Königinstr.11
80539 München, Germany
Tel: +49 / 89/45 80 20 23
Fax: +49 / 89/ 45 80 20 21
info@kunth-verlag.de

www.monacobooks.com
www.kunth-verlag.de

ISBN 978-3-89944-484-1

Printed in Germany

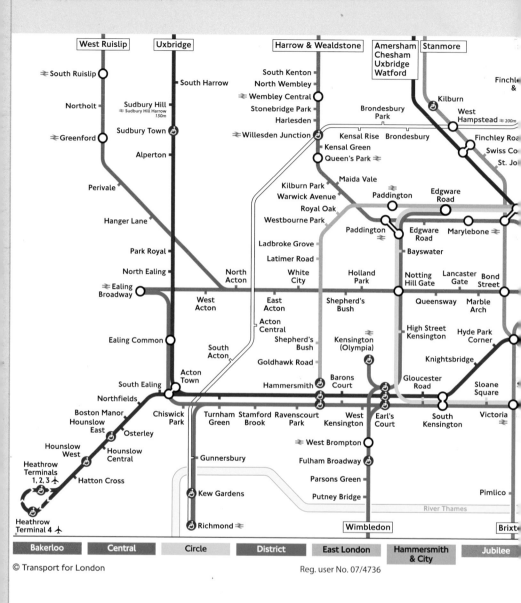

West Ruislip | Uxbridge | Harrow & Wealdstone | Amersham Chesham Uxbridge Watford | Stanmore

⇌ South Ruislip

Northolt

⇌ Greenford

■ South Harrow

Sudbury Hill
⇌ Sudbury Hill Harrow 150m

Sudbury Town ♿

Alperton

Perivale

Hanger Lane

Park Royal

North Ealing

⇌ Ealing Broadway

Ealing Common ♿

South Ealing

Northfields

Boston Manor
Hounslow East
Osterley

Hounslow West
Hounslow Central

Heathrow Terminals 1, 2, 3 ✈
Hatton Cross

Heathrow Terminal 4 ✈ ♿

South Kenton
North Wembley
⇌ Wembley Central ♿
Stonebridge Park
Harlesden
⇌ Willesden Junction ♿

Brondesbury Park
Kensal Rise  Brondesbury
Kensal Green
Queen's Park ⇌

Maida Vale
Kilburn Park
Warwick Avenue
Royal Oak
Westbourne Park

Ladbroke Grove
Latimer Road

North Acton

West Acton

East Acton

Acton Central

Shepherd's Bush

Goldhawk Road

White City

Shepherd's Bush

Kensington (Olympia) ♿

Hammersmith ♿

Holland Park

Barons Court

West Kensington

Earl's Court ♿

Chiswick Park | Turnham Green | Stamford Brook | Ravenscourt Park | West Kensington

⇌ West Brompton

Fulham Broadway ♿

Parsons Green

Putney Bridge ⇌

♿ Kew Gardens

♿ Richmond ⇌

Gunnersbury

Kilburn ♿
West Hampstead ⇌ 200m
Finchley Road
Swiss Co
St. Jo

Finchle &

Paddington ⇌
Paddington ♿
Edgware Road

Edgware Road
Bayswater

Notting Hill Gate
Lancaster Gate
Bond Street

Queensway
Marble Arch

High Street Kensington
Hyde Park Corner

Knightsbridge

Gloucester Road
Sloane Square

South Kensington
Victoria ⇌

Marylebone ⇌

Edgware Road

Pimlico

River Thames

Acton Town
South Acton

Wimbledon | Brixt

**MAYOR OF LONDON**

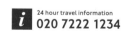

24 hour travel information
020 7222 1234

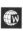